New •Land •Marks

**public art, community, and
the meaning of place**

Fairmount Park Art Association
Edited by Penny Balkin Bach

Publication Coordinator: Sarah R. Katz
Publication Editor: Sarah Fass
Associate Editor: Douglas Gordon
Art Director: James Pittman

Copyright © 2001 by Fairmount Park Art Association
1616 Walnut Street, Suite 2012
Philadelphia, PA 19103-5313
Tel: 215-546-7550

First published in the
United States of America by:
EDITIONS ARIEL, an imprint of
Grayson Publishing
Suite 505
1700 17th Street NW
Washington, DC 20009
Tel: 202-387-8500
James G. Trulove, Publisher

ISBN 0-9679143-4-5

Library of Congress Card Number 00-111582

Printed in Hong Kong

First Printing, 2001

1 2 3 4 5 6 7 8 9 /04 03 02 01 00

This book accompanies an exhibition presented at the Pennsylvania Academy
of the Fine Arts, Philadelphia, February 10–April 15, 2001, and has been
published with the support of the Philadelphia Exhibitions Initiative, a
program funded by The Pew Charitable Trusts and administered by The
University of the Arts, Philadelphia; The William Penn Foundation; and the
Fairmount Park Art Association.

To Ellen Phillips Samuel (1849–1913), whose vision and generosity at the beginning of the twentieth century made so much possible by the end of it.

Contents

Essays

Works in Process: *New·Land·Marks* Proposals

Charles Moleski and Robin Redmond, proposal descriptions
James Abbott, site photography; Sarah R. Katz, biographies

New·Land·Marks Program
Philadelphia, PA

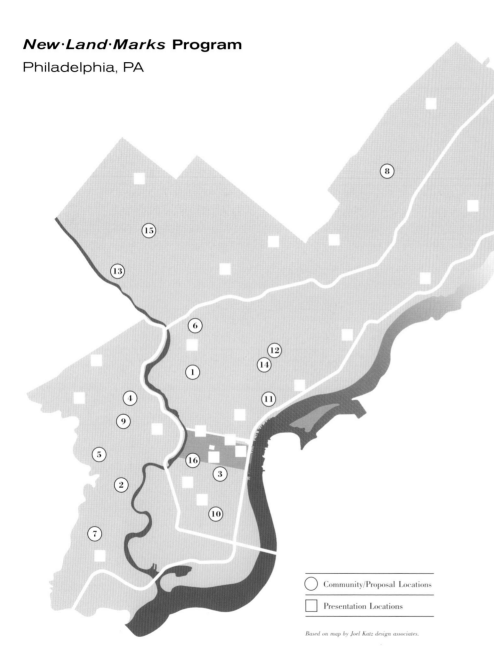

Based on map by Joel Katz design associates.

○ Community/Proposal Locations

□ Presentation Locations

1 CHURCH LOT
Lorene Cary, Lonnie Graham, and John Stone with Project H.O.M.E.

2 BALTIMORE AVENUE GEMs: GRAND PLANTERS,
EARTHBOUND CROW'S-NEST, MIDSUMMER'S FOUNTAIN
Malcolm Cochran with Baltimore Avenue in Bloom

3 THEYAREUS
Ap. Gorny with the gay, lesbian, bisexual, and transgender community
in association with the William Way Community Center

4 GOLDEN MOUNTAIN BUNKA-ZA
Mei-ling Hom with the Friends of the Japanese House and Garden

5 THE REVITALIZATION OF MALCOLM X MEMORIAL PARK
Martha Jackson-Jarvis and JoAnna Viudez with the Friends of
Malcolm X Memorial Park

6 BRIGHT LIGHT TRAIL
Zevilla Jackson Preston with The Allegheny West Foundation

7 A CENTURY OF LABOR
John Kindness with the Friends of Elmwood Park

8 EMBODYING THOREAU: DWELLING, SITTING, WATCHING
Ed Levine with the Pennypack Environmental Center Advisory Council

9 MAY STREET: A PLACE OF REMEMBRANCE AND HONOR
Rick Lowe and Deborah Grotfeldt with the Mill Creek Artists' Collaborative

10 THE VIETNAMESE MONUMENT TO IMMIGRATION
Darlene Nguyen-Ely with the Vietnamese United National Association

11 PERSEVERANCE
Todd Noe with the communities of Kensington and Fishtown

12 I HAVE A STORY TO TELL YOU . . .
Pepón Osorio with Congreso de Latinos Unidos

13 MANAYUNK STOOPS: HEART AND HOME
Diane Pieri and Vicki Scuri with the Manayunk Development Corporation

14 THE GLORIETAS OF FAIRHILL SQUARE:
THE COMPLETION OF A NEIGHBORHOOD COSMOS
Jaime Suárez with the Neighbors of Fairhill

15 PROPOSALS FOR THE WISSAHICKON
George Trakas with the Friends of the Wissahickon

16 OPEN-AIR LIBRARY AND FARMER'S MARKET PLAZA
Janet Zweig with the South of South Neighborhood Association

Foreword

New•Land•Marks: public art, community, and the meaning of place builds upon the Fairmount Park Art Association's long tradition of partnerships with communities in Philadelphia. Established in 1872, the Art Association is the nation's first private, nonprofit organization dedicated to the integration of public art and urban planning. Today, the Art Association continues to promote the appreciation of public art through advocacy efforts and programs that commission, interpret, and preserve public art in Philadelphia.

Over the years, the Art Association has supported city planning projects; commissioned and acquired numerous works of sculpture and public art; established a sculpture conservation program; and sponsored exhibitions, publications, and educational programs. *New•Land•Marks* follows this tradition by engaging artists and communities to plan enduring works of public art as a legacy for future generations. This book represents the "works in process" as we move from the proposal phase to commission, fabrication, and—ultimately—installation and dedication. The proposals are in various stages of development, and the *New•Land•Marks* program forms the framework for a series of commissions that will be undertaken by the Art Association over the next decade.

This book also addresses public art from the perspective of a variety of different disciplines. Penny Balkin Bach looks at the urban and cultural underpinnings of *New•Land•Marks*, Ellen Dissanayake discusses public art from the biological and anthropological viewpoints, Thomas Hine examines the political and communal imperatives for public art, and Lucy R. Lippard writes about the complexities and outcomes of public art practice. The Art Association is deeply grateful to Ms. Bach, the initiator of this project and the general editor of this book, who has brought together an abundance of ideas in this abbreviated glimpse at the *New•Land•Marks* program.

For Philadelphia's communities, the *New•Land•Marks* program has been an opportunity to take an active role in shaping the appearance and meaning of public spaces. For artists, the program has provided a chance to work directly with the public from an early point in the creative process.

New•Land•Marks is a long-term program with short-term milestones. In phase one, the staff held presentations and community meetings throughout the city, highlighting significant public art projects worldwide and the need for responsible stewardship. From hundreds of "Requests to Participate," eighteen communities and twenty-five artists were invited to work with the program.

The second phase, the planning process, has demanded a tremendous amount of time, effort, and goodwill from all parties. A series of Public Art Workshops was held to address essential issues related to the creation of public art. For almost a year, community representatives and artists engaged in an ongoing dialogue. The resulting proposals were presented at a *New•Land•Marks* Symposium at the Philadelphia Museum of Art in May 1999, a significant event that gave the artists and community participants the opportunity to present their proposals in a public forum.

In phase three, a number of events have kept the proposals visible as the projects develop. A Community Exhibition Series has traveled to locations in participating neighborhoods throughout the city and has offered the opportunity to preview this material in the community contexts from which the work emerged. The proposal process culminates with this *New•Land•Marks* book and the accompanying exhibition at the Pennsylvania Academy of the Fine Arts.

Art critic Robert Hughes, in a speech published in *The New Yorker*, could not have better expressed the challenge of public art. He said, "The arts are the field on which we place our own dreams, thoughts, and desires alongside those of others, so that solitudes can meet, to their joy sometimes, or to their surprise, and sometimes to their disgust. When you boil it all down, that is the social purpose of art: the creation of mutuality, the passage from feeling into shared meaning." *New•Land•Marks* represents that passage.

Charles E. Mather III
President, Fairmount Park Art Association

Acknowledgments

The New•Land•Marks program, this book, and the accompanying exhibition have benefited from the interest, generosity, and cooperation of many people.

First thanks must rightfully go to the artists and communities who have participated in New•Land•Marks. Their extraordinary efforts and the creative results are the basis for this book, which in itself has been a "work in process."

I would like to express deepest gratitude to the Board of Trustees of the Fairmount Park Art Association for their encouragement and support. Particular thanks are extended to President Charles E. Mather III, Vice-President Gregory M. Harvey, Esq., and Treasurer Theodore T. Newbold, as well as the distinguished members of the Board: Suzanne Sheehan Becker, Anne d'Harnoncourt, Leonardo Diaz A.I.A., Mrs. Daniel W. Dietrich, J. Welles Henderson, Esq., Steven Izenour, Susan A. Maxman F.A.I.A., Noel Mayo, David N. Pincus, Philip Price Jr., Daniel Rosenfeld, Jonathan D. Scott, Anne Whiston Spirn, Ana D. Thompson, Stanley C. Tuttleman, the late Henry W. Sawyer III, Esq.; and to the Fairmount Park Art Association's estimable Artists Advisory Council: Siah Armajani, Steve Berg, Tom Chimes, Jody Pinto, and Martin Puryear.

The staff of the Art Association have given generously of their time and talents. Charles Moleski and Robin Redmond joined the staff as Program Coordinators and helped to shape New•Land•Marks with their enthusiasm, fresh perspectives, and hard work. Last year Robin left the Art Association to serve as Program Analyst for Arts and Culture at the William Penn Foundation, and Charlie assumed the position of Program Manager for the New•Land•Marks commissioning process. Sarah R. Katz joined the staff as Exhibitions and Program Coordinator when we most needed her abilities, and her dedication to making this book and its accompanying exhibition a reality is greatly appreciated. Thanks also to Laura S. Griffith, Assistant Director, for her skillful professionalism and balanced viewpoint, and to Ginger Osborne, Administrative Assistant, for capably managing our office and

supporting our work. Hillary Blake, Research Assistant; Jennifer Rodriguez, Intern; and Andrea Gottschalk, Archivist, assisted us along the way.

We extend our deep appreciation to the essayists: Ellen Dissanayake, Thomas Hine, and Lucy R. Lippard. Their cogent writing and grasp of the issues speak volumes far beyond what could be published here, and I am honored to write alongside them. Dolores Hayden inspired our work and offered great encouragement early on, and Anne Whiston Spirn's exemplary thinking and writing continues to inform.

James B. Abbott's beautiful and brilliant photography sets the book apart. We heartily thank James Pittman for his sensitive and lyrical design, and James Trulove, the publishing force behind this book, for his advice, abiding interest in our work, and the high standards he sets for design and publication. We thank Sarah Fass for her capable editing of the manuscript; Douglas Gordon for his most generous editing of the proposal descriptions; Will Brown for his studio photography and patience; and Joel Katz design associates, especially Joel Katz and Dave Schpok, for creating the outstanding New•Land•Marks logo as well as designing our program materials and exhibitions. Our photography research was kindly assisted by Joseph Benford and Joel Sartorius, The Free Library of Philadelphia; Michael Sherbin, Pennsylvania State Archives; and Susan Drinan, Atwater Kent Museum.

The William Penn Foundation has encouraged this idea from the start, and with their generous support made New•Land•Marks possible. In a rare act of philanthropy, they took a chance when this idea was still evolving and promised initial funds for the commissioning process even before we had proposals in hand. Particular thanks are due to Janet Haas, M.D., President; Olive Mosier, Program Analyst; and Cathy Weiss, former Program Analyst, who had steadfast confidence in the program.

The New•Land•Marks exhibitions and publication are also supported by the Philadelphia Exhibitions Initiative, a grant program funded by The Pew Charitable Trusts and administered by The University of the Arts, Philadelphia. Paula Marincola, Director of the Philadelphia Exhibitions Initiative, offered encouragement that has been very much appreciated. As of this writing, additional support for New•Land•Marks has been granted by The Andy

Warhol Foundation for the Visual Arts, the National Endowment for the Arts, the Pennsylvania Council on the Arts, the Samuel S. Fels Fund, the Independence Foundation, Heritage Preservation, and The Leeway Foundation.

The Pennsylvania Academy of the Fine Arts welcomed the *New•Land•Marks* exhibition with tremendous enthusiasm, and we thank Joshua C. Thompson, President; Donald R. Caldwell, Chairman; the Museum Committee; Derek A. Gilman, Executive Director and Provost; Daniel Rosenfeld, Museum Director; Sylvia Yount, Chief Curator; Jonathan Binstock, Assistant Curator; Glenn Tomlinson, Director of Museum Education; Gale Rawson, Museum Registrar; and all of the Museum staff who have helped to make the exhibition a reality.

We offer our appreciation to Elliot L. Shelkrot and the staff of The Free Library of Philadelphia, who made their resources and branch libraries available to us for our community presentations.

We thank the initial *New•Land•Marks* Advisory Committee: Stephanie Bell Andrews, former Executive Director, Friends of Philadelphia Parks; J. Blaine Bonham, Vice President of Programs; Pennsylvania Horticultural Society; Tina Brooks, Program Director; Local Initiatives Support Corporation (LISC); Donna Cooper, former Deputy Mayor of Policy and Planning; City of Philadelphia; Steve Culbertson, Executive Director, Philadelphia Association of Community Development Corporations (PACDC); Carmen Febo-San Miguel, M.D., President, Taller Puertorriqueño; Gail Greene, former Executive Director, Mayor's Office of Community Services; Germaine Ingram, Esq., Chief of Staff, The School District of Philadelphia; Thora Jacobson, Executive Director, Samuel S. Fleisher Art Memorial; Ernest Jones, Esq., former Executive Director, Greater Philadelphia Urban Affairs Coalition; Kate Lapszynski, Volunteer Coordinator, Fairmount Park Commission; Cheryl McClenney-Brooker, Vice President for External Affairs, Philadelphia Museum of Art; William Mifflin, Executive Director, Fairmount Park Commission; Patrick T. Murphy, former Director, Institute of Contemporary Art; Rochelle Nichols-Soloman, Director, North Philadelphia Compact, The Philadelphia Education Fund; Jeremy Nowak, Executive Director, Delaware Valley Community Reinvestment Fund; Philip Price Jr., Executive Director,

The Philadelphia Plan; Pedro A. Ramos, Esq., Board Member and current President, The School District of Philadelphia; Eva Ray, Program Services Manager, Pennsylvania Horticultural Society; Sabrina Soong, A.I.A., Soong Associates, Inc.; John Taylor, Manager, Philadelphia Neighborhood Development Corporation (PNDC).

We extend our appreciation to the following individuals who have provided invaluable insight, talent, and support to *New•Land•Marks*: Lois Abendroth; Forest Aegiano; Joanne Aitken; Nashid Ali; Zakiyyah Ali; Jorge Arauz; Frances Aulston; Ernesta D. Ballard; Randy Baron; Arlene Bell; Amanda Benner; Margot Berg; Karen Bey; Saiyda Bey; Jamie Bischoff; Honorable Jannie L. Blackwell; Marci Bondurant; Lauren Bornfriend; John Boyce; David A. Boyd; Cathy Brady; Sandra Gross Bressler; Edith Brown; Helen Brown; Jacqueline Brown; William Burke; Bonnie Burnham; Ann Butchart; Sondra Butler; Marv Cadwell; Jim Campbell; Stephen Capsuto; John Carpenter; John Carr; Julia Chapman; Thomas A. Childers; Tschombia Choice; May Chu; George L. Claflen Jr.; Sherry Clements; Cathryn Coate; Gregorio P. Cojulun Jr.; Beverly Coleman; William S. Coleman; Julie Courtney; Susan Crowder; Jeffrey A. Cruse; Steve Culbertson; Helen Cunningham; Stephanie Craighead; Sam Curry; Diane Dalto; Dimonique T. Davis; Michael L. A. Davis; Susan Davis; Del Deets; Ron Dewey; Doris Dewey; Dr. Marylouise DeNicola; Michael DiBerardinis; Anne Edmunds; Sharon Erwin; Vince Esposito; Charles A. Evers; Chuck Fahlen; Dick Fernandez; Rafael Ferrer; Denise Ferrigno; Johannah Fine; Mary Wood Fischer; Jim Flaherty; Mark Focht; Susan Frankel; Melissa Franklin; Mildred Franklin; Danielle Frazier; Lesley Fredericks; Emma Freeman; Amy Freitag; John Fry; Norma Garcia; Dan Garofalo; Sandra L. Garz; Denise Gause; Jimmy Gaven; Patricia Gillespie; Marti Gillin-Bernicker; Bob Gittler; Marian Godfrey; Nancy Goldenberg; Eric Goldstein; Nancy Gonzales; William Gonzales; Tom Griffin; Michael W. Groman; Barry Grossbach; Jacqueline Hall; Conrad Hamerman; Mike Hardy; Samuel Harris; Nico Hartzell; Jody and John Haubrich; Jovanna M. Helwick; Cindy Henry; Jane Golden Heriza; Titus Hewryk; Richard Heyl; Bill Higgins; John Higgins; Melissa Hinton; Ronald E. Hinton Jr.; Thao Van Ho; John Holland; Diane Holman; Susanne Horan; Christine House; John Howard; Suzanne

Horvitz; Joyce Hutchinson; Huong Huynh; Eric Iffrig; Frances Jackson; Joanne Jackson; Mary Jane Jacob; Christine James-Brown; Torben Jenk; John Jerzak; LaVerne Jones; Diana Kalenga; Barbara J. Kaplan; Emanuel Kelly; Allison Kelsey; Kathy Kester; JoAnne Killebrew; Ray King; Thomas L. Kline; Jack Kmetz; Dave Knapton; Debora Kodish; Joyce Kozloff; David Kratzer; Peter Kurtz; Peter Lapham; Carol Lawrence; Denise Lawus; Lauren Leatherbarrow; Ernie Leonardo; Joseph Leonardo; Nora Lictash; Kate Loal; Tyrell Logan; Dolores Lombardi; Jorge Lovera; Tom Lussenhop; Peter Lynch; Maria I. MacLaury; Irene Madrak; Kevin Maguire; Paul F. Malvey; Alan Mandel; Honorable Richard Mariano; Edward Marschner; Marcelle Martin; Alba Martínez; Joe Matassino; Barbara McCabe; David McClelland; Deborah McColloch; Arthur Meckler; Darlene Messina; Wanda Mial; Ken Milano; Christopher Miller; Cierra Miller; Jacquelyn Miller; J. Wyatt Mondesire; Walter Montague; Marsha Moss; Charles Mottershead; Carlean Mullen; Kathryn T. Newland; Hung Nguyen; Kim Ngoc Nguyen; Thu Hun Nguyen; Tu Thi Nguyen; Doris Nogueira-Rogers; Doug Norman; June Washikita O'Neill; Laurie Olin; Gil Ott; Chris Palmer; Veronica Palmer; Len Pannirello; Patreice Perry; Cuong Nhu Pham; Ut Van Pham; Bob Pierson; Etienne Juarez Phipps; Myrna Pope; Edward Pussinsky; John Ravenal; Kurt Raymond; Richard Redding; David L. Reid; Julie Regnier; Valerie Reynolds; Angela Richardson; Linda Waters Richardson; Lisa Rodriguez; David Rosario; Harold Rosenberg; Greg Rowe; James E. Rush; Jasmine A. Rushum; Joe Ruane; Andrea Sáenz; Stephan Salisbury; Sandy Salzman; the late Nick Sambor; Honorable Teresa Sarmina; George C. Schmidt Sr.; Sister Mary Scullion; Susan Seifert; Katherine M. Shelfer; Susan Sherman; Margaret Shire; Theresa Sims; Kay Smith; Vernon Smith; Amare Solomon; R.C. Stabb; Ed Stainton; Josephine Stamm; Lisa Steiger; Paul Steinke; Mark Stern; Blane Stoddart; Mike Sweeney; Joseph Syrnick; Debbie Szumowski; Steven Tatti; Ann Temkin; Jeremy Thomas; Vicki Thompson; Mark Thompson; June and Richard Tittlemayer; Jeff Tober; Rochelle Toner; Anh Tran; Hoa Tran; Kenneth Trujillo; Beverly Tuttle; Art Verbrugghe; Beth Vogel; Maurice Walden; Dean Walker; Frances Walker; Tom Wilson Weinberg; Cheryl Weiss; Chris Whaley; Wayne M. Wormley; Ralph Wynder; Darlene Wynder-Jenkins; Sandy Yannatell; Lily Yeh; Theresa Yorg; Janet Yudkin; and Hope Zoss. Please forgive us for any oversights.

We also thank the following groups: Atkin, Olshin, Lawson-Bell and Associates Architects; Agoos-Lovera Architects; Allegheny West Foundation; American Institute of Architects; Baltimore Avenue in Bloom; Caroll Park Community Council; Cicada Architecture/Planning; Claflen Associates, Architects and Planners; Congreso de Latinos Unidos; Fairmount Park Commission; Fairmount Park Natural Land Restoration and Environmental Education Program; Free Library of Philadelphia; Friends of Clark Park; Friends of Elmwood Park; Friends of Gorgas Park; Friends of Malcolm X Memorial Park; Friends of Philadelphia Parks; Friends of the Japanese House and Garden; Friends of the Manayunk Canal; Friends of the Wissahickon; Kensington South Neighborhood Advisory Committee; Lutheran Settlement House; Manayunk Development Corporation; Mayor's Office of Community Services; Mill Creek Artists' Collaborative; Mill Creek Jazz and Cultural Center; Neighbors of Fairhill; New Kensington CDC; North Light Community Center; Partnership CDC; Pennsylvania Horticultural Society; Pennypack Environmental Center; Pennypack Environmental Center Advisory Council; Philadelphia Association of Community Development Corporations; Philadelphia Capital Programs Office; Philadelphia City Council; Philadelphia City Planning Commission; Philadelphia Department of Recreation; Philadelphia Museum of Art; Philadelphia Office of Arts and Culture; The Philadelphia Plan; Philadelphia Streets Department; Project H.O.M.E.; Samuel B. Huey School; South of South Neighbors Association; Spruce Hill Community Association; Taller Puertorriqueño; University City District; University of Pennsylvania; Vietnamese United National Association of Greater Philadelphia; and the William Way Community Center.

My very deepest appreciation goes to my husband, John A. Clauser, for his insight, patience, and understanding.

Penny Balkin Bach
Philadelphia, July 2000

Defining the Public Context

by Penny Balkin Bach

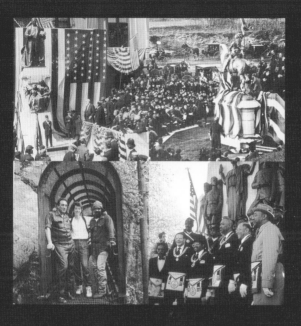

Defining the Public Context

by Penny Balkin Bach

*I*s this the class for English as a second language?" the woman asked politely in a heavy Russian accent. "No, this is a talk about public art," I replied. And so it was that after thirty minutes of seemingly rapt listening, more than half of the people at this, our first well-attended public presentation, suddenly walked out of the library's meeting room. As fate would have it, one of the individuals who remained was a member of the Pennypack Environmental Center Advisory Council, a group that months later would be selected to participate in *New•Land•Marks*. Such are the realities of life and art: the city and its people are in flux, outcomes are unpredictable, control is provisional, and competing interests reign. Art is meant to be part of this, but how?

Earlier on that foggy, rainy night, Charles Moleski and Robin Redmond—the *New•Land•Marks* Program Coordinators—and I were on our way to the first of our twenty-some public presentations throughout Philadelphia. For months we had been meeting with dozens of cultural and civic leaders who had offered much useful advice, and at their recommendation the presentations were co-sponsored by community service groups that had both name recognition and clout in the neighborhoods. We knew that we were not alone in wanting to make *New•Land•Marks* a reality, but the road still seemed uncharted and uncertain.

We drove in a rented car for over an hour, along a traffic-laden expressway, to our destination in the far upper reaches of Northeast Philadelphia. Previously, Robin and Charlie had been to the neighborhood to talk with the librarian and scope out the place. We finally arrived at a bustling branch library:

Excerpts from the
***New·Land·Marks* Prospectus**

Summary

The Fairmount Park Art Association initiated *New·Land·Marks: public art, community, and the meaning of place* in order to plan and create unique and original public art projects. *New·Land·Marks* combines artists' imagination, creativity, skill, and energy with the knowledge, experience, commitment, and enthusiasm of communities. *New·Land·Marks* encourages projects that celebrate community identity, commemorate "untold" histories, inspire civic pride, respond to the local environment, and invigorate public spaces. These projects, designed to support both the artistic and community perspectives in neighborhood

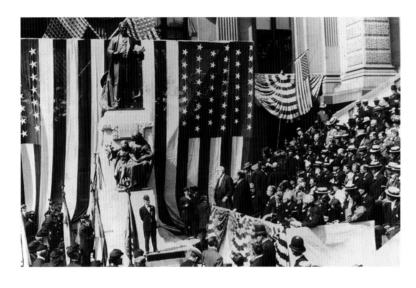

children scurrying about, teens socializing, seniors gathering with newspapers. Here was a snapshot of community reality, in a place far from the downtown art world. Our Russian audience was among the newest wave of immigrants to Philadelphia, and their mission—to learn their newly adopted language— was far more pressing than my public art talk. Still, as I look back, I realize that the Russian speakers had recognized a number of the works in our slide presentation, had asked pertinent questions, and even had commented on how much they liked the *Salem Witch Trials Tercentenary Memorial* in Massachusetts, which, inexplicably, some of them had apparently seen.

But what brought us and *New•Land•Marks* to that particular place? Just think about the significance of "place": place in living, place occupied, place located, place of occurrence, place in the social order, place recognized, establishing place, how one identifies place and gains identity through it.

Indeed, the origins of the Fairmount Park Art Association are rooted in placemaking, in the synergistic association of art and urban planning. In the late nineteenth century, the founders of the Art Association sought to provide an antidote to encroaching industrialism by introducing art into the landscape. By the turn of the century, the organization's mission had expanded

development, incorporate public art into ongoing revitalization efforts, public amenity improvements, urban greening initiatives, and other aesthetic and practical enhancements. *New•Land•Marks* will enable communities to create enduring projects that will represent our culture and serve as legacies for future generations.

What is public art?

Public art is a reflection of how we see the world—the artist's response to our time and place combined with our own sense of who we are. Public art is not an art "form." Its size can be huge or small. It can tower fifty feet high or call attention to the paving beneath your feet. Its shape can be abstract or realistic (or both), and it may be cast, carved, built, assembled, or painted. It can be site-specific or stand in contrast to

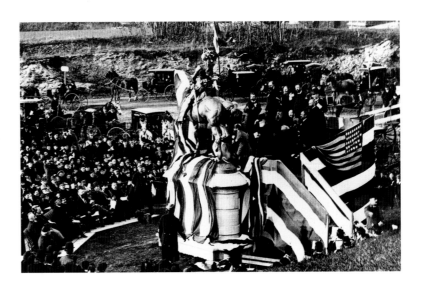

RIGHT: Dedication ceremony. Emmanuel Frémiet, Joan of Arc, 1890. Gilded bronze sculpture, Kelly Drive at 25th Street.

its surroundings. What distinguishes public art is the unique association of how it is made, where it is, and what it means. Public art can express community values, enhance our environment, transform a landscape, heighten our awareness, or question our assumptions. Placed in public sites, this art is there for everyone, a form of collective community expression.

How does public art happen?

Public art in Philadelphia has been initiated by a wide range of individuals, organizations, and agencies with different missions. These initiators include the Fairmount Park Art Association, the City of Philadelphia, the Redevelopment Authority, state and federal agencies, universities, museums, developers, corporations, civic groups, private donors, and artists. Overall, Philadelphia's

to "promote and foster the beautiful in Philadelphia, in its architecture, improvements, and the city plan." This was accomplished not only by the commissioning and placement of sculpture and monuments of enduring character, but also through the Art Association's planning efforts and its forceful advocacy in support of opportunities for artists to both practice their craft and contribute to society.

As a nonprofit membership organization, the Art Association's earliest activities depended on the involvement and financial support of the community. Members of the French community in Philadelphia, for example, with the assistance of the Art Association, commemorated the centennial of the French Revolution with an equestrian sculpture of *Joan of Arc* (1890) by Emmanuel Frémiet. The work was unveiled to extensive fanfare at a bilingual dedication ceremony. But controversy, the aroused handmaiden of public art, was hard on the heels of even the earliest commissions: a member of the selection committee complained that the maid's horse had "the nervous action of a fat cow."

Similarly, when President McKinley was assassinated, a committee worked with the Art Association to commission a sculpture in his honor, and $50,000

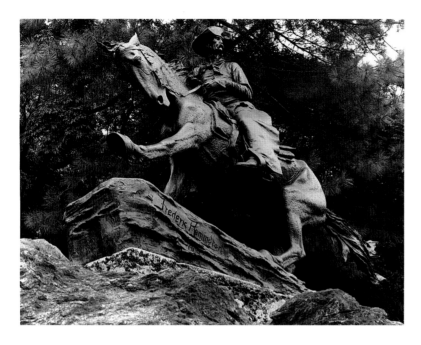

LEFT: Frederic Remington, Cowboy, 1908. Bronze sculpture, Kelly Drive in Fairmount Park. An early example of site-specific work.

was raised through $1 contributions solicited by *The Philadelphia Inquirer.* In 1908, the same year that the McKinley sculpture was completed, what is now called "site-specific" sculpture was virtually invented in Philadelphia when Frederic Remington created his bronze *Cowboy.* Remington's rider pulls his horse up short, stopping just before a precipice that overlooks the Schuylkill River. This sculpture has its origins in local identity as well: the cowboy model was Charlie Trego, a native of Chester County, Pennsylvania, and the feisty manager of Buffalo Bill's Wild West Show.

Throughout the last century, artists—predictably—have chosen to address a world in transition. However, the rise of museums and galleries and the central modernist belief in art's autonomy combined to detach works of art from their public context. Then, by the mid-twentieth century, the first "percent for art" programs were established in Philadelphia to rehabilitate modern architecture; the idea was that public art on a more human scale might enrich an increasingly bleak public environment. This was a signal

extraordinary collection of public art can be attributed to the city's long and impressive history of civic involvement. In the nineteenth century, the Art Association became the nation's first public art organization. City Council passed the trailblazing "percent for art" ordinance in 1959, making Philadelphia the first municipality in the United States to mandate that a percentage of construction costs for city projects be set aside for fine arts. That same year, the Redevelopment Authority established its unprecedented program that requires redevelopers to allocate one percent of their construction costs for fine arts.

Who is the "public" for public art?

In a diverse society, all art cannot appeal to all people, nor should it be expected to do

RIGHT: Jody Pinto, Triple Tongue Pier, 1981. Mixed-media model.

BELOW RIGHT: Jody Pinto, Fingerspan, 1985. Mixed-media model. Pinto's proposal for Wissahickon Creek evolved from Triple Tongue Pier to Fingerspan in response to community and environmental concerns.

so. Art attracts attention; that is what it is supposed to do. Is it any wonder, then, that *public* art causes controversy? Varied popular opinion is inevitable, and it is a healthy sign that the public environment is acknowledged and not ignored. To some degree, every public art project is an interactive process involving artists, architects, design professionals, community residents, civic leaders, politicians, approval agencies, funding agencies, and construction teams. The challenge of this communal process is to *enhance* rather than limit the artist's involvement.

What is the "art" of public art?

As our society and its modes of expression evolve, so will our definitions of public art. Materials and methods change to reflect our contemporary culture. The process,

that the public environment had finally, and properly, become an aesthetic issue; but meaningful public involvement was still largely absent.

The Art Association's response to the gap between public art and ordinary life was Form and Function, a program initiated in 1980. We invited artists to propose projects that would be utilitarian, site specific, and integral to community life—works that would be integrated into the public context through *use* as well as placement. Each artist was asked to give meaning and identity to a place, to probe for the *genius loci*, or "spirit of the place." The Art Association's intention in Form and Function was to respond to the needs of a changing city as well as to accommodate the expressions of individual artists; but the role of the community was still seen, at that time, as one of grateful recipient rather than active participant.

Nonetheless, one project from that period, which began as Jody Pinto's *Triple Tongue Pier*, was transformed slowly and radically by a combination of environmental issues and community recommendations. The result was *Fingerspan* (1987), a pedestrian bridge that leaps across a deep gorge along the Wissahickon Creek. When *Fingerspan* was first proposed, it was vehemently opposed by some local residents as both unnecessary and intrusive. Today, by contrast, it is one of the most beloved and enduring amenities and markers of place in the Wissahickon section of Fairmount Park.

Inspired by the universal childhood longing for a tree house, Martin Puryear's *Pavilion in the Trees* (1992) was another Form and Function project. It began as a proposal for a pavilion with steps in Germantown's Cliveden Park. Although the project was supported by the local improvement organization, opposing community forces feared the structure would encourage undesirable behavior in the park. Ultimately, an alternative location had to be found, and the ramped *Pavilion* now reaches across a natural basin near the Fairmount Park Commission's Horticulture Center. High among the treetops, the work has become a much favored place to relax and contemplate nature from a bird's-eye view.

As it turned out, Form and Function served as a useful marker. In the twenty years since the program began, radical changes in Philadelphia's political, civic, and cultural territories have combined to create an auspicious

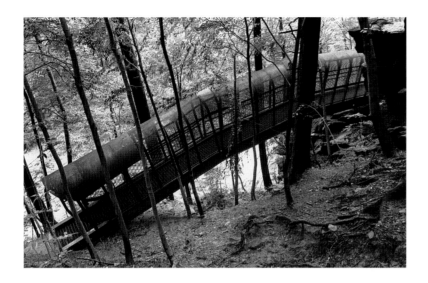

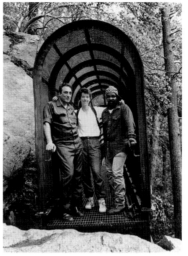

FAR LEFT: Jody Pinto, Fingerspan, 1987. Weathering steel span, Wissahickon Creek Trail near Livezey Dam.

LEFT: Pinto with fabricators at Fingerspan's entrance.

climate for *New•Land•Marks*. And yet, even today, perhaps more than any other art activity, the creation of public art demands reconciliation among the diverse and often conflicting interests of many—artists, architects, planners, public officials, administrators, curators, conservators, developers, civic leaders, and the ubiquitous "general public." From the beginning, *New•Land•Marks* set out to engage and reconcile these diverse interests by addressing the role of the "public" in contemporary public art practice.

A snapshot of the past twenty years reveals some key advances in the cultural climate in Philadelphia, compared to that of other cities throughout the United States. The city's pioneering "percent for art" program has been resuscitated and reformed; the Redevelopment Authority's Fine Arts percent program has flourished; the City Planning Commission, in its plan for Center City, has acknowledged Philadelphia's strong public art tradition by urging increased public and private participation; and galleries, museums, cultural organizations, and entrepreneurs have promoted festivals and installation opportunities that enable artists to experiment "in public." Artist Lily Yeh, for example, has brought international attention to the *Village of Arts and Humanities* in North Philadelphia, where she has worked with residents to

guided by professional expertise and public involvement, should seek out the most imaginative and productive affinity between artist and community. Likewise, artists must bring to the work their artistic integrity, creativity, and skill. What is needed is a commitment to invention, boldness, and cooperation—not compromise.

Why public art?

Public art is a part of our public history, part of our evolving culture, and part of our collective memory. It reflects and reveals our society and adds meaning to our cities. As artists respond to our times, they reflect their inner vision to the outside world, and they create a chronicle of our public experience. Philadelphia's long and rich tradition of public art reflects our powerful and insistent desire for public expression.

RIGHT: Martin Puryear, Pavilion in the Trees, *1981–1983. Wood model with ramp.*

BELOW RIGHT: Martin Puryear, Pavilion in the Trees, *1981. Wood model with steps. For aesthetic and safety reasons, Puryear modified the approach to* Pavilion *by using a ramp in place of a staircase.*

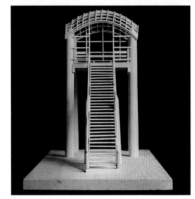

What is *New•Land•Marks*?

New•Land•Marks is a public art program designed to explore the possibilities for new landmarks by engaging artists and community organizations in the planning and creation of enduring works of public art. Each project will be the outcome of a partnership, combining the artist's imagination, creativity, skill, and energy with the knowledge, experience, commitment, and enthusiasm of Philadelphia's communities. We believe that artists are the pioneers of our cultural territory. With community insight and support, they can give shape to our dreams. *New•Land•Marks* encourages artists and communities to take advantage of our most valuable urban resources: people, their history, and their hopes for the future.

establish an ongoing and comprehensive community revitalization effort that includes mosaic murals, sculpture, and plantings. Meanwhile, the City of Philadelphia's Mural Arts Program has held workshops and created numerous wall paintings in communities throughout Philadelphia.

In the political sector, in the 1990s the Mayor's Office of Community Services took an active role by organizing citizen involvement and raising funds for community efforts; as a result, Philadelphia became the location for a state Enterprise Zone and three Federal Empowerment Zones. The Fairmount Park Commission and the Friends of Philadelphia Parks supported the establishment of a citywide network of volunteer "Friends" groups dedicated to park stewardship. And in recent years, the Fairmount Park Commission initiated the Natural Lands Restoration and Environmental Education Program to restore and preserve natural areas that offer rare islands of wilderness in the midst of one of America's most populous cities.

On the community front, the community development corporation (CDC) took hold as a means by which citizens could participate in community improvement at the most local level. Various Philadelphia-area organizations were formed in support of this type of activity, including the Delaware Valley Community Reinvestment Fund, the Local Initiatives Support Corporation, the Philadelphia Association of Community Development Corporations, and the Philadelphia Neighborhood Development Corporation. In addition, The Philadelphia Plan was established, encouraging corporations to become involved by "adopting" CDCs and making significant annual financial contributions over a ten-year period.

At the same time, other citywide organizations were also promoting community participation. The Pennsylvania Horticultural Society's celebrated Philadelphia Green program, through its Neighborhood Parks Revitalization Project, began working with the city's Department of Recreation and neighborhood groups to revitalize deteriorating parks and promote long-term maintenance. Community engagement also characterized the School District of Philadelphia's Children Achieving agenda and The Free Library's revamping of neighborhood branches and services. The Preservation Alliance, the Foundation for Architecture, and the regional chapter of the American Institute

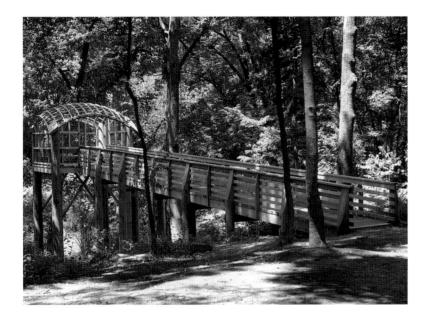

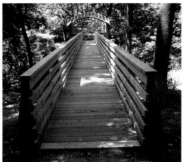

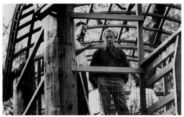

FAR LEFT AND LEFT: Martin Puryear,
Pavilion in the Trees, 1993. Wood amenity,
Horticulture Center in West Fairmount Park.

BELOW LEFT: Puryear (right) and project
architect Richard Hodge of Keiran,
Timberlake, and Harris.

of Architects undertook a major expansion of their educational and advocacy efforts on behalf of the built environment.

There was also a growing awareness of the need to protect and care for Philadelphia's outstanding and irreplaceable collection of outdoor sculpture. Indeed, this "museum without walls" had succumbed to the threats of time, pollution, neglect, and vandalism. In the 1980s the Art Association initiated a highly visible pilot sculpture conservation program, and a select group of works of historic and artistic significance received initial treatment and annual maintenance. One such work was sculptor J. Otto Schweizer's heroic *All Wars Memorial to Colored Soldiers and Sailors*, which at that time was consigned to a remote part of Fairmount Park, although it had originally been conceived for a prominent site along the Benjamin Franklin Parkway. The Art Association continued to care for the sculpture annually, and in 1994 an extraordinary and overdue event occurred. Sixty years after its original installation, the city relocated the *All Wars Memorial* to a much more visible site on the Parkway. A day of festivities was planned by an enthusiastic

Why landmarks?

Public art that functions as a landmark identifies an area in a unique and recognizable way, and every artist who has created a landmark has had extraordinary conditions with which to work. These could include: a momentous occasion (the Tour Eiffel in Paris); a meaningful location (Alexander Milne Calder's *William Penn* on City Hall tower); a symbolic purpose (Frédéric Auguste Bartholdi's *Liberty Enlightening the World*, better known as the Statue of Liberty); a tragic event (Maya Lin's Vietnam Veterans Memorial); or a special opportunity or challenge (Eero Saarinen's Gateway Arch in St. Louis). The community brings purpose and support to the artist's creative endeavor.

*RIGHT AND BELOW RIGHT: J. Otto Schweizer,
All Wars Memorial to Colored Soldiers and
Sailors, 1934. Bronze sculpture, Benjamin
Franklin Parkway at Logan Square. Before
(TOP), and after (BOTTOM) 1984 conservation
treatment.*

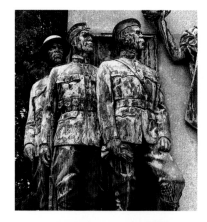

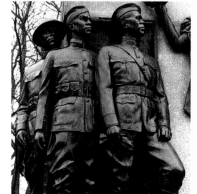

Why new landmarks?

Philadelphia possesses a rare and remarkable urban character. It is a city of public values, public spaces, and public art. Yet the features that give our city its identity have been accomplished only through the tremendous efforts and will of pioneering visionaries. Today, Philadelphia's cultural vitality and community development efforts combine to make our city a unique and wonderful place to live—a city rich in tradition and ripe with possibility. These are qualities that *New·Land·Marks* seeks to promote, by stimulating projects that celebrate community identity, commemorate "untold" histories, inspire civic pride, respond to the local environment, and invigorate public spaces. These projects, designed to support both artistic and

civic group, "The Committee to Restore and Relocate the *All Wars Memorial*." Doris Jones Holliday—the granddaughter of state legislator Samuel Beecher Hart, who had sponsored the original bill for the sculpture—was eleven years old when she first unveiled the work at its dedication; at the mayor's invitation, she now unveiled the sculpture a second time. Also attending the emotional ceremony were the artist's granddaughters and the niece of one of the soldier models. The history of the *All Wars Memorial* represents the ideals and values of *New•Land•Marks*. It embodies what we mean by "enduring"—that public art has a "life" after the people who helped to create it are gone.

All of the preceding conditions served as both the context and the "armature" for *New•Land•Marks*. Of course, the local and national philanthropic community made much of the progress possible, particularly through the support of the William Penn Foundation and the Pew Charitable Trusts. Still, when we began *New•Land•Marks*, there was no single program that broadly linked communities with public art and artists. As we met with colleagues involved in all aspects of community development, we also came to recognize that the domains of art and community often used different languages, each laden with jargon. One of our first steps, therefore, was to create a public art "glossary" (see page 152).

We decided that one of the key objectives of *New•Land•Marks* would be to reflect the larger issues of urban life. Criminologist James Q. Wilson's famed "broken windows" theory, articulated in a groundbreaking 1982 article in *The Atlantic Monthly*, asserts that urban despair festers in a disorderly environment because it appears that no one cares about how things look. An obvious countermeasure is suggested by Suzi Gablik in *The Reenchantment of Art*, a book that calls for an interactive, participatory art practice relevant to the processes and systems of our time.

In recent years, community participation in public art has generally taken the familiar route of murals, mosaics, and community gardens, and for obvious reasons: the materials are relatively inexpensive, the results are swift and gratifying, and the cultural and political gains are measurable. Community participation in other forms of contemporary public art has been much less

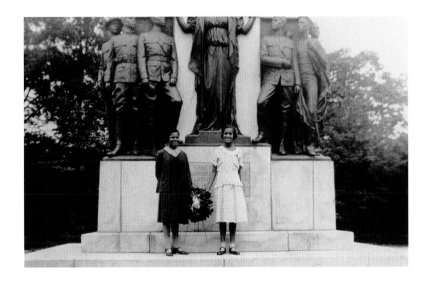

LEFT: Sisters Doris Jones Holliday and Harriett Catherine Jones visiting the All Wars Memorial, *Fairmount Park, Memorial Day 1937.*

frequent. Often, in fact, public art is associated with new construction in downtown areas, with the result that neighborhoods, which might benefit the most from an artist's ideas, rarely have the opportunity. Moreover, artists are typically engaged to work on public art projects *after* the design and planning process is completed, and they are then given the unfair challenge of somehow "beautifying" or "enhancing" the results. Not surpisingly, these conditions discourage a truly visionary art. This challenge is addressed by artist Joyce Kozloff in her article in *Public Art Review* "The Kudzu Effect," in which she laments the myriad derivative works that follow in the path of genuine innovation.

As the millennium approached, the international art scene witnessed an emphasis on artists' encounters with the real and the everyday, responding to an area's cultural history with temporary installations. This was evidenced by the decentralization of the Venice Biennale and its spread to sites throughout the venerable Italian landscape; the expansion of documenta X from the railway station through the pedestrian tunnels and along the Parcours in Kassel, Germany; and the probing of historical narratives in Sculpture Projects Münster, 1997. International exhibitions from Istanbul

community perspectives in neighborhood development, may incorporate public art into community history ventures, ongoing revitalization efforts, public amenity improvements, urban greening initiatives, and other aesthetic enhancements.

Who can participate in the program?

New·Land·Marks will reflect the geographic variety, social richness, and cultural diversity of Philadelphia's neighborhoods. For the purposes of this program, however, the definition of community is not restricted to geographic areas or neighborhoods, but may also include groups that have a shared history, identity, or interest. Artists and community members will collaborate in this unique opportunity to extend Philadelphia's rich tradition of public art. In addition,

RIGHT AND BELOW RIGHT: 1994 parade and celebration honoring the city's relocation of the All Wars Memorial from Fairmount Park to a more visible site on the Benjamin Franklin Parkway at Logan Square.

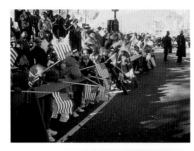

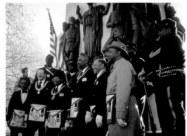

New•Land•Marks will encourage the involvement of creative people in many other fields —for example, historians, writers, educators, anthropologists, and folklorists.

Program Timetable and Milestones

1996

March............Proposal to William Penn
 Foundation
July................Grant awarded

1997

January..........Coordinators begin
February........Research interviews begin
April...............*New•Land•Marks* program
 officially announced
Summer.......Advisory Committee
 established
September...*New•Land•Marks* Prospectus
 distributed

to Johannesburg drew on artists' responses to local cultural revelations. Allan Ruppersberg's *The Best of All Possible Worlds*, for example, was a poignant tour through Münster, a small German town that was rebuilt after being 90% destroyed in World War II. The artist based his meta-story on Voltaire's Candide—who as it turns out began his journey in Westphalia—and through this framework Ruppersberg addressed the literary, philosophical, poetic, and historical aspects of Münster. The project was a collaboration with the citizens of the town to create an interactive walking tour of eleven stops which do not have official status or significance, but which nonetheless resonate in the minds of private citizens. Such multidisciplinary and multisited exhibitions combined art with "fieldwork" as invited artists searched for shared meanings in places often far from home. In contrast, the profoundly amusing Russian émigré art team of Vitaly Komar and Alexander Melamid created the world's "most wanted" paintings by using capitalism's most revered and remote tool: the market research poll. Their findings (an almost universal desire for serene, blue landscapes) caution us about the probable mediocrity of "design by committee."

With these considerations in mind, *New•Land•Marks* set out to invert the traditional public art process. We asked communities to volunteer their participation and to think about what they wanted to leave to future generations. As the program progressed, artists were selected on the basis of how their ongoing inquiry addressed the stated interests of the community group. The *New•Land•Marks* strategy had a single, central directive: *to understand the community, not merely to decorate it.*

New•Land•Marks is a model—but not necessarily a formula—for navigating through the central issue in today's public art—namely, how to promote community engagement and, at the same time, create a framework for the most creative artistic outcome. We asked communities not only to approach the process with openness to new ideas, but to go further by identifying at least three representatives who would facilitate proposal development. In turn, we asked artists to engage in a dialogue with community representatives. On those inevitable occasions when disagreement occurred, issues were settled peaceably, with mutual respect. We also incorporated "escape valves" as part of the process. For example, when it became apparent that the first

artist who was invited to work with the Allegheny West neighborhood was committed to creating a mural, while the community was hoping for something more comprehensive, the artist voluntarily withdrew from the project and architect/planner Zevilla Jackson Preston was invited to address the community's needs. Similarly, when the group Kensington HISTORIES decided to withdraw from the program, artist Todd Noe continued to seek feedback from other groups in the community. After members of the Frankford Avenue Coalition decided that an initial proposal was simply not what they had in mind, they decided to direct their support toward Noe's project, which they felt could be adapted to sites in Kensington and Fishtown. There were occasions when—despite good intentions—the requisite agreements were not reached. The huge task of addressing the vast Gorgas Park was tackled by a team of artists, but none of their ideas took root. Such transitions were neither tidy nor easy, but they became dynamic turning points guided by the Art Association's requirement that a project simply could not proceed without community endorsement.

The dialogues that emerged from the working relationships between artists and communities were indeed varied and, in some cases, surprising. Interestingly, we found little correlation between an artist's place of residence (local, national, or international) and the community's satisfaction with a given proposal. Some participants expressed concern about the limited amount of time several busy artists were able to spend with the communities; but this, too, was not correlative, and the intensity—not the quantity— of the artist's involvement seems to have been a more accurate predictor of the outcome. In the end, however, issues of "success" and "failure" were measured against the initial expressed desires of the communities. Ironically, one of the most objective and supportive comments about the program came out of an otherwise skeptical article written by Gerard Brown and Eils Lotozo for the *Philadelphia Weekly*. The article attributed to the program the lofty goal of "keeping our communities intact," an objective which, of course, we never set out to accomplish. And yet, in the end, the authors noted that "all of the groups interviewed hold out the hope that they'll be included in the first round of commissions."

The history of the *All Wars Memorial* represents the ideals and values of *New·Land·Marks*. It embodies what we mean by "enduring"—that public art has a "life" after the people who helped to create it are gone.

October	*New·Land·Marks* public presentations begin
1998	
January	Request to Participate due
February	Begin review process
April	Meetings with potential community participants
May	Discussions with artists
June	Artists and communities begin working together; First Workshop
Summer	Proposal development begins
September	Artist/community teams officially announced; Second Workshop
October	Third Workshop
1999	
March	Proposals due
May	*New·Land·Marks* Symposium

New·Land·Marks is a model—but not necessarily a formula—for navigating through the central issue in today's public art—namely, how to promote community engagement and, at the same time, create a framework for the most creative artistic outcome.

New•Land•Marks is about reclamation in the broadest sense; it is about loss and desire, about the recovery not only of vacant lots, but of powerful memories. New•Land•Marks is about celebration and identity, not only of heroes and achievements, but of the human capacity to endure and transcend catastrophe. New•Land•Marks encouraged artists and communities to pursue a variety of directions. Those desiring *new* landmarks sought creation, innovation, and change; those in pursuit of new *land* marks looked for meaning in hearth, sanctuary, and path; and those seeking new land *marks* emphasized placemaking through an evocation of the historic past.

As the New•Land•Marks program develops, its outcomes remain fluid, and expectations continue to run high. The New•Land•Marks process demonstrates that there are many approaches to community-building and placemaking, and that a sensible awareness of limitations and potential problems, combined with a creative exploration of possibilities, is the necessary first step. Looking over the results, I am struck by how "American" the New•Land•Marks proposals seem. That is to say that they reflect a spirit of pragmatic improvisation that is typically American. Some proposals suggest innovative and unusual uses for commonplace materials, while others may require innovative applications of new technologies.

At this writing, five projects are in progress. Others require feasibility studies and additional research in order to prepare them for consideration and funding once the initial projects are underway. It is likely that some projects will change dramatically from the graphic proposals illustrated here, and some may not happen if the power of community is not behind them. Although the "process" is important and deserves scrutiny, at the end of the day it is the result that matters. The question continues to be: What will New•Land•Marks leave behind for future generations?

June..............Proposal review begins

Summer........Exhibition and publication
announced

2000

March...........First five commissions
announced

July................Community Exhibition
Series begins

Summer........Commissions in progress;
Research and development
in progress

2001

February........New·Land·Marks Publication;
New·Land·Marks Exhibition

Public Presentation Locations

African American Museum in Philadelphia; Foundation for Today's Art-Nexus; Frankford Group Ministries; Settlement Music School, Germantown Branch; University of

PENNY BALKIN BACH is the Executive Director of the Fairmount Park Art Association. She has presented exhibitions, lectures, and workshops about public art and has written extensively about art and the environment, including the book Public Art in Philadelphia. *She is responsible for initiating the Art Association's* New•Land•Marks *program as well as its predecessor, Form and Function, and she has served as an advisor, curator, and juror for public arts projects nationwide.*

Why Public Art is Necessary

by Ellen Dissanayake

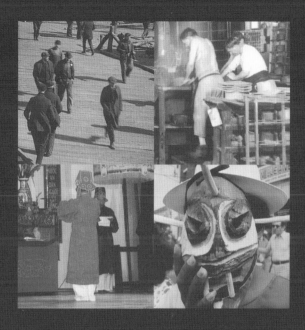

Why Public Art is Necessary

by Ellen Dissanayake

*I*n my books and essays I frequently make the astonishing or dubious claim that the arts are "necessary." I derive this claim from what I've learned about the place the arts hold, and have held, in societies other than our own, especially in the small-scale subsistence societies that character-ized the human species from its origins.

For most people in modern societies, the arts are hardly essential; this is exemplified by the attitude that leads governmental authorities to set aside a "percent for art" for artworks in or on public buildings as a pleasant "extra." For us, the really essential things are those that we are required to do every day—practical activities like earning a living and maintaining a household. The arts, by contrast, generally are made or enjoyed in our spare time. Interestingly, this is the reverse of the practice in many small-scale societies, which devote enormous resources of time, energy, and material goods—often *one hundred* percent—to their art-filled ceremonies, which are meant to ensure that life will be prosperous and safe.

To someone with a scientific world view, such ideas seem superstitious or quaint. Masked dancers are not likely to be used today to bring rain, heal the sick, or ensure good fortune. Nevertheless, the arts apparently provided benefits of some kind to those who practiced them, or they would not have persisted throughout tens of thousands of generations of human history and

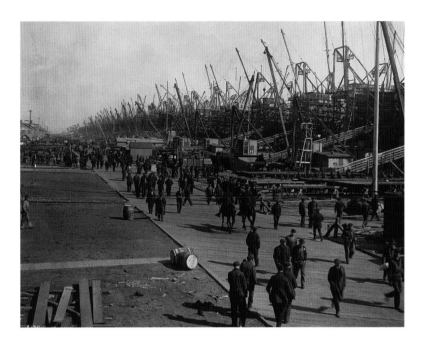

prehistory, making art and life interdependent in a way that we can scarcely imagine today.

What are these benefits? Although our modern and postmodern ways of life have become very different from the lives of hunter-gatherers or small-scale horticulturalists, I suggest that we nevertheless continue to *need* the arts, because we are creatures who evolved, biologically, to require the social and emotional satisfactions they bestow. If I am correct, it follows that *without* the arts, we are incomplete human beings. Certainly we can deprive ourselves of the arts, just as some people are deprived of other human necessities— of shelter and safety, of love or fulfilling work. Or we can use substitutes for the arts. But in so doing, I suggest, we are not satisfying our complete human nature.

In my view, there are ten contributions that the arts have made to human life from the remote past to the present day. These psychological benefits of the arts are that they (1) provide a sense of identity; (2) build community

Reinvestment Fund; Fairmount Park Commission; The Foundation for Architecture; The Free Library of Philadelphia; Friends of Philadelphia Parks; Greater Philadelphia Federation of Settlements; Greater Philadelphia Urban Affairs Coalition; Local Initiatives Support Corporation (LISC); Mayor's Office of Community Services; Pennsylvania Horticultural Society; Pew Fellowships in the Arts; Philadelphia Association of Community Development Corporations (PACDC); Philadelphia Department of Recreation; Philadelphia Neighborhood Development Corporation (PNDC); The Philadelphia Plan; Samuel S. Fleisher Art Memorial.

Request to Participate

Those who wish to participate in the *New·Land·Marks* program (community organizations, artists, or creative teams) may

and reciprocity; (3) allow the physical and psychological satisfaction of making and creating something with one's hands and body; (4) engage nonverbal parts of our minds; (5) enhance and enrich both the natural and the man-made environments; (6) help us to deal with anxiety; (7) provide refreshment, pleasure, and enjoyment; (8) put us in touch with important life concerns; (9) acknowledge the things we care about, and allow us the opportunity to mark or celebrate that caring; and (10) awaken us to deeper self-understanding and to higher levels of consciousness.

Stated so boldly, in an unadorned list, these ten benefits of the arts may not immediately seem self-evident. It is possible to think of avenues other than the arts for addressing the needs they fulfill. However, the arts address them *particularly well*, and I am struck by how comprehensively public art in our own time does so—perhaps more than any other kind of contemporary art. Indeed, as I consider the various proposed New•Land•Marks public art projects, I cannot help but note how well they illustrate the psychological benefits of the arts as I describe them.

It is not really surprising, for if one takes the deepest and broadest possible view—back into time and across geographical space—it is plainly evident that most human art has been "public" art—that is, art that affects members of a community, which experiences it collectively.

The arts in traditional societies from the Paleolithic era to the present were rarely made for private delectation, nor were they expressive of the private ruminations of a solitary artist. Prehistoric paintings on rock walls may have been seen only by certain people, such as hunters, or initiates, or males—no one knows. Their subject matter, however, reflected group belief, needs, and lore. The giant monuments of neolithic civilizations were made to entomb or memorialize particular leaders and aristocrats, but were visible and impressive to everyone. Even the precious objects commissioned by royalty were seen and admired by the court. It is only recently that people have viewed art objects silently in museums or have looked at pictures of them in books or journals read in the privacy of their own homes.

In museum vitrines, the masks and other carved or painted artifacts from premodern societies in Africa, Oceania, and elsewhere are isolate and

unmoving. To us, they are "works of art," like any modern sculpture, but they were made to be worn or used publicly and to be seen by members of a social group who participated in the ceremonies for which they, along with songs, dances, and sacred texts, were the bearers of meaning.

Despite the differences in our arts and our lives, modern human beings have the same psychological needs as our ancestors. It is ironic that while most people in modern societies are free from the material anxieties about food and safety that beset premodern people, many suffer deeply from psychological anxieties related to identity, belonging, meaning, and competence or self-worth that these ancestors did not know. Although our world and our anxieties are different from those of hunter-gatherers, the public arts, even today, have particular relevance to both individual and communal concerns.

I offer ten contributions that the public arts make particularly well to the social and emotional well-being of individuals and their communities.

1. *The arts display and even help to create a sense of identity*—both collective and personal. People in premodern societies tend to display a collective identity—their membership in an age group (e.g., post-pubescent, elder) or their attainment of a particular social status (e.g., married, initiated, widow, warrior). In modern societies, individuals choose their clothing and personalize their homes and other possessions to indicate their individual personalities, tastes, and social backgrounds. A "lifestyle" includes all choices that communicate a person's "self." The body piercings, hairstyles, clothing, and insignia of today's youth display both individual and collective identity. A concern with collective identity is evident in most of the *New•Land•Marks* proposals, and many of them use photographs and other images that recount a people's or group's common heritage, sense of place, and commitment.

2. *The arts build a sense of community and reciprocity.* As just described, identity in small-scale subsistence societies is generally more collective than individual. Although the arts today have become avenues primarily for expressing personal style and individuality, they are still able to foster the satisfactions of community and cooperation that modern societies often tend to neglect. For example, participants in socially-significant events that have involved personal sacrifice, such as wars or protests, are especially inspired

I suggest that we nevertheless continue to need the arts, because we are creatures who evolved, biologically, to require the social and emotional satisfactions they bestow. If I am correct, it follows that without the arts, we are incomplete human beings.

considered as participants will have the opportunity to meet with the Art Association staff for further discussion.

The Art Association will review the artists' submissions and recommend a potential artist or creative team to each community group. Artists will be selected on the basis of their previous work, their willingness to participate in the community planning process, and opportunities for their ongoing interests and work to be extended to the community setting. This is not a "competition"; all judgments will be based on the overall goals of the program and the potential to create significant new landmarks. Final decisions will be based on the input, criteria, and opportunities presented by the community. The community may voluntarily withdraw from the program at that time.

RIGHT: Artist Todd Noe's proposal for the communities of Kensington and Fishtown makes historical references to past industry through the iconographic use of products once manufactured locally—including the world-famous Stetson hat, visible in this 1914 photograph of Kensington's Stetson Factory.

Community Dialogue and Proposal Development

The Art Association will facilitate proposal research and development. New·Land·Marks staff will serve as advocates for the projects and as resources to the participants. During this period, a series of workshops will be presented to stimulate discussion and offer an expanded view of the possibilities for public art. The goals for proposal development include: building supportive working relationships and mutual understanding among artists and communities; offering unusual and uncommon opportunities for artists; providing possibilities for communities to realize public art works of character, distinction, and meaning; and seeking "placemaking" outcomes that distinguish community locations. In this stage,

and moved by impressive monuments and formal observances that commemorate and seem to "sum up" the efforts and feelings that composed these events. Collaborative arts, like theater and other kinds of performances, provide an exhilarating sense of mutual involvement and accomplishment. Virtually all of the New•Land•Marks proposals instill and reinforce community concerns and values—in the historical references to past industry and landmarks, the use of local materials, and the use of local names and the actual words and stories of community members.

3. *Making and creating something with one's hands and body provides an undeniable sense of both physical and psychological satisfaction.* There seems to be something about shaping and embellishing—a bodily movement, a musical phrase, an idea or emotion, a material or motif—that gives a sense of fulfillment over and above that of the pleasure of mere physical activity. For hundreds of thousands of years, our ancestors made everything they needed for their lives with their hands, using natural materials that

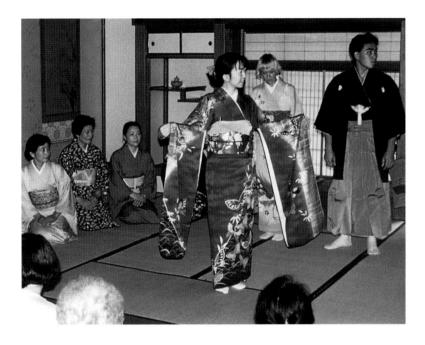

they gathered and prepared. Because physical, manual activity was so essential, prehistoric people obviously had not only to use their hands, but to *like* to do so. Although modern people are not required to make the things they use, the activity of making continues to give pleasure and meaning to human lives. Participation provides a sense of pride and ownership. Most of the *New•Land•Marks* proposals encourage active participation by the community, which of course helps to create and reinforce communal identity and reciprocity.

4. *The arts give satisfaction by appealing to and exercising nonverbal parts of our minds.* Especially in modern societies, a large part of our lives is devoted to processing—analyzing and transmitting—verbal information. Societies built upon literacy tend to think of meaning as "dictionary" meaning, but the arts provide access to other sorts of meanings that are multivalent, symbolic, and emotional. In modern life, it can be easily forgotten that often the most important things cannot be expressed in words. In virtually all of

as in all others, community dialogue will be encouraged.

Project Development

Upon completion, the proposals will be documented, exhibited, and publicized, linking the various approaches to public art and presenting them to the community at large. A *New•Land•Marks* Symposium will bring together all the participants to learn more about the city-wide impact of the program. We anticipate that each project will have special development and funding requirements. The Fairmount Park Art Association expects to commission three to five projects as part of a long-range plan to develop as many *New•Land•Marks* projects as possible through innovative and cooperative relationships and funding strategies. In some cases, construction funds may be

RIGHT: Artist Darlene Nguyen-Ely and the Vietnamese United National Association, which organized this ceremony, would link traditional Vietnamese culture to the spiritual and emotional journey of immigration through a monument imbued with complex, symbolic meanings.

available through a community development initiative, and *New·Land·Marks* funds could be applied toward artist and design fees. In other cases, the community may have very limited financial resources but may be in a position to support the project in other ways. We will be looking to "leverage" funds and coordinate with ongoing community efforts as much as possible in order to maximize the impact of the *New·Land·Marks* projects.

Artists will be expected to . . .

. . . approach the community process prepared to create new and challenging work. Artists should be willing to apply their ongoing line of inquiry to new and challenging community situations. Artists should not have developed preconceived projects before

the *New•Land•Marks* proposals, visual elements are imbued with complex, symbolic meanings that emotionally reinforce the sense of identity, community, and active participation of those who encounter them.

5. *The arts enhance and enrich the natural and manmade environments.* Any shaping or embellishment of the natural world adds human significance to it. For millennia, humans have painted and carved upon cave walls and stony outcroppings. Standing stones and other neolithic monuments can be found all over the world. The marking of significant places, times, and events—as practiced by the Australian aborigines, who find every geographic feature to have potent meaning, which they often go on to enhance even more—is a way of appreciating and feeling connected to the world in which one lives. Taking the trouble to beautify or specially treat one's surroundings is a mark of humanness today just as much as it was in the past. For *New•Land•Marks*, each project reconceives, enhances, and enriches its proposed environment, whether it is a neglected park or an urban

streetscape. Beautification and reclamation are evident in every *New•Land•Marks* encounter.

6. *The arts help us to deal with anxiety.* Prescribed activities provide "something to do" in times of confusion and distress. It is no accident that ritual ceremonies in premodern societies are overwhelmingly concerned with circumstances that cause anxiety—illness, suffering, life-stage transitions (puberty, marriage, childbirth, death), warfare, procuring food, assuring prosperity. Focused, patterned activity suggests that the important matter is being dealt with. It provides a form for feeling and allows the expression of what cannot be said in words.

Participation in artful activities that improve one's neighborhood or home, through beautification or the contribution of labor and materials, reinforces the sense that a problem is being addressed, a need being met. The structuring and unification of public space through public art contributes to a concomitant sense of a structured life, of order and beauty. Commemoration of a historical past roots neighbors in a common identity. The very excess—size, beauty, wondrousness—of some of the *New•Land•Marks* conceptions underscores their importance, and by extension the importance of those who live with and respond to it.

7. *Refreshment, pleasure, and enjoyment are all concomitants of the arts,* although one must be careful not to call the arts necessary simply because they are often pleasurable or "fun." Officials in charge of purse strings often "de-fund" or "under-fund" the arts precisely because they are considered to be merely enjoyable pastimes and therefore not central to community life. However, *public art*, which is often located in parks and open spaces, can be seen as an essential aspect of civic life, and the *New•Land•Marks* proposals show precisely how public art can expand and enhance opportunities for recreation, contemplation, and relaxation that may already be in place.

8. *The arts put us in touch with important life concerns* that can easily be neglected in our day-to-day existence. Everyone agrees on the importance to our personal lives of such human verities as the giving, finding, and keeping of love; the inescapability of moral choice; sacrifice; human suffering and

The structuring and unification of public space through public art contributes to a concomitant sense of a structured life, of order and beauty.

they learn about their community partners. **...engage in a dialogue with community representatives.** Each project will respond to a community's physical *and* social environment. Discussions among artists and community members will inform the *New·Land·Marks* process. We expect that each community will have different interests and will provide unique opportunities for proposals.

...accompany the community through the public art process. Artists will be expected to participate actively in the public art process. Three workshops will be held to support proposal development, and artists and community representatives will be asked to attend together. These workshops will provide opportunities to exchange ideas with other

RIGHT: *Two* New•Land•Marks *proposals would add to the active cultural life of Latino Philadelphia, reflected in this 1980 mural dedication along North 5th Street. Congreso de Latinos Unidos with artist Pepón Osorio and the Neighbors of Fairhill with artist Jaime Suárez seek to acknowledge, mark, and celebrate the heritage and future of the Latino community.*

artists, community groups, and the Art Association staff.

. . . develop visual and written materials to describe the proposal. Proposals will be submitted in any way that best represents the project: drawings, blueprints, site photographs, models, historic documents, sample materials, or sculptural elements. Artists should keep in mind that a selection of the submitted materials will form the basis of an exhibition. Final submissions also will include a written description by the artist, a written summary and endorsement from the community group, preliminary budgets, and design specifications.

. . . remain involved as the project develops. Because *New·Land·Marks* projects will be expected to endure for

redemption; longing and loss; and life and death. These are what life is, and they are the primary subject matter of the arts, today as in the past.

9. *The arts not only acknowledge the things we care about, but allow us to mark or celebrate that caring.* In premodern societies all individuals participate in artful activities, while today we are more inclined to watch others enact our celebrations and concerns. Nevertheless, through the arts we acknowledge what is of ultimate value to us.

10. By means of all the above, *the arts awaken us to deeper self-understanding and to higher levels of consciousness.* Subsistence lives made our ancestors inescapably aware of truly important existential verities, as mentioned earlier. In the relentlessly busy, fractioned, even materially deprived and psychologically desperate, lives that many people lead in the twenty-first century, there is often little time or opportunity to think seriously about the abiding questions that comprise the human condition. Yet it is through consideration of these questions that we demonstrate and express our humanness.

The *New•Land•Marks* proposals touch upon such humanly relevant themes as work, cooperation, friendship, exchange, sacrifice, heroism, memory of a lost past, life change, myth and cosmology, and the abidingness of the natural world. In experiencing the works privately or collectively, community members are reminded of, and encouraged to reaffirm, these serious themes, and to feel themselves a part of a wider human condition. By involving themselves in the arts—whether actively or passively—participants make both themselves and the arts more alive. Through the arts, we become our better nature, our deeper and higher selves.

ELLEN DISSANAYAKE is an independent scholar and lecturer. She is the author of numerous articles and three provocative books: What is Art For?, Homo Aestheticus: Where Art Comes From and Why, *and* Art and Intimacy: How the Arts Began. *Her work investigates the evolutionary origins and biological necessity of art and its social and cultural importance in daily life. Her insights are drawn from living and working in Sri Lanka, Papua New Guinea, India, and Nigeria. She has taught at the New School University and has spoken at nearly one hundred universities and professional conferences around the world.*

The Art of Identity

by Thomas Hine

The Art of Identity

by Thomas Hine

*I*n Philadelphia's Independence Square, in a prominent spot opposite
the tower of Independence Hall, stands a bronze statue of a man in a
tricorn hat. He has a resolute look on his face and his right hand is pointing
forward. The inscription on the base reads "Barry."

It's likely that few of those who pass by the statue know who Barry was,
nor do they care. However, many of those who do know that Commodore John
Barry was "the father of the U.S. Navy" care very deeply. Barry was Irish,
and his presence, just a stone's throw from where the Founding Fathers hashed
out the Declaration of Independence and the Constitution, affirms that a
people who has survived discrimination and exploitation are, nevertheless,
part of the mainstream of American history.

This acceptance was a bit belated. The work was dedicated in 1907, and
paid for by the Society of the Friendly Sons of St. Patrick. By this time, Irish-
Americans had the political clout to convince City Council to give the work
so prominent a location, and the money and leadership to make it happen.

Like many other commemorative sculptures, the Barry statue, by Samuel
Murray, functions not so much as a work of art as a piece of civic punctua-
tion. One could hardly call a ten-foot-tall bronze in so visible a location a
secret monument, yet the work is rather silent about its significance. The
people for whom it means something know. The rest simply pass by.

Samuel Murray. Commodore John Barry, *1907. Independence Square.*

FAR LEFT: Bronze sculpture.

LEFT: Identifying plaque (detail).

As part of the *New•Land•Marks* program, the artist Ap. Gorny has proposed a series of almost hidden works, one of which would stand not far from Commodore Barry. The artist, who is working with members of the gay, lesbian, bisexual, and transgender community, seeks to remind those who notice his rather discreet memorials, of the presence and oppression of members of these groups throughout history. Those who wish to remain oblivious to his works can do so, he argues, but the presence of the works will, he says, "queer the space."

Just as Gorny's works would "queer the space," it is hard not to think of how Barry "Irishes" Independence Park, how the Columbus obelisk "Italians" Penn's Landing and *Joan of Arc* "Frenches" the Kelly Drive. The desire

collaborative process in which the community's goals and the artist's vision are brought together. Neither communities nor artists should approach *New·Land·Marks* with specific projects in mind.

. . . identify community representatives and cooperating organizations who will work with the artist to support proposal development. Participating communities will identify at least three individuals to work with the artist and represent the community in the planning process. These representatives should reflect the range of perspectives found in the community. They will act as the project's advocates, representing the project to appropriate city agencies and during the community and civic approval process.

*RIGHT: Ap. Gorny, Theyareus, 1999.
Cartouche of sculpture and photographic
image. Proposal for a location near
Independence Hall. See page 68.*

**. . . participate in the artist selection
process.** The Fairmount Park Art Associ-
ation will work closely with the community
representatives to identify artists who are
especially inclined to address the particular
community conditions expressed in the RTP.

**. . . guide the artist or creative team
in identifying unique opportunities
for New·Land·Marks projects.** Com-
munity representatives will advise the artists
as the proposals develop and serve as
important resources for the artist in devel-
oping new ideas. Community representa-
tives will be encouraged to attend public art
workshops with the artists.

**. . . determine how the works will
be maintained after they are built.**
Like streets, lights, gardens, and other
parts of our public spaces, public artworks

of all kinds of groups to make their presence felt, and to muster the money
and the political means to do so, is one of the chief reasons that Philadel-
phia has such a rich endowment of public sculpture and civic adornment.

Moreover, this same impulse is at work in many of the other proposals
that have emerged from the *New•Land•Marks* program. One would give a
monumental presence to the Vietnamese community. Another gives overdue
recognition to the contributions of the labor movement, and yet another
literally gives a rehabilitated building a series of Latino faces. Several are
intended to provide a focus for neighborhoods that feel neglected by the city
at large. Others seek to transform public investment in streetscapes and other
civic improvements. And several involve public parks, which are often at risk

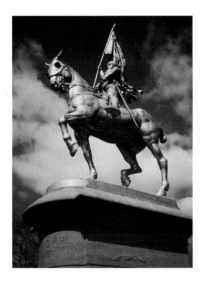

FAR LEFT: Emmanuel Frémiet, Joan of Arc, 1890. Gilded bronze sculpture. Kelly Drive at 25th Street.

LEFT: Venturi, Scott Brown and Associates, Christopher Columbus Memorial, 1992. Stainless steel and granite monument, International Sculpture Garden at Penn's Landing.

unless they create their own constituencies of people who use and maintain the parks and agitate for improvement.

These proposed works continue a long and often forgotten tradition. A high percentage of the works we now view as part of our patrimony of public art have been, in some sense, political. Relatively few, however, have sought to embody a policy agenda (though the temperance movement produced many fountains and watering troughs, remnants of which survive.) More often, the politics have consisted of a simple demand for recognition: We're here and we're queer (or Polish or Armenian). Get used to it, and give us our due. People sometimes assume that identity politics is a product of recent decades. A survey of the city's bronzes shows that it is not.

With *New•Land•Marks*, the Fairmount Park Art Association recognizes the vitality and validity of the constituency-based tradition of generating public monuments. It then becomes far more appropriate to view art as an expression of community than, for example, as an adornment to a building project, as the "percent for art" programs tend to do. At the same time, though, *New•Land•Marks* attempts to increase the artistic ambition of this grassroots approach by matching communities with artists who have attained

need to be maintained regularly in order to avoid long-term problems. Often, the maintenance involves a simple task such as annual washing. Some artworks require more specialized care under the guidance of a conservator. Planning ahead is the single most effective way to preserve public art for future generations.

The Fairmount Park Art Association will . . .

. . . seek the most creative and inspired partnerships between artists and communities. From the RTPs, the Fairmount Park Art Association will select community groups to participate in the *New·Land·Marks* program. The *New·Land·Marks* Advisory Committee will assist in this process. The Art Association will also identify artists who have expressed

an interest in making a commitment to the *New·Land·Marks* program and whose work would be stimulated by the opportunities posed by a particular community.

...assist and nurture proposal development. The Art Association has over 125 years of experience in commissioning art for public places in Philadelphia, and it is recognized nationally as a leader in the field of contemporary public art. The Art Association will facilitate the development of each proposal and will also provide professional consultations with architects, landscape architects, structural engineers, conservators, and other specialists. The Art Association will seek additional resources and opportunities for projects and will work with city agencies as needed.

a measure of critical recognition, and who might bring a higher level of ambition to the project than would otherwise be the case.

Thus, *New•Land•Marks* is a bold undertaking. The Fairmount Park Art Association's mission has historically been to beautify and improve the city as a whole, at least insofar as the Art Association's leaders could imagine it. Should the Art Association now cast itself as an instrument of the contending small voices of the city? Shouldn't art be used not to embody the city's divisions, but to help it cohere?

These are not small questions, though I do believe that they posit a dichotomy that is false. A city that is healthy as a whole must be healthy in all its parts. Art has only a very limited ability to affect the city's many pathologies. But art is more likely to be helpful when neighbors come together to help realize something they have come to care about. When an object is simply plunked in our midst, without warning or consultation, it is likely to be initially unpopular, no matter how good the experts proclaim it to be.

Thus, while *New•Land•Marks* might well be viewed as an example of political correctness, it may be that its greatest importance is as an exercise in political realism. When public space is used for an elementary school, for example, or a garbage dump, most people can agree that this is a political decision. Using such a space for a work of art is likewise political. But when proposed or actual works of art have caused public controversies that were acted out in the political realm, many artists and their advocates claim to be shocked. Those who question the appropriateness of a new work of public art should not have authority to judge its fate, the argument goes, because by the very act of questioning they demonstrate their failure to understand it. One of the more unfortunate tendencies within the public art movement of the last half-century has been to mistrust the public and the institutions by which the public will is expressed.

During the last fifteen years or so, public art advocates and administrators have sought to lessen this polarization by groping for procedures for community participation. This goal was helped immensely by the willingness of many artists to view such interaction as an important part of their

work. Such artists take on a difficult task. They are being asked to be responsive to the declared needs of those with whom they work, while at the same time producing something wonderful that nobody else has imagined. Visionaries with humility are a rare breed, yet these are the attributes required to produce art that succeeds both aesthetically and as an enhancement of public life. (Richard Serra's notorious *Tilted Arc*, for example, was a great work of art, but the qualities that gave it its power were precisely those that made it difficult to live with every day.)

The *New•Land•Marks* program is notable in that it doesn't merely accept the broadly political dimension of public art, but in addition, seeks to use it to realize the works that are its focus. If *New•Land•Marks* works, and there are already indications that a number of the projects will be realized, it will produce not only objects, but also a body of guardians and advocates, and perhaps even a lasting sense of the meaning of what the artists and the communities have accomplished together.

The Fairmount Park Art Association's track record is longer than that of most of its counterparts, so it isn't surprising that, as an institution, it would show an understanding of the politics of public art. For one thing, it has been taking care of art over an extended period of time. Responsibility for a work of art does not end when it is erected. Indeed, that's when it begins, and every work of public art needs a constituency of people who care about it. Over time, the work may lose some of the meanings it had when new, but it gains others by its association with a particular place and the passage of people's lives.

New•Land•Marks shifts the common model—in which a government agency and/or an artist picks a site, develops an idea, and then seeks community involvement—to one in which the community volunteers to be part of the process. There was no assurance that all the projects would actually be built, and from the outset the group seeking the art could expect to have to work to make it happen. By requiring community groups to compete to participate in the program, *New•Land•Marks* sought to transform their leaders from passive recipients into advocates and organizers. The Art Association matched each community group with artists who wanted to

People sometimes assume that identity politics is a product of recent decades. A survey of the city's bronzes shows that it is not.

THE REQUEST TO PARTICIPATE (RTP) GUIDELINES
Artist Eligibility

Artists who work in all visual and interdisciplinary media, including but not limited to sculpture, crafts, folk art, installation art, architecture, design, photography, and film, are eligible to participate. Visual artists may submit as individuals or as creative teams which may include people working in other disciplines, such as poetry, writing, history, ecology, archeology, and cultural anthropology. Artists should submit a one-page statement describing how your existing work would be applied in a community setting. How might you approach the *New·Land·Marks* program? What unique perspectives do you bring? (Artists who

have never worked in a community setting may participate. Artists who have never been commissioned to create permanent public art work may also submit an RTP. However, community involvement and public art work do not suit every artist. Please consider whether your work fits into the context of *New·Land·Marks*.)

Community Eligibility

Communities must be located within Philadelphia's city limits. The definition of community is not restricted to geographic areas, however. It may also include groups that have a shared history, mission, identity, or interest. You probably know the answers to most of these questions already. Include any additional printed information about your community group that can help us understand more about your community.

participate in the program. Ethnicity played a role in this matchmaking, but the chief goal was to find a fit between the desires the groups expressed and the interests the artists showed.

It was inevitable that some of these "arranged marriages" would founder. That's the price of experimentation. Indeed, if all had prevailed, that would, perhaps, be a sign that not enough risks had been taken. At this writing there have been very few cases in which the relationship between the artist and the neighborhood group did not produce any idea that was strong enough for the group—or for anyone else—to feel passionate about.

There have also been some conspicuous successes, though—as with all outwardly successful marriages—one must be cautious in one's optimism. One possible measure of success could be the enthusiasm that speeds a work from proposal to completion. The collaboration of Irish artist John Kindness with the Friends of Elmwood Park, which seems likely to be among the first realized projects, surely meets this standard. And this success derives, in substantial measure, from the same kind of forces that produced the Barry monument and its many companions.

The organizers of the Elmwood effort sought not only to improve a typical neighborhood park, but to make a larger statement. By deciding to celebrate the contributions of the labor union movement to society, they identified an important aspect of the region's history that has not been the subject of other monuments. And not incidentally, their decision gave the work a large constituency beyond their immediate neighborhood. The viability of this work thus depends on the involvement and contributions of many in the labor movement. Kindness's proposal also has some other virtues that are more difficult to quantify. It is memorable and likable, clearly the work of an artist but as comfortable as the old blue jeans from which it takes its color palette and motifs.

Embodying Thoreau: dwelling, sitting, watching by Ed Levine with the Pennypack Environmental Center Advisory Council seems a success of a very different sort. Levine's hut, benches, and bird blind promise to be a ravishing aesthetic experience. Details of their execution have been carefully thought through. And they would be a worthy addition to Philadelphia's strong

tradition of art encountered in the woods. Northeast Philadelphia has far less public art than most of the rest of the city, and Pennypack is part of the Fairmount Park system that has escaped the Art Association's attentions for far too long. Thus even this most poetic of the projects has a political wind at its back that should help it to be realized.

Sometimes, remarkable ideas help create their own constituencies. That seems to be the case with the proposal by Janet Zweig and the South of South Neighborhood Association (SOSNA) for an outdoor library. This is perhaps the most unlikely idea to emerge from New•Land•Marks; nevertheless, it appears to be moving toward realization.

An outdoor library seems a paradox, but it does respond to many of the paradoxical challenges the artist faced. As Zweig notes, reading is a way of leaving the neighborhood in one's mind without leaving it physically. If the artist had simply done a drawing and made a statement, however, this project would never become a reality. By demonstrating how the outdoor storage of books works in Paris and New York, and above all by enlisting the cooperation of the Drexel University College of Information Science and Technology, she established a realistic basis for a visionary scheme. SOSNA has secured a piece of land on which the work will be built. Acquiring this site required the assistance of local politicians and agencies, who responded to the way that leaders and residents had adopted Zweig's vision as part of their plans for the neighborhood's improvement.

These three otherwise dissimilar projects share three characteristics. They embody ideas that are clear and compelling; they have been refined into proposals that seem practical without feeling commonplace; and they have captured the imagination of people who would like to see them realized.

By singling these three out as likely successes, I don't mean to imply that others won't be completed. Rather, my purpose is to acknowledge that different works have different gestation periods, and some have ambitions that will prevent them from being realized quickly.

For example, Malcolm Cochran's efforts with Baltimore Avenue in Bloom to create new bus shelters, giant planters, and a lookout platform for people awaiting trolleys will require cooperation from bureaucracies including

Responsibility for a work of art does not end when it is erected. Indeed, that's when it begins, and every work of public art needs a constituency of people who care about it.

1. Define your community organization and its mission. What are the boundaries of your community, if any?

2. What is it about your community that is unique? What would inspire a New·Land·Marks project? Please draw up an "inventory of inspiration" based on what your community might want to leave for future generations.

3. How would your community measure a successful New·Land·Marks project?

4. Are there any collaborating groups or organizations in your community? If so, please also include a brief letter of intent from each.

5. What are the current projects and future initiatives in your community? Please describe any master-planning efforts, infrastructure improvements, community

Visionaries with humility are a rare breed, yet these are the attributes required to produce art that succeeds both aesthetically and as an enhancement of public life.

development projects, or plans for new construction or public amenities.

6. Do you have any criteria regarding artist selection? Would you be willing to work with an artist who is from outside of Philadelphia or from a foreign country?

7. For the purposes of New·Land·Marks, who will represent your community? Please list the names, affiliations, addresses, and daytime phone numbers of three people who will serve as community representatives. These people should also review and sign the RTP.

Public Art Workshops

Guest speakers included New·Land·Marks artists, as well as Jody Pinto, public artist; Bonnie Burnham, President of the World Monuments Fund; Steven Tatti, Conservator, and Edward Marschner, Esq.

SEPTA (Southeastern Pennsylvania Transportation Authority) and the Streets Department and, very likely, funding from city, state, and federal agencies. Though it has aspects that seem sure to capture the public imagination, the ideas in the project will only be realized if the community and the artist succeed in winning the bureaucratic and political support they need.

While questions about the possibility of realizing Cochran's proposal concern its scale, those raised by Gorny's proposal concern the nature of the statement the artist is trying to make. In order for it to happen, it must offer something around which its constituency can rally. Historically, the purpose of public monuments has been to stand out aggressively and stake a claim on the public consciousness. Gorny seems to be asking his potential supporters to reject this traditional desire to be recognized as part of the mainstream. Instead, the work invites them to celebrate their differences from others in a way that may be intelligible only to themselves. The gay, lesbian, bisexual, and transgender community does have a long history of being forced to hide. Will a work of art that reveals its message only to those who know how to look for it seem to enshrine this oppression?

One thing you should probably keep in mind about New•Land•Marks is that this publication and the exhibition it accompanies are phases in a much larger agenda. Just as the Art Association has shown itself to be willing to experiment and take risks, it has also been willing to be patient, to wait for ideas to develop and change enough to make success a strong possibility.

New•Land•Marks, with its multiple interest groups and open acknowledgment of the need for constituency-building and other broadly political processes, is a complex undertaking. A few projects may happen quickly, others may be defeated, and some may change beyond recognition. Like democracy itself, the results of New•Land•Marks will be unpredictable. But I, for one, am looking forward to seeing them, confident that I will be surprised.

THOMAS HINE writes about American culture, design, and architecture and is the author of Populuxe, Facing Tomorrow, *and* The Total Package. *His most recent book,* The Rise and Fall of the American Teenager, *chronicles the phenomena of adolescent identity and life into the twentieth century. From 1973 to 1996, he was the architecture and design critic of* The Philadelphia Inquirer.

The Object of Process

by Lucy R. Lippard

The Object of Process

by Lucy R. Lippard

Excerpts from the
***New·Land·Marks* Prospectus**
(continued)

At the Well: artists, creativity, and new visions

At the Root: communities, histories, and new identities

To open the door for the creative process, the first workshop will help the artists and community teams learn more about each other. Artists with considerable public art experience will describe the ideal working conditions for creating public art, the ingredients for a successful public art project, and how a community can effectively contribute to the artistic process. In turn, community representatives will share information about their communities and discuss critical issues their communities face.

*E*ighteen artists or artist teams meet with eighteen neighborhood groups to decide the nature of a series of place-specific public artworks. In the process—and process is paramount—important work gets underway; conflicts are acknowledged; alliances are forged; two projects fade away. The current conventions of public art are exposed to view and sometimes challenged. The tensions between art and life are writ large.

Community members hope for a talisman, positive images that will illuminate their place, bring different elements together, create a local focus, garner respect, and make their neighborhood something special. The public art process, however, no matter how well facilitated, seldom finds a smooth path to completion. I am writing this in the middle of the process, and the products cannot yet be examined. However, *New•Land•Marks* already offers a fascinating view into the public art process and its relationship to significant place, suggesting a range of possibilities, broadening and deepening people's understanding of artists' intervention in their public places.

A lot of us would like to reclaim our public spaces from corporate monotony, from ogling tourists, from gentrifying agents, but the economic power of development (or civic pride) is hard to get a grip on if we don't know what we think of ourselves—if we don't know how to think for ourselves. As tourists in our own hometowns, we watch them change.[1] And we are changing them

LEFT: *Artist Rick Lowe speaks with residents of West Philadelphia about a petition to close off May Street.*

even by being curious and paying attention to our surroundings. No place is static. The outreaching arts need to change along with the place.

Place is the common ground. *New•Land•Marks'* mandate, in most cases, was basic placemaking. Reading the cultural landscape is the most important factor in this process of defining a place as a collaboration between people and geography. In urban locations the geography may be harder to see, but it has determined the layers that cover it, offering its clues to the social history of land use—a compelling part of any little chunk of turf. Architectural historian M. Christine Boyer might have been advising public artists when she wrote that "to read across and through different layers and strata

Communities are the source of a rich and dynamic public history. This workshop also examines ways in which artists have used the "raw materials" contained within a community to inspire public art works. Philadelphia's historic and cultural institutions also contain a wealth of information that can stimulate proposal development. Representatives from various research institutions describe where artists can search to uncover these "untold" histories.

Outwitting Time: site, materials, and maintenance

Public art must endure the punishing effects of time, withstand exposure to the elements, and survive cycles of human indifference. These environmental factors should be considered during the planning process. Furthermore, once a work has

RIGHT: Artist Pepón Osorio and staff members from Congreso de Latinos Unidos review plans for Congreso's new facility.

been created, it requires attention on the part of the community. There are very few, if any, public art projects that can be considered "maintenance-free." Artists and conservators discuss issues regarding site and material selection, ongoing maintenance, and community involvement.

But is it Art?: controversy and the laws of public art

Because tastes vary and change, people's responses to public art will vary as well. In fact, it is probably not possible for an entire community to reach a "consensus" about a work of art. However, community response can be an important and exciting feature of a work. This workshop addresses controversy as an inevitable result of the placement of art in the public environment. It also reviews the legal issues surrounding

of the city requires that spectators establish a constant play between surface and deep structured forms, between purely visible and intuitive or evocative allusions."[2] It is always dangerous to forget that cities are actually vital parts of their regions. They interlock with everything else surrounding them. Understanding our place's place in a larger place helps us understand our own place in the world.

One way to get the picture is to move out from your neighborhood, your city, in different radiuses, looking around as you go. Many Philadelphia parks are radially designed and some of the artists here have picked up on this form, focusing on the way in which every section, every city, is *placed* in relation to every other place. The *New•Land•Marks* artists often choose between centrifugal or centripetal approaches. Some focus on one site, bringing in the radiuses, creating a gathering place that pulls people in. Others may scatter clues throughout a neighborhood, counting on an accumulative process to make the connections. Or they may create a linear journey. The work's outcome of course is often determined by the site itself.

Many of the *New•Land•Marks* proposals use paths as a bridging strategy. Curbs or pavements are often inscribed with quotations or images or mosaic patterns. As landscape architect Anne Whiston Spirn has pointed out, she and her students learned by trial and error in Philadelphia's Mill Creek community that "a path is a meeting place."[3] For *New•Land•Marks*, George Trakas worked with a natural path, the Wissahickon Creek (which, unlike the buried Mill Creek, still has a presence), utilizing an old stepping stone crossing, near the remains of a mill constructed in 1636. Not only space but time is bridged by four hundred years of nature/culture interchange. Malcolm Cochran's recognition of the importance of the trolley line to the Baltimore Avenue community led him to propose three handsome trolley-related structures, providing a "crow's nest" from which to spot the trolley, a shelter while waiting for it, and planters for enhancement of the site. In some cases the paths exist for the artist to highlight; in others they offer new entrances to old places. In Malcolm X Memorial Park, Martha Jackson-Jarvis and JoAnna Viudez offer several entry points, repeating spiral motifs representing unraveling time between their ancestral "shrine house" and the mural in memory

of park savior Rena Ellis. Zevilla Jackson Preston's *Bright Light Trail*, a walking meditation on positive imagery and communal role models proposed with the Allegheny West Foundation, employs cultural symbols to create coherent patterns. Community leader Ronald Hinton applauded the way "you can read your way through the neighborhood."[4]

If "location location location" is the real estate industry's mating call, public artists need to think "context context context." Here Spirn's new book, *The Language of Landscape*,[5] is invaluable, especially in *this* context, since she has worked on the ground in a West Philadelphia community for many years. Rick Lowe and Deborah Grotfeldt are the beneficiaries of her work in Mill Creek as they work with the Mill Creek Artists' Collaborative. They approach "social sculpture" not as a *thing*, but as an artistic process that will "build rituals that define community. . . . Part of the design strategy is cleaning and maintaining the site as part of the artwork," they say. Lowe and Grotfeldt perceive the project's permanence as part of "the human capacity to care for its neighborhood."

Photographer Lonnie Graham of the multifaceted Project H.O.M.E. team also emphasizes the organic quality possible when process is paramount: "The ongoing aspect is important. The thing takes on a life of its own and begins to grow." Project H.O.M.E.'s offices are in the surviving rectory of Saint Elizabeth's church, which burned to the ground in 1995. "We lost the one standing symbol in our community for hope and relief," says community member Vicki Thompson. Three monuments will replace that standing symbol: an amphitheater (recalled by team member and writer Lorene Cary as "walls like the arms of a mother holding her children"); a sanctuary/pavilion with a fountain at the former altar site; and a "common room"—a repository for an ongoing oral history project, defining the artist team's focus on continuity. The Project H.O.M.E. team (Graham, Cary, and sculptor John Stone) cites "leisure and memory" as their prime concerns. They are building from very solid ground, on a place that is already made and will be altered both to recall the past (the church) and herald the future (represented by the beloved red-and-white-uniformed drill team called the North Philadelphia Foot Stompers).

It is always dangerous to forget that cities are actually vital parts of their regions. They interlock with everything else surrounding them. Understanding our place's place in a larger place helps us understand our own place in the world.

the commissioning of public art work: placement, approvals, agreements, ownership, liability, copyrights, and long-term care of the work.

Some Frequently Asked Questions

Q. If there is no presentation in my neighborhood, can I attend a presentation at another place?

A. Yes! All presentations are open to the public. We have tried to schedule presentations in most areas of Philadelphia, including each city council district. We encourage you to go to the one that is closest to your neighborhood or to one that is co-sponsored by an organization with which you are affiliated. However, you are welcome to attend any public presentation that fits your schedule.

RIGHT: *Artist Zevilla Jackson Preston facilitates The Allegheny West Foundation's community design charrette.*

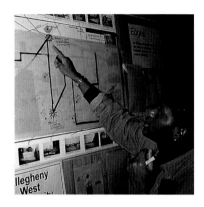

"In a forgetful century, memory resists,"[6] says Daniel Abramson, a writer who has defined topophilia as "the fetishizing of place."[7] But a real sense of place is a virtual immersion rather than the separation implied by the fetishizing impulse. Such immersion depends on lived experience and a topographical intimacy that's also rare today both in ordinary life and in traditional educational fields. Walking around, talking to people, hearing stories that are tied to specific buildings or sites is how one learns the layers of a place.

Almost every *New•Land•Marks* proposal is a memorial in one sense or another. This is perhaps a millennial impulse, to carve into memory, if not into stone, what has happened here in this place, and to cast it, if not in stone, at least in a positive light. In this case, the memorialized are not individuals and are rarely events. The *New•Land•Marks* artists are challenged to make the past meaningful in the present and instrumental in the future. Some tend to commemorate everyday life at a time that may have been forgotten, while others may nudge the present in a place that has (usually) changed. Some depend on horticulture as much as on high culture to integrate their projects into the geographical place. Vulnerable like places and like art, plants also change and "hold an important place in memorials," according to writer Judith Wasserman: "They symbolize hope and regeneration. They mark the passage of time, and display the cycles of life."[8]

Architecture is important in Philadelphia and plays a major role in several *New•Land•Marks* projects. Ed Levine, working with the Pennypack Environmental Center, presents the dwelling as nest, overlaying Thoreau's philosophy on a concern for birds. Diane Pieri and Vicki Scuri take the peculiarly Philadelphian "stoop" (or front step) as the jumping off point for stories told and connections made there. Mei-ling Hom augments the already powerful aura and ambassadorial history of the sixteenth-century Japanese House with a new performance space and abstract Buddha. Ap. Gorny uses architecture as an emblem of social power, a firepoint, a way of "queering" spaces. He chooses sites that evoke the civil abuse of power in relation to the gay, lesbian, bisexual, and transgendered community. The elegance and small scale of his photographic and illusionistic sculptures do not belie their anger so much as magnify it.

"It is the tension or outright conflict between history and memory that seems necessary and productive," observe authors Randolph Starn and Natalie Zemon Davis.[9] What better place to implement this dual goal than in a library? Janet Zweig's proposal for South of South Neighborhood Association (SOSNA) to "turn a cultural institution inside-out" is the most innovative to emerge from *New•Land•Marks*. Determined to come up with something both "marvelous" and "functional," Zweig took as her model the open-air bookstalls of the Paris quais and New York City's Union Square, creating a place that is everyplace. The project complements the "interior" activity of reading (food for thought) with the "exterior" activity of a farmer's market (food for the body).

The "overgrown objects" syndrome is particularly interesting, reflecting a loyalty to the overwhelmingly sculptural history of public art.[10] Objects trigger memories rather than overtly teaching history. Somewhere along the line (in the last two decades), a diluted Oldenburgian trend has become popular in public domains. Sculpture as object has become object as sculpture. Claes Oldenberg's endearingly gawky or overgrown objects are witty and formally powerful, but their content is often oblique or simply entertaining in context. Today, more is demanded of the elephantine object. It has become the carrier, or reifier, of idealism, of community pride (or boosterism). In the *New•Land•Marks* context, these object are icons, immediately recognizable emblems of something the neighborhood wants to remember or to achieve. "There is a fine line between preserving a memory and its reification—allowing, literally, rigor mortis to overcome the ritual and healing potential of comemorabilia," writes Judith Wasserman.[11]

Todd Noe, who has worked with emblematic objects in miniature for some time and has put his ideas into full scale with the Kensington and Fishtown communities, says, "Some things become images easier than others do"; they can be strung together to create "sort of a sentence." The giant, or isolated, sculptural object—such as Noe's Stetson *Hat Bandstand*, *Propeller Bench*, *Soup Bowl Bench*, or *Sunken Schooner Benches*, or Malcolm Cochran's enlarged vessels as trellises, or John Kindness's tables based on magnified buttons from laborers' clothing—refers to local history or the products of a

In this case, the memorialized are not individuals and are rarely events. The *New·Land·Marks* artists are challenged to make the past meaningful in the present and instrumental in the future.

public art experience. Are we still eligible?

A. Of course! The Art Association will help by identifying potential artists and will work with community groups to develop the most creative partnerships between artists and communities.

Q. I am not an artist, but I am an expert in my field, and I have creative ideas. Can I apply?

A. Sure! We are especially interested in attracting multidisciplinary teams to this process. If you are a writer or a scientist, for example, you should identify a visual artist who can be part of your creative team. The creative team should submit a single RTP.

Q. My community has its share of problems—poverty, unemployment, substance abuse, and crime. How can *New·Land·Marks* solve our problems?

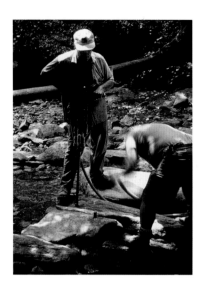

RIGHT: *Artist George Trakas works with Fairmount Park Commission staff on* Water Bridge (Gawain's), *a demonstration project at Devil's Pool in the Wissahickon Park.*

A. It is probably unrealistic to think that *New·Land·Marks* can have a direct impact on such problems. However, some dynamic works of public art have the potential to call attention to these issues or to uplift community spirit. *New·Land·Marks* cannot help but reflect the larger issues of urban life. For example, criminologist James Q. Wilson's famed "broken windows" theory suggests that urban problems and despair fester in a disorderly environment because it appears that no one cares about how the community looks.

Q. Our community has been led through many planning processes and has been promised many things that have resulted in very little. How do we know this program is not another dead end?

A. There are no guarantees, but we hope participating communities will not be

local factory or some other emblem of a community. Another use of the displaced but evocative object is Darlene Nguyen-Ely's semi-abstract and understated homage to the Vietnamese Boat People (she was one). A huge sailboat form, with its precarious balance, evokes exploration and new lives as well as the boat/lantern image central to the traditional Vietnamese Moon Festival.

Most neighborhoods, and all cities, are collages of different times and cultures and circumstances. One way to bring them out is to call attention to these puzzling juxtapositions or create some new ones that make a point. Sometimes just labeling or rearranging familiar elements in the public domain can bring out their true character. Monuments that have become invisible over the years can be put in a different context or recontextualized on site and suddenly pop back into public view.

The *New•Land•Marks* program is admirable in its attempts to close the rarely acknowledged abyss that has existed between over-hyped "public art" and undervalued "community art." Because all of the participating communities are different and the artists were chosen for their range, each one of these projects has its own look, its own tack into history. Jaime Suárez, for instance, has literally built upon the demolition of the utility building supporting Rafael Ferrer's previously erected *El Gran Teatro de la Luna*. In a symbolic restructuring of public space, Suárez added Ferrer's moon to his own sun and proposed a work by José Bédia to "complete the cosmos" of the park.

Photography is often used this way. As the art of memory, photographs are objects flattened or projected from the past. In his *I have a story to tell you . . .*, Pepón Osorio embeds images of the past in today's architecture, creating a "conceptual laboratory" to be incorporated into the new quarters of Congreso de Latinos Unidos. He describes his photographic patchwork on the building's facade and his photo-walled greenhouse as dialogues, "conversations transformed into series of testimonies shared in formal and informal settings." Town meetings will be held to select the enlarged images, some of which will reflect the Puerto Rican migration into the area. Osorio's proposal is strongly supported by Congreso's leadership.

Looking at the *New•Land•Marks* process, it is clear how far we have come. The good news is the ways in which communities are consulted and invited to participate. The bad news is the increased bureaucracy everywhere that accompanies any movement toward democracy. The process can be brutal to artists and, at times, to art. For the most part, however, art and audiences are the winners. The notion that the "lowest common denominator" drives community-based public art downhill is outdated. On the contrary, the highest "common" denominator is possible only when artists are open and inventive enough to do their best while still respecting the communities with which they are working. A neat and far from easy trick, but one with which artists are becoming increasingly familiar and even comfortable. Many of the controversies over public art, for instance, have raised consciousness around issues of power and cultural representation. They have made people think, but they often don't have much to do with art. I'm fond of quoting the Fluxus artist Robert Filliou, who said, "Art is what makes life more interesting than art."[12]

This new spate of projects raises a number of difficult questions about what art in the public domain means for and to those who experience it. Is it intended to beautify? Entertain? Empower? Educate? Enhance community life? Or are "communities" (which rarely boast the kind of togetherness implied by the name) being used to enhance art? Public artists are faced with a confusing panoply of choices, not the least of which is whether to let their imaginations (and/or egos) run wild, whatever the consequences, hoping that "the public" will eventually come around. Even if—or when—everybody doesn't agree, the public art process can help people make up their own minds about their own places.

LUCY R. LIPPARD is the author of twenty books, primarily on contemporary art. For more than thirty years she has worked with artists' groups such as the Artworkers' Coalition, Artists Meeting for Cultural Change, Women's Action Coalition, and Alliance for Cultural Democracy. Her numerous publications include the landmark book Overlay: Contemporary Art and the Art of Prehistory; Get the Message? A Decade of Art for Social Change; Mixed Blessings: New Art in a Multicultural America; The Lure of the Local: Senses of Place in a Multicentered Society; *and her recent book* On the Beaten Track: Tourism, Art, and Place.

disappointed. Because the Art Association has a long-term commitment to public art in Philadelphia and specifically to the *New·Land·Marks* program, we intend to assist, develop, and realize as many of the proposals as possible. *New·Land·Marks* projects will emerge as a consequence of community engagement—the projects are unlikely to happen unless they strike a chord with members of the community.

New·Land·Marks is . . .

. . . an opportunity for communities and artists to create a legacy for future generations.

. . . an opportunity for artists to work with communities in a responsive approach to public art.

. . . a unique, cooperative process in which the artist's vision and the

community's goals are balanced, and both are treated as important. ...a way of working in a supportive and positive relationship, with the assistance of the Fairmount Park Art Association as facilitator, advocate, and resource. ...a program offered without direct cost to community groups, requiring a time commitment, coordination, and, in some cases, "leveraging" of community development funding.

NOTES

1. Lucy R. Lippard, "The Tourist at Home," in *On the Beaten Track: Tourism, Art, and Place* (New York: The New Press, 1999), 12–13.

2. M. Christine Boyer, *The City of Collective Memory: Its Historical Imagery and Architectural Entertainments* (Cambridge: MIT Press, 1994), 21.

3. Anne Whiston Spirn, *The Language of Landscape* (New Haven: Yale University Press, 1998), 73.

4. Ronald Hinton in Jackson Preston presentation at the *New•Land•Marks* Symposium, May 7–8, 1999. All quotations from artists or community representatives below come from this symposium, videotaped by VideoCrafters and available through the Fairmount Park Art Association.

5. See note 3. Spirn is Professor of Landscape Architecture and Regional Planning and Director of the Urban Studies Program at the University of Pennsylvania. She also directs the West Philadelphia Landscape Project, which integrates research, teaching, and community service—an exemplary public art process in itself.

6. Daniel Abramson, "Make History, Not Memory," *Harvard Design Magazine* (Fall 1999): 78. This provocative essay on the conflicts between history and memory provides significant insights into virtually all the *New•Land•Marks* projects.

7. Ibid., 73.

8. Judith Wasserman, "Monuments and the Landscape," *Designer/builder* (Dec. 1999): 15.

9. Randolph Starn and Natalie Zemon Davis, "Introduction," *Representations 26* (Spring 1989): 5.

10. For a history of Philadelphia's public art see Penny Balkin Bach, *Public Art in Philadelphia* (Philadelphia: Temple University Press, 1992).

11. Wasserman, op. cit., 15.

12. Robert Filliou, quoted in Lippard, *On the Beaten Track*, 103.

Works in Process: *New·Land·Marks* **Proposals**

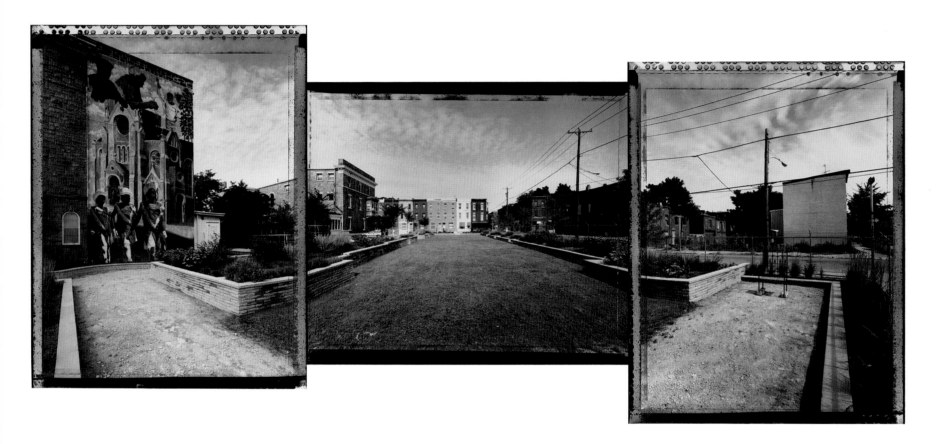

PROJECT H.O.M.E. (Housing, Opportunities, Medical Care, Education) is a nonprofit organization that works in partnership with chronically homeless people and impoverished communities as they strive to reach their fullest potential. The agency bases its efforts on the belief that the most effective means to combat homelessness is to build positive working relationships among people from all walks of life. An active partner in a citywide plan to revitalize and improve the quality of life in North Central Philadelphia, Project H.O.M.E. is committed to long-term community development activities in its St. Elizabeth's Focus Area, centered at 23rd and Berks Streets.

Church Lot

Lorene Cary, Lonnie Graham, and John Stone
with Project H.O.M.E.

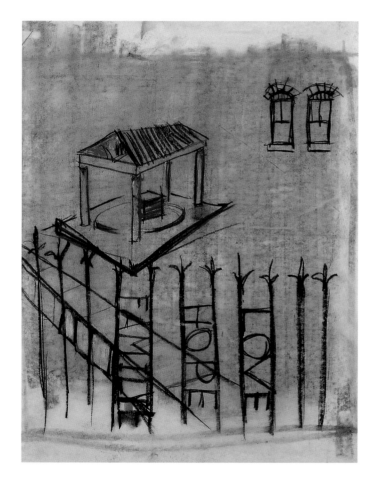

ABOVE: John Stone, Church Lot, 1999.
Pastel drawing. Proposed six-foot-high iron
fence with sanctuary, fountain, and common
room windows.

Once a valuable cultural and social asset for the North Central Philadelphia community, St. Elizabeth's church stood at 23rd and Berks Streets from 1883 until its tragic destruction by fire in 1995. "On the day that the church caught on fire, I think we cried enough tears to put the fire out, if they would have harvested them," recalled local resident Vicki Thompson. Indeed, neighbors still refer to the land where the church stood as "the church lot."

Now, under the auspices of Project H.O.M.E., residents have combined with a unique team—author Lorene Cary, photographer Lonnie Graham, and sculptor John Stone—to develop *Church Lot*, a proposal for a mixed-use community space on the former site of St. Elizabeth's church.

When discussions of a public art project began, residents stressed the spiritual as well as the practical needs of the neighborhood. They sought ways to imbue young people with an awareness of community relationships and history. The conversations led Cary to reflect, "It is not in isolation, but in community that we learn how, in God's name, to live large despite pinched circumstances." Ultimately, in response to these early discussions, Cary, Graham, and Stone envisioned *Church Lot* as a three-part project: a performance area, a sanctuary with a fountain, and a common room to house an archive of oral and photographic history.

RIGHT: Community members meet to discuss the working model.

FAR RIGHT: Lonnie Graham, Church Lot, *1999. Mixed-media model.*

BELOW: The award-winning North Philadelphia Foot Stompers drill team.

The first phase of the project, already created as part of Project H.O.M.E.'s recent renovations to the site, is *Church Lot Amphitheater*, which includes a 7,000-square-foot rectangular grass area for performances and festivals. The North Philadelphia Foot Stompers, an award-winning youth drill team, rehearse and perform in this space. A mural of the Foot Stompers, created by artist Cavin Jones and the Mural Arts Program, looms at one end of the performance area. On the perimeter, a low stone wall incorporates recessed seats, which were created from marble steps recycled from demolished homes in the community. Around the performance space, cherry and cypress trees provide color in the spring and shade in the summer.

As part of the amphitheater, Cary, Graham, and Stone propose to carve quotations from community residents into French marble facing stones donated by the Philadelphia Museum of Art. A six-foot-high iron fence would be constructed to enclose the area. Words such as "experience," "strength," and "hope" would be built into the fence between the vertical bars, offering continuous inspiration for the community.

At one end of the performance space, on the spot still referred to as the "altar" of St. Elizabeth's church, the artists propose *The Sanctuary: An Altar/Fountain*. This open-air pavilion for prayer and reflection would be composed of four stone columns supporting a simple roof. The artists also suggest that a frieze along the roof could incorporate bronze life casts of the faces of local residents, young and old, as "representatives of past and future." Another variation suggests the use of stained glass as a reference to the former church.

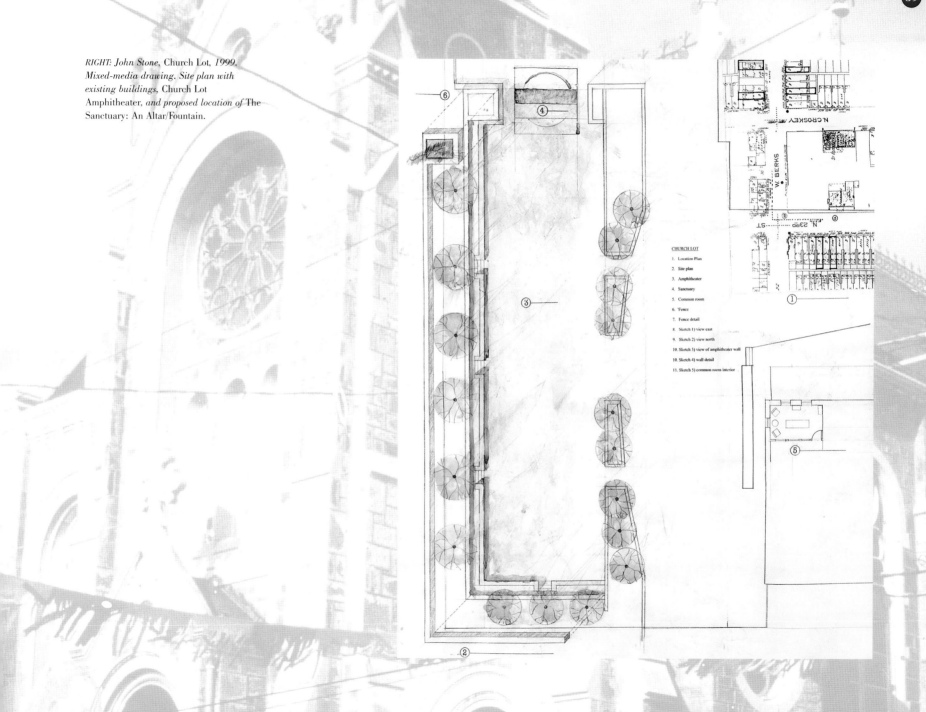

RIGHT: *John Stone*, Church Lot, *1999. Mixed-media drawing. Site plan with existing buildings,* Church Lot Amphitheater, *and proposed location of* The Sanctuary: An Altar/Fountain.

CHURCH LOT

1. Location Plan

2. Site plan

3. Amphitheater

4. Sanctuary

5. Common room

6. Fence

7. Fence detail

8. Sketch 1) view east

9. Sketch 2) view north

10. Sketch 3) view of amphitheater wall

10. Sketch 4) wall detail

11. Sketch 5) common room interior

John Stone, The Sanctuary: An
Altar/Fountain *(five images), 1999–2000.*
Watercolors and computer rendering.
Alternative designs for the sanctuary.

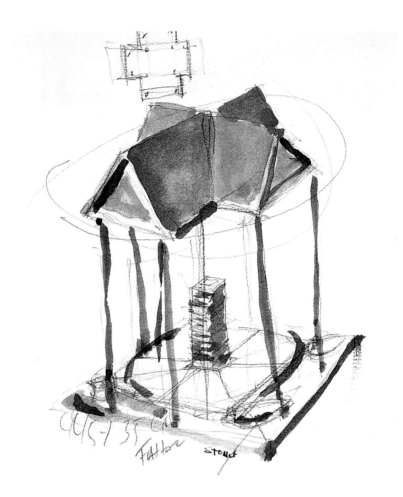

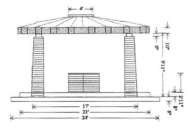

LEFT: *St. Elizabeth's church before the devastating fire of 1995.*

LORENE CARY, LONNIE GRAHAM, AND JOHN STONE

Lorene Cary, a Philadelphia native, is the award-winning author of Black Ice, The Price of a Child, *and* Pride. *She is also an acclaimed educator and the founder of Art Sanctuary, a program that brings leading African American writers, musicians, and poets to perform at the Church of the Advocate in North Philadelphia. Lonnie Graham, a photographer whose work is dedicated to "making an investment in the spiritual past," has exhibited nationally and internationally, at such institutions as the Carnegie Museum of Art, the Smithsonian Institution, and Philadelphia's Fabric Workshop. As a participant in Pittsburgh's Three Rivers Art Festival in 1995, Graham worked with residents to develop a project that included "sister" community gardens in Kenya and Pittsburgh. The work of sculptor John Stone uses found materials and combinations of everyday objects, photographs, and text to explore the history and place of the artist in society. Stone, who has worked as a construction manager for Project H.O.M.E., has exhibited at venues throughout the Philadelphia area, including the Levy Gallery at Moore College of Art and Design.—SRK*

Built into a circular platform under the sanctuary roof, a stone fountain would be visible from all directions. To connect the spiritual lives of the local residents to other places and times, the fountain would incorporate arrows directed toward marble slabs placed in the garden, in the common room, and elsewhere in the neighborhood. These slabs would bear the names of places with which residents have historical family relationships, such as small towns in North Carolina and Virginia. The artists also propose to inscribe the fountain with a phrase from Psalm 118 appropriate to Project H.O.M.E.'s mission: "The stone that the builders rejected has become the chief cornerstone."

The final component, *The Common Room: A Living Archive for Oral and Photo History*, would be housed in the church's former rectory, where Project H.O.M.E maintains its offices. Here, Graham proposes to create a photo archive of the neighborhood. Long-term plans also call for oral history programs that would encourage young people to record the narratives of older residents.

Church Lot, the artists say in summary, "is our collective response to this community's vision of art as wholly miraculous and wholly down-to-earth."—RR

BALTIMORE AVENUE IN BLOOM: AN URBAN BOTANICAL TRAIL is a project driven by the volunteer efforts of a coalition of local residents, institutions, businesses, and community organizations to make physical improvements along Baltimore Avenue in West Philadelphia. To enhance the streetscape, the group develops greening initiatives that evoke the botanical and ecological heritage of the Lower Schuylkill River basin. Baltimore Avenue in Bloom also celebrates the unique architectural and social history of its West Philadelphia neighborhood, which developed in the nineteenth century as one of the country's first "streetcar suburbs" and contains some of the country's finest Victorian architecture. Today, the trolleys that run along Baltimore Avenue remain central to the vitality of this diverse community.

Baltimore Avenue GEMs: Grand Planters, Earthbound Crow's-Nest, Midsummer's Fountain

Malcolm Cochran with Baltimore Avenue in Bloom

Not far from Baltimore Avenue, eighteenth-century botanists John and William Bartram developed an international reputation for importing botanical species to the New World and shipping American specimens abroad. Today, to improve the streetscape, Baltimore Avenue in Bloom sponsors thematic plantings in keeping with the neighborhood's heritage, mixing native species like the red maple with more exotic species such as the Japanese Zelkova tree.

Artist Malcolm Cochran understands the importance of a community's ecological past, and his work has always been inspired by the nature of the place in which it is sited. From his first meeting with Baltimore Avenue community members, Cochran says, "it was clear that a New•Land•Marks project ought to respond to the larger context of streetscape development." Working with the University City District and the City Planning Commission, Baltimore Avenue in Bloom also capitalized on a special community resource—the many architects, urban planners, and landscape architects who reside in the neighborhood. Cochran was the catalyst for convening a day-long community design charrette during which a group including twenty of these professionals took a comprehensive look at the avenue.

ABOVE: Malcolm Cochran, Grand Planter, *1999. Mixed-media rendering. Ironwork structure (with wisteria) for traffic triangle.*

When Cochran presented his initial ideas, the participants embraced certain concepts, such as visually unifying the streetscape and creating sculptures that would support the greening initiatives. However, they felt that some of his other ideas, such as a gateway arch, seemed out of scale with the residential character of the neighborhood.

The dialogue was challenging at first, but Cochran absorbed many useful and constructive suggestions. The result is his proposed *Baltimore Avenue GEMs: Grand Planters, Earthbound Crow's-Nest, Midsummer's Fountain.* A series of steel and cast-iron sculptures would serve as trellises to support flowering vines planted and maintained by community gardeners. The repetition of a lattice motif would visually unify the diverse streetscape, and the design would also refer to historic Philadelphia ironwork. Indeed, Samuel Yellin's renowned Arch Street Metalworker's Studio was located in West Philadelphia.

The *Earthbound Crow's-Nest,* in Clark Park at 43rd Street, would begin the series of *GEMs.* At this spot, residents often stand to watch for trolleys approaching on both Chester Avenue and Baltimore Avenue; then they dash for whichever trolley appears first. Besides serving trolley-watchers, Cochran's *Crow's-Nest* would incorporate view-finding elements to direct viewers' gazes to often-overlooked elements in the landscape, such as sites of local historic significance and details in the nearby Victorian architecture.

The proposal also includes two *Grand Planters,* whose shape derives from Cochran's study of table centerpieces. Like a floral arrangement at the center of a table, each *Grand Planter* would be ten to twelve feet high and would serve as a visual focal point. Cochran imagines placing the planters

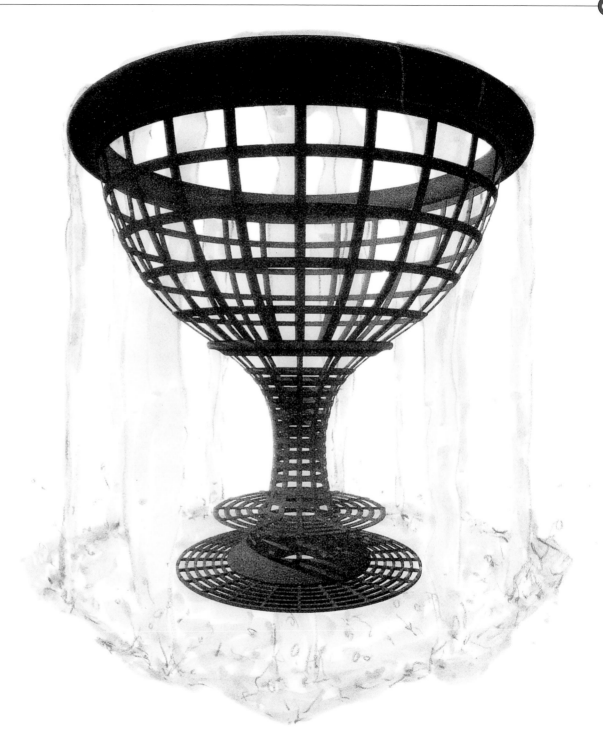

RIGHT: Malcolm Cochran, Midsummer's Fountain, 1999. Mixed-media rendering. Ironwork structure (with water) for traffic triangle.

RIGHT: Malcolm Cochran, Baltimore Avenue GEMs, 1999. Mixed-media drawing. Map with suggested locations of proposal elements.

BELOW: Malcolm Cochran, Trolley Shelter, 1999. Computer rendering.

BELOW RIGHT: Baltimore Avenue's #34 trolley at a typical traffic triangle and suggested location for Grand Planter.

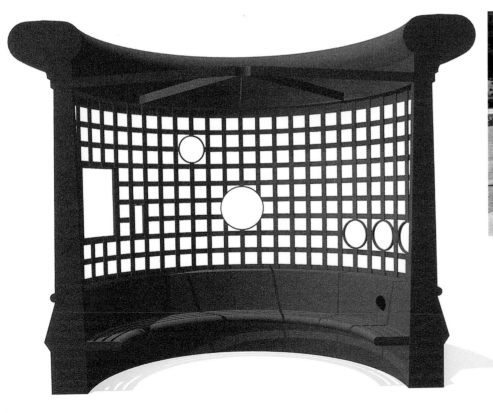

LEFT: Malcolm Cochran, Earthbound Crow's-Nest, *1999. Computer rendering. Ironwork structure proposed for Clark Park.*

on two of the triangular traffic islands formed by Baltimore Avenue as it cuts across the city's rectangular street grid.

One of the *Grand Planters*, Cochran suggests, could be connected to a water source. On special occasions the water would be turned on, creating a *Midsummer's Fountain*. Besides becoming a source of neighborhood anticipation, the fountain would capitalize on "a standing tradition of turning on fire hydrants during hot weather."

Finally, the artist proposes a series of functional trolley shelters. These would be placed at several sites along the trolley route, which plays a central role in the life of the avenue. The shelters' semicircular latticework, incorporating view-finding elements, would coordinate with the design of the other *GEMs* structures. Benches and roofs would add to the comfort of people waiting for trolleys. The shelters would also support climbing vines or other plants chosen by Baltimore Avenue in Bloom.

"In addition to supporting our greening initiatives," says community member Mike Hardy, "the project would highlight the trolley's vital role as a neighborhood developer and social connector." Overall, Cochran believes, the *GEMs* structures can "serve as catalysts for extensive renewal of the streetscape." In the long term, he hopes, they will "help establish a unique identity" for the neighborhood and evoke "the commitment to place that residents feel for their slice of the city."—CM

MALCOLM COCHRAN

Since the mid-1970s, Malcolm Cochran has created large-scale objects, installations, and site-specific works inspired by the nature of their locations or by circumstances and events in his own life. For example, Field of Corn (with Osage Oranges), *a 1994 permanent public commission in Dublin, Ohio, commemorates farmland lost to urban sprawl. Cochran's work explores the history of a site, as well as the experiences of those who know and use it. In 1995, as part of the exhibition* Prison Sentences *at Eastern State Penitentiary in Philadelphia, Cochran created* Soliloquy, *an installation evoking the experience of the prison's nineteenth-century female inmates. In 1999 the Cleveland Center for Contemporary Art and the Weston Art Gallery in Cincinnati organized a mid-career survey of Cochran's work. The Columbus Museum of Art recently exhibited* Illusions of Eden: Visions of the American Heartland, *which will travel within the United States and to Vienna and Budapest.—SRK*

THE GAY, LESBIAN, BISEXUAL, AND TRANSGENDER COMMUNITY IN ASSOCIATION WITH THE WILLIAM WAY COMMUNITY CENTER is a collection of diverse groups and individuals from throughout the city who are drawn together—culturally, politically, and socially. Although there are identifiable neighborhoods in Philadelphia where businesses and agencies that serve this community cluster, the community is not geographically bounded. The nonprofit William Way Community Center, at 13th and Spruce Streets, provides human services, cultural programming, outreach, and education and acts as a central meeting place for members of the greater Philadelphia sexual and gender minority community.

Theyareus

Ap. Gorny with the gay, lesbian, bisexual,
and transgender community in association
with the William Way Community Center

Ap. Gorny proposes a series of sculptures to commemorate events important
to the city's gay, lesbian, bisexual, and transgender citizens. His multi-sited
work, *Theyareus*, would celebrate acts of heroism and resistance and bear
witness to incidents of repression.

Comprising a great diversity of individuals, Philadelphia's gay, lesbian,
bisexual, and transgender community is unique in that it crosses all social,
political, economic, educational, racial, ethnic, and cultural boundaries.
With the passage of laws protecting the rights of sexual minorities, gay cul-
ture has become increasingly visible in recent years, and a number of
institutions have begun to serve the Philadelphia community, including the
nonprofit William Way Community Center. Yet, says community member
Tom Wilson Weinberg, "the story of this community has been suppressed
until very recently. It is hard to imagine that the Art Association's phrase
'untold histories' could resonate more with any community than it does
with ours."

Once the *New•Land•Marks* program was underway, artist Ap. Gorny
began to meet with community members to explore ways for a public art
project to inspire and inform future generations of gay citizens in Philadel-
phia. After a number of ideas were exchanged, Gorny proposed a series of

ABOVE: Ap. Gorny, Theyareus, *1999.
Computer rendering. Cartouche of sculpture
and photographic images. Proposal for a
location near Pennsylvania Hospital.*

Ap. Gorny, Theyareus (two images), *1999.*

RIGHT: Glass and paint. Experimental model.

BELOW: Computer rendering. Sculpture proposed for a location near City Hall.

stainless-steel sculptures, a "fragmented whole" that would address the community's history and "emotional geography."

At twelve inches high, each sculpture would be approximately portrait scale. They would be placed on traditionally proportioned granite pedestals carved with different interpretive texts. The sculptural forms, says the artist, would reflect "profoundly influential cosmic forces" such as the patterns found in mathematical chaos functions, deep stellar space, and sound waves. The underside of each sculpture would have a small bas-relief image based on a photograph of an event from the city's gay history. These images would commemorate instances of "courage, vulnerability, empowerment, or insight."

The sculptures would be placed in different parts of the city, near buildings that have a memorable connection to the events depicted in the photographs. The curving, highly polished steel surfaces would reflect "collapsed" images of the architecture. In this way, says Gorny, the sculptures would illustrate how the lives of gay individuals "both reflect and shape the landscape." The artwork would "add previously unacknowledged significance to city spaces." It would also raise questions about "who 'owns' public spaces, how these spaces resound in private memory, how some landmarks make a territorial claim, how certain landmarks can simultaneously commemorate and exclude."

RIGHT: Ap. Gorny, Theyareus, 1999. Computer rendering. Cartouche of sculpture and photographic images. Proposal for a location near City Hall.

RIGHT: Ap. Gorny, Theyareus, *1999.
Computer rendering. Cartouche of sculpture
and photographic image. Proposal for a
location near Independence Hall.*

BELOW: Ap. Gorny, Theyareus, *1999.
Computer rendering. Sculpture proposed for a
location near Independence Hall.*

*BELOW RIGHT: Christopher Shaw, Illustration
from* Dynamics—the Geometry of Behavior.
*Physics theories of deep space inspired the
sculptural forms of* Theyareus.

7.4.2. As with saddle cycles, these
positive CM's could correspond to sur-
faces with any *even* number of twists.
Here, the first return, R(x), is on the
same side of the fast-inset as the initial
point, x.

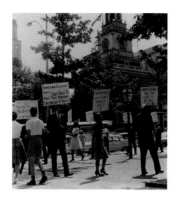

LEFT: *East Coast Homophile Organization demonstration at Independence Hall, July 4, 1965. Gorny reflects that "certain landmarks can simultaneously commemorate and exclude."*

AP. GORNY

The work of Ap. Gorny, which incorporates photography, sculpture, installation, and performance, addresses multiple issues ranging from the media's influence on the perception of gay people to affirmations of self and sexuality. Running through much of Gorny's work is an emphasis on the role that science and social institutions have played in the construction of identity and the imposition of social and sexual norms. His 1995 installation In:Visible *at the Franklin Institute Science Museum in Philadelphia explored these themes through the history of optics, and a show at Philadelphia's Locks Gallery later that year,* Aye.I.Eye, *drew on the birth of psychiatry—with its focus on self, discipline, and surveillance. Gorny's work is in numerous collections throughout the United States, including the National Gallery of Art in Washington, D.C., and the Philadelphia Museum of Art. A distinguished member of Philadelphia's arts community, Gorny recently joined the faculty of the San Francisco Art Institute in California.—SRK*

A number of sites have been initially suggested. A sculpture placed near the Family Court building could celebrate Philadelphia's landmark recognition of gay domestic partnerships, as well as the fact that many members of the gay community are parents. A site near Pennsylvania Hospital, where many people with AIDS have been treated, could acknowledge both the heroism and the horror of the epidemic. A sculpture near Independence Hall might commemorate a 1964 march that took place in front of the Liberty Bell—the city's first demonstration for equal rights for sexual minorities. Another sculpture placed opposite the Fairmount Water Works could acknowledge the importance of "Judy Garland Park," a nearby riverside gathering spot for the gay community where some members have been arrested or attacked. Other locations—from the historic Eastern State Penitentiary (see page 68, far right) to popular contemporary gathering spots—have also been discussed.

In the artist's view, a city's identity is "shaped in part by the remembrance of acts of moral and ethical imperatives." For sexual minorities in Philadelphia, however, there has been little formal encouragement to remember the past. With *Theyareus*, Gorny hopes to "annotate history's dominant narratives and interrupt its forceful silences." As Weinberg adds, the artwork should "leave a record of the struggle. We want people in the future to know the significant local events, people, and places that gave meaning and shape to our community."—RR

FRIENDS OF THE JAPANESE HOUSE AND GARDEN was incorporated as a nonprofit organization in 1982 with a mandate to assist the Fairmount Park Commission with the maintenance of Shofu-so (Pine Breeze Villa). Today, the organization actively administers the site and oversees its preservation. Committed to making Shofu-so accessible to a broad range of visitors and promoting intercultural understanding, the group also offers a lively interpretive program for diverse audiences, including educational tours and activities for schoolchildren as well as special events and classes for the general public that showcase aspects of traditional and contemporary Japanese culture. As part of its preservation program, the Friends recently organized a successful campaign to restore the Japanese House's unique bark roof.

Golden Mountain Bunka-za

Mei-ling Hom with the Friends of the Japanese House and Garden

Artist Mei-ling Hom's proposal includes both a large sculpture and a multi-purpose performance space for the future Visitors' Center of the Japanese House and Garden in West Fairmount Park.

The Japanese House, whose formal name is *Shofu-so* (Pine Breeze Villa), is a re-creation of a sixteenth-century Japanese residence. Designed by architect Yoshimura Junzo, it was exhibited at the Museum of Modern Art in New York from 1954 to 1955. Following the exhibition, *Shofu-so* was presented to the City of Philadelphia as a gift from the people of Japan. Landscaper Sano Tansai designed the surrounding formal garden.

The site in West Fairmount Park near the Horticulture Center is rich in historical associations with Japan. In 1876 the Japanese Pavilion of the Centennial Exhibition stood here, and later a Japanese garden and temple gate occupied the area. Today, the Friends of the Japanese House and Garden administer the site, coordinate tours, and offer programs to promote awareness of Japanese culture. Growing interest in *Shofu-so* has encouraged the Friends to plan a nearby Visitors' Center, which would allow increased educational and cultural programming without altering or encroaching on the historic structure. Hom proposes to integrate her performance space into the design for the Visitors' Center prepared by the architectural firm of

ABOVE: Mei-ling Hom, Bunka-za (detail), 1999. Styrofoam and cardboard model. Amphitheater seating area.

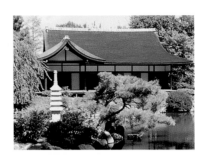

Atkin, Olshin, Lawson-Bell and Associates. The performance space would be used for many of the festival celebrations and theatrical events that the Friends present.

During a prior six-month residency in Japan, Hom was inspired by Japanese theater, and she has chosen to incorporate elements of the traditional Kabuki stage in her design. Like a Kabuki theater, *Bunka-za*—a term Hom coined from the Japanese words for culture and theater—would include a wide stage with a revolving circular section in the center. Through several trap doors in the bamboo flooring, performers could enter and exit and sets could be raised and lowered. Small side stages would accommodate musicians or narrators. At the back of the stage, a full-width projection screen could be used for stage images, shadow puppet shows, or film screenings.

Facing the stage, a garden amphitheater cut into a grassy hillside would offer intimate seating on carved granite benches set amid flowering azaleas and dwarf bamboo hedges. The amphitheater would include sculptural rock forms similar to the ones found in traditional Japanese gardens, as well as forms made of nontraditional materials such as terrazzo and pigmented concrete. By integrating plants and sculptures into the seating area, the artist hopes to create "a variety of private, contemplative seating niches" from which to enjoy a performance. At the back of the amphitheater, dense hedges would be shaped "in the profile of a mountain landscape" set against the backdrop of Fairmount Park's existing landscape.

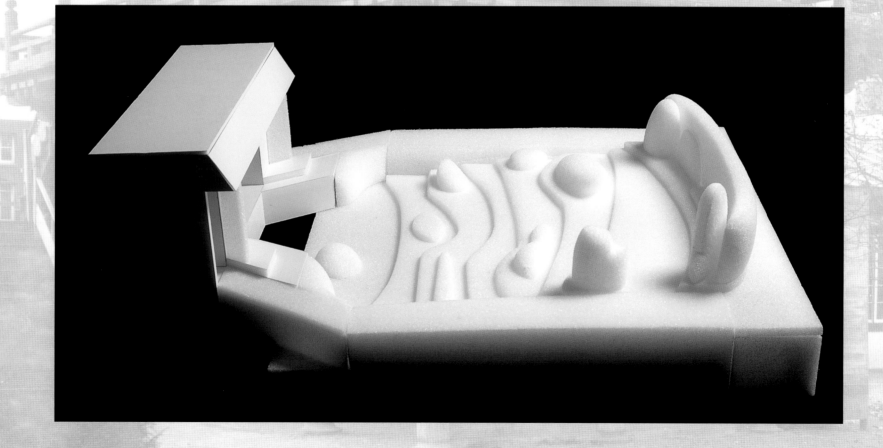

BELOW: Mei-ling Hom, Bunka-za, 1999. Styrofoam and cardboard model. Amphitheater stage and seating area.

RIGHT: Shofu-so gate.

FAR RIGHT: Detail of wall and terracotta ornament surrounding Shofu-so.

BELOW: Japanese Pavilion of the Centennial Exhibition. Built in 1876, it was the first of three buildings to occupy Shofu-so's site.

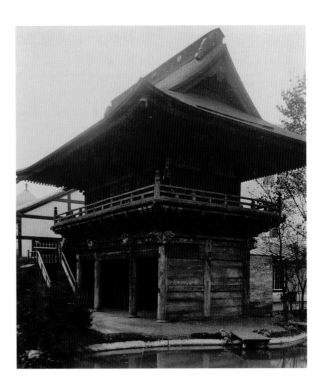

Hom's ingenious design also allows for indoor seating in cold or rainy weather. With the projection screen raised, viewers could see the stage from inside the Visitors' Center. Here, a heated section of the stone floor would seat fifty to seventy people on Japanese cushions.

In the distance beyond the amphitheater, Hom's *Golden Mountain*, a ten-foot-high bronze sculpture reminiscent of a seated Buddha, would serve as a distinctive marker for the Visitors' Center. "Golden Mountain" was a term used by early Japanese and Chinese immigrants to describe the United States, a country they saw as a land of riches and opportunity. In Hom's view, her sculpture would represent "not only those Asian immigrant dreams but also the invested lives given to the reshaping of America." Set on a crest of ground, the bronze would be visible from the Visitors' Center as well as from neighboring roadways.

According to the Friends of the Japanese House and Garden, the group is seeking a "new landmark that will tie all the historic, contemporary, and future potential of the site together." Mei-ling Hom hopes to fulfill that ambition with *Golden Mountain Bunka-za*. The work, she says, would offer a sculpture "invested with metaphorical meaning" linked to a performance space that would gain its meaning from the community itself.—RR

BELOW: Mei-ling Hom, Golden Mountain, 1999. Cast-bronze model. Ten-foot-high sculpture proposed for the hilltop above the amphitheater.

MEI-LING HOM

Through her site-specific installations, Mei-ling Hom examines the conflicts of her hybrid Chinese-American identity and addresses cultural questions shared by Asian Americans. Her recent work explores the influence of Asian cultures in America and the ways in which "their very presence transforms, redefines, and expands our ideas of American culture." Hom is also known for community collaborations in which she works with groups of Asian Americans to examine cultural identity and the changing of traditions in response to an American setting. A Philadelphia resident, Hom is the recipient of a 1999 Leeway Foundation Fellowship and a 1998 Pew Fellowship in the Arts. Her work has been featured nationally and at museums and galleries throughout Philadelphia, including the Philadelphia Museum of Art, the Pennsylvania Academy of the Fine Arts, and Temple Gallery. Hom has also received a U.S.-Japan Creative Artists Exchange Fellowship for a six-month residency in Japan.—SRK

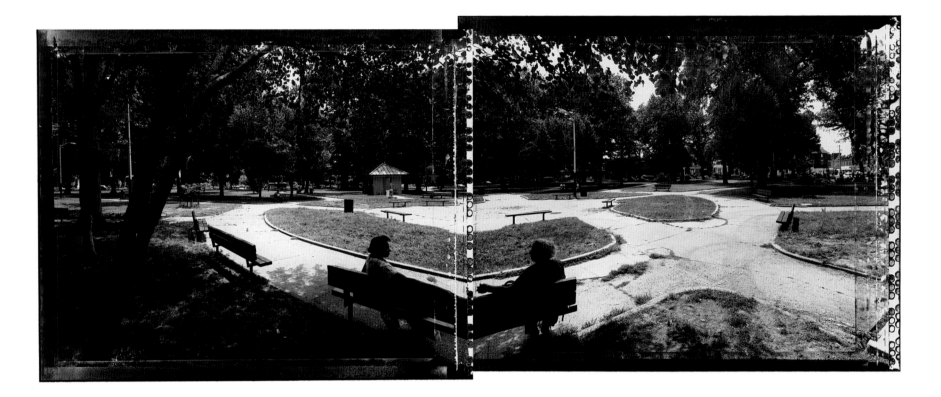

FRIENDS OF MALCOLM X MEMORIAL PARK is a group of concerned neighbors who, in cooperation with the students and teachers of the nearby Huey Elementary School, provide community support for Malcolm X Memorial Park, a Department of Recreation site located at 52nd and Pine Streets in West Philadelphia. The mission of this community organization is to reestablish the park as a focal point in the community, a gathering place where residents and visitors can come together to celebrate and appreciate one another and their neighborhood. Since 1996, the Friends have worked with the Pennsylvania Horticultural Society's Parks Revitalization Project to organize cleanups, make improvements to the park, and increase usage by neighborhood residents.

The Revitalization of Malcolm X Memorial Park

Martha Jackson-Jarvis and JoAnna Viudez with the Friends of Malcolm X Memorial Park

For many years, the teachers and students of the Huey Elementary School in West Philadelphia celebrated Earth Day on a concrete lot adjacent to the school. Meanwhile, across the street, Malcolm X Memorial Park sat vacant and cluttered with debris, its park house covered in graffiti. During this time, the park was home to illicit activities but little of a family or community nature.

Rena Ennis, whose home bordered the park, recognized potential beauty in the seven-acre site, and the restoration of Malcolm X Memorial Park became her mission. Serendipitously, Ennis met Kate Loal, a teacher at the Huey School, on a day when Loal's students were collecting cans for recycling. The two women became close friends and began to work together to revitalize the park. With assistance from the Pennsylvania Horticultural Society, Ennis and Loal established the Friends of Malcolm X Memorial Park. The effort became, in Loal's words, "a way to bring together the students, their families, and the larger community."

Through the *New•Land•Marks* program, the Friends of Malcolm X Memorial Park were introduced to sculptor Martha Jackson-Jarvis, who was immediately inspired by the park's large black oak trees. Jackson-Jarvis also empathized with the group's guiding ideals, the Nguzo Saba, or seven

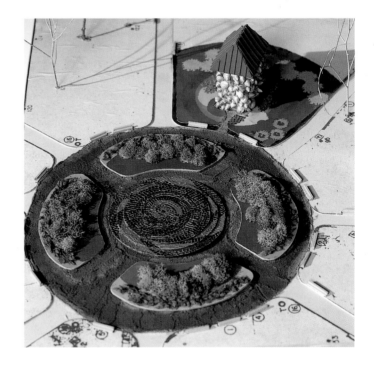

ABOVE: Martha Jackson-Jarvis and JoAnna Viudez. Revitalization of Malcolm X Memorial Park *(detail), 1999. Mixed-media model. Mosaic, plantings, and "shrine house" proposed for the park's center.*

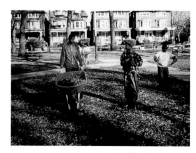

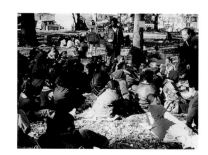

principles of Kwanzaa: Umoja (unity), Kujichagulia (self-determination), Ujima (collective work and responsibility), Ujamaa (cooperative economics), Nia (purpose), Kuumba (creativity), and Imani (faith).

To develop the *New•Land•Marks* proposal, Jackson-Jarvis joined with landscape designer JoAnna Viudez, who became equally committed to helping the park serve as "a beacon of self-determination and environmental consciousness for the West Philadelphia community." Studying the site, Jackson-Jarvis and Viudez decided to make use of the artistic vocabulary provided by the existing fence that surrounds the park. The fence is made of iron railings that pass through obelisk-shaped, concrete fence posts with pebbly surfaces. "Wonderful moments exist," the artists noted, "where railings, obelisks, and trees have grown together, evidencing a symbiotic relationship between materials and site."

These shapes and materials, as well as the "pass-through" motif, became integral to the artists' design. At each of the park's four corners, they propose to install four twelve-foot-high obelisk columns, made of cast concrete with a pebbly surface. Passing through each column near its top, rails and spirals of forged iron would form a pergola-like archway. A functional metal birdhouse would rest on top of each column. Bordering the diagonal entry path, the columns would be surrounded by beds of ground cover and flowering bulbs.

At each of the park's entrances, the artists would integrate concentric spiral railings into the existing fence. The paving, too, would bear spiral designs. For the center of the park, the artists suggest a performance space

RIGHT: Martha Jackson-Jarvis and JoAnna Viudez, Revitalization of Malcolm X Memorial Park, *1999. Computer rendering. Plan with proposed plantings.*

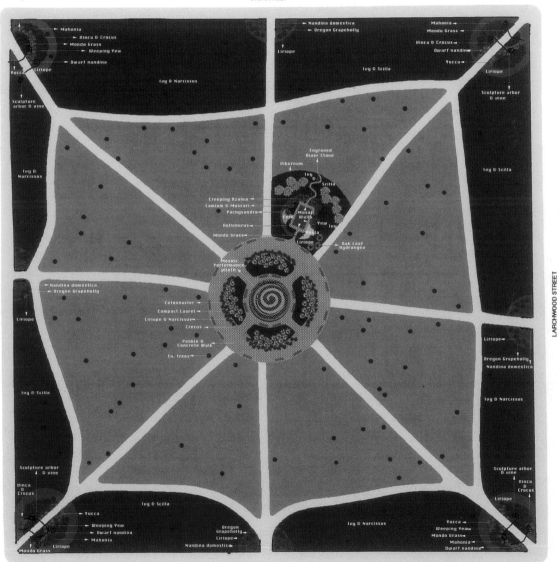

Martha Jackson-Jarvis and JoAnna Viudez,
Revitalization of Malcolm X Memorial Park
(two images), 1999. Mixed-media model.

RIGHT: Detail of one of four corner entrances.

BELOW: One quadrant of the park site.

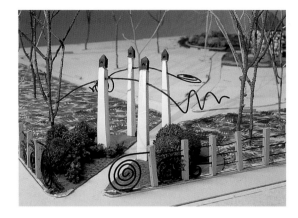

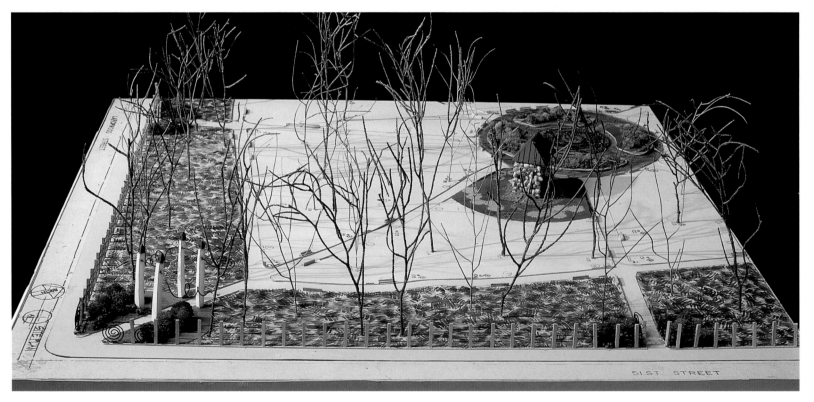

*FAR LEFT: Eric Okdeh, Mural Arts Program,
A Tribute to Rena Ennis, 1998. Painted
mural memorializes the community leader.*

*LEFT: The proposal refers to the park's
existing obelisk-shaped, concrete fence posts.*

MARTHA JACKSON-JARVIS AND JOANNA VIUDEZ

*Martha Jackson-Jarvis's work challenges
viewers "to see the place where they are
as extraordinary." Through her
sculpture, which incorporates mosaic,
ceramic, and found objects, Jackson-
Jarvis explores "the power of objects to
construct a place" that embodies the
history and experiences of a community.
She also addresses the way that issues of
identity are at once part of contemporary
life and rooted in tradition. Jackson-
Jarvis has been featured in numerous
exhibitions throughout the United States,
including Charleston, South Carolina's
1997 Spoleto Festival USA, for which she
created the site-specific sculpture* Rice,
Rattlesnakes and Rainwater. *A
comprehensive solo exhibition of her
work appeared at the Corcoran Gallery
of Art in Washington, D.C. JoAnna
Viudez, a Maryland-based sculptor and
landscape designer, participated in the
Maryland-National Capital Park and
Planning Commission's 9th Annual
Traveling Exhibition and in 1997
created the sculptural installation*
Generations *at the Smithsonian
International Gallery in Washington,
D.C.—SRK*

and amphitheater, twenty feet in diameter. On the ground of the amphitheater, an elaborate mosaic of brown and black river stones would echo the spiral pattern of the entranceways.

The park house, which stands near the park's center, already bears a mural—created by the Mural Arts Program—honoring the memory of Rena Ennis, who recently passed away. The artists propose to complement the mural with a mosaic of stone, glass, shell, and concrete. In this plan, the park house becomes a "shrine house," a jewel-like memorial to Ennis and to the children and other community members who have worked to revitalize the park.

Surrounding the park house, a forty-by-sixty-foot central garden would feature intricate designs of azaleas, hosta, hydrangeas, and bulbs. This garden would adjoin a "Kwanzaa rock garden," where a serpentine walkway, composed of large black river stones, would be engraved with the seven principles of the Nguzo Saba.

Throughout the park, beds of ivy and flowering bulbs would add texture and color and help to unify the landscaped areas. A sense of unity would also arise from the repetition of shapes and materials. Even the birdhouses would echo the form of the roof of the "shrine house." By these means, Jackson-Jarvis and Viudez hope to create a sense of Malcolm X Memorial Park as a "destination" and a "special place," a true community landmark.—RR

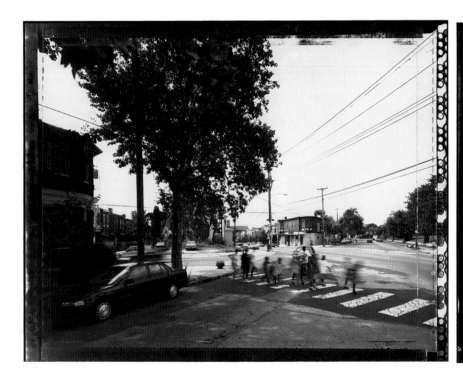
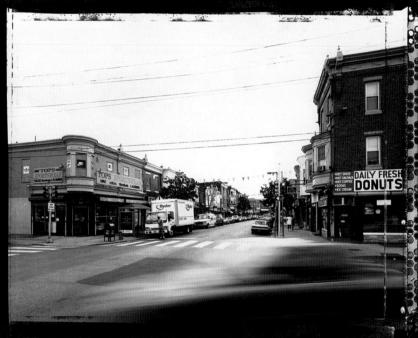

THE ALLEGHENY WEST FOUNDATION is a nonprofit community development corporation working to revitalize the area of North Philadelphia bounded by 17th Street to the east, Ridge Avenue to the west, Lehigh Avenue to the south, and Westmoreland Street to the north. Organized in 1968 and incorporated in 1974, the Foundation is one of the city's oldest CDCs. Allegheny West works in cooperation with local businesses, community groups, and government agencies to improve the quality of life for area residents by developing affordable housing, promoting local economic and commercial development, and improving health and social services. The Foundation also offers job training and academic enrichment programs for neighborhood youth.

Bright Light Trail

Zevilla Jackson Preston with The Allegheny West Foundation

For more than three decades, The Allegheny West Foundation has sponsored programs to improve housing, education, and economic development within its North Philadelphia community. The neighborhood also boasts more than twenty civic associations. Yet, until the *New•Land•Marks* program began, little thought had been given to works of public art. As one resident commented in a public meeting, "Allegheny West has no art whatsoever. No carvings, no figures … nothing that reflects our neighborhood or engages and enlightens our residents."

The Foundation has long worked to ease tensions among the diverse civic groups. Ronald Hinton, President of The Allegheny West Foundation, felt that a *New•Land•Marks* project might "unify the communities around a single vision." Through *New•Land•Marks*, architect Zevilla Jackson Preston joined with the Foundation to explore ways to celebrate the neighborhood and unite the disparate civic associations. Residents, too, began to see art's potential for inspiring community identity.

For Jackson Preston, special inspiration came from the children of Allegheny West. "When I first came to the community," she remembers, "the children kept asking me, 'Are you a Bright Light? Are you a Bright Light?' Finally, I asked, 'What is a Bright Light?' They explained to me that

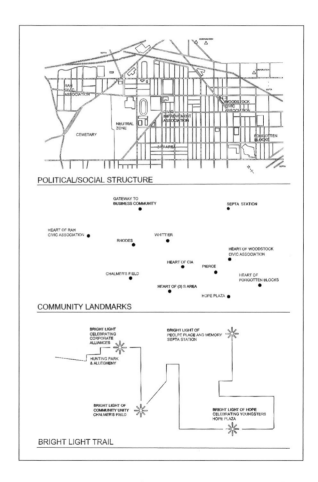

ABOVE: Zevilla Jackson Preston, Bright Light Trail, 1999. Computer rendering. Schematic relates characteristics of Allegheny West to the Bright Light Trail.

RIGHT: Neighborhood children at New•Land•Marks workshop.

FAR RIGHT: Zevilla Jackson Preston facilitates a community design charrette.

BELOW: Zevilla Jackson Preston, Bright Light, *1999. Computer rendering.*

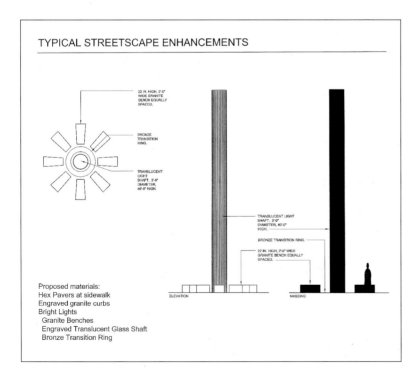

TYPICAL STREETSCAPE ENHANCEMENTS

22 IN. HIGH, 2'-0" WIDE GRANITE BENCH EQUALLY SPACED.

BRONZE TRANSITION RING.

TRANSLUCENT LIGHT SHAFT, 3'-0" DIAMETER, 40'-0" HIGH.

TRANSLUCENT LIGHT SHAFT, 3'-0" DIAMETER, 40'-0" HIGH.

BRONZE TRANSITION RING.

22 IN. HIGH, 2'-0" WIDE GRANITE BENCH EQUALLY SPACED.

ELEVATION MASSING

Proposed materials:
Hex Pavers at sidewalk
Engraved granite curbs
Bright Lights
 Granite Benches
 Engraved Translucent Glass Shaft
 Bronze Transition Ring

there is a Bright Light Society for children who are achieving in school and in their community. A Bright Light refers to anyone with a passion for learning, reading, sharing knowledge, and being helpful. Last but not least, a Bright Light is one who is an example to all. It means a lot to the young people and the parents to say, 'I am a Bright Light.'"

With this impetus, Jackson Preston conceived *Bright Light Trail*, a 20,000-foot path to celebrate those who have demonstrated leadership in the community. Beginning at the Southeastern Pennsylvania Transportation Authority (SEPTA) station at 22nd Street and Allegheny Avenue, the sidewalk trail would follow a winding route through the neighborhood, ending at the corner of Ridge Avenue and Clearfield Street. All along this path, the sidewalks would be formed of colorful hexagonal pavers. Granite curbs would be inscribed with the inspirational thoughts and memories of community residents. Punctuating the trail, four tall light shafts—the *Bright Lights*—would rise at significant points in the community.

Each *Bright Light* would consist of an approximately thirty-foot illuminated shaft. Around the base, granite benches arranged in a circular pattern would provide "respite and a place of meditation." Bronze would be used for a "transition ring" between the shaft and the benches. Each shaft would

Zevilla Jackson Preston, Bright Light Trail *(two images), 1999.*

RIGHT: Mixed-media collage. Group rendering of the Bright Light Trail created at the community charrette.

BELOW: Mixed-media collage. Aerial view of Allegheny West highlighting community landmarks.

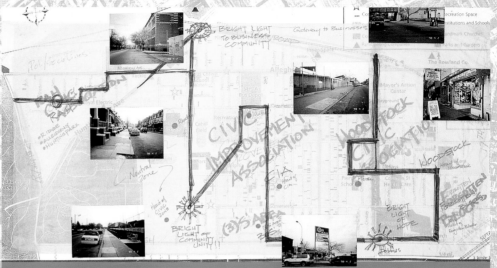

ALLEGHENY WEST FOUNDATION COMMUNITY CHARRETTE

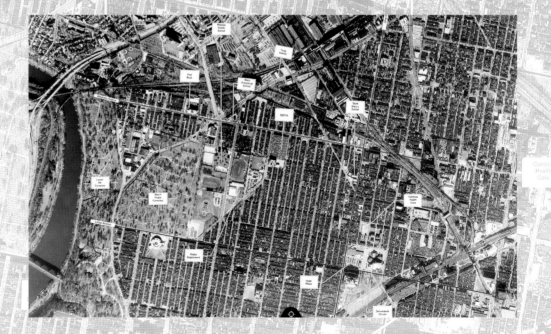

RIGHT: A typical residential street in Allegheny West.

BELOW: Zevilla Jackson Preston, Bright Light Trail, 1999. Wood and cardboard model.

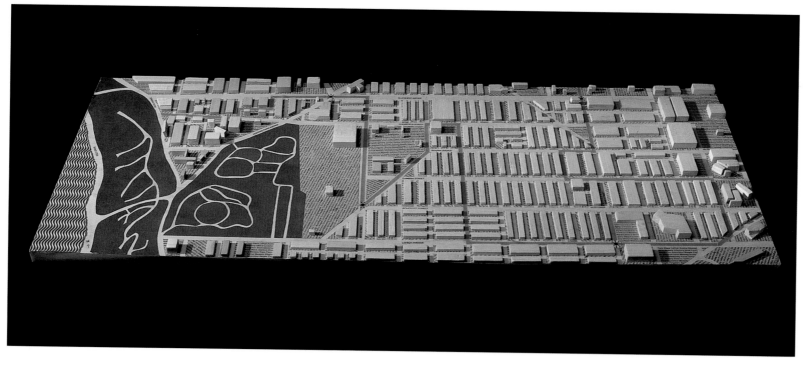

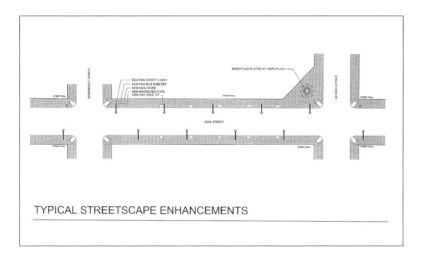

TYPICAL STREETSCAPE ENHANCEMENTS

bear inscriptions—either the names of local individuals and community groups or appropriate quotations.

In Jackson Preston's plans, the *Bright Light of People, Place, and Memory*, located at the SEPTA station, marks the beginning of the trail with inscriptions celebrating community history. The *Bright Light of Hope Celebrating Youngsters* includes the names of children "who have proven to be examples to all." *The Bright Light of Community Unity* commemorates local civic organizations and groups that are committed to community development. Finally, the *Bright Light Celebrating Corporate Alliances* honors local businesses that have shown dedication in "working with residents and local community groups to ensure a better tomorrow for all."

During a community design charrette, Jackson Preston posed this question to community members: "If you could change the nature of public space in Allegheny West, how would you change it?" One resident responded, "I would make the space informative and positive. The space should spark an interest in all people for different reasons." That is what Jackson Preston intends to accomplish with her *New•Land•Marks* project. She sums up her proposed work as "20,000 linear feet of a community's history, memories, sense of place, and *Bright Lights*."—RR

ZEVILLA JACKSON PRESTON

Zevilla Jackson Preston is an architect and principal of J-P Design Group, Inc., in New York City. A lifelong resident of Harlem, Jackson Preston is concerned about the urban built environment, and she explores planning and preservation strategies to improve the quality of life in minority communities. In 1998, Jackson Preston participated in a design team, organized by New York City's Cityscape Institute, that created a streetscape plan for 110th Street in Harlem—the northern edge of Central Park. The plan uses recurring design elements such as "memorial mats" installed in the sidewalk to create a unified "gateway to Harlem" and to celebrate the area's cultural history. The plan also addresses issues of safety, maintenance, and public access to the park. Jackson Preston was featured in Landscape Architecture *magazine for her work on this project.—SRK*

FRIENDS OF ELMWOOD PARK is a community organization comprised of neighbors whose homes border Elmwood Park, a seven-acre Department of Recreation site located in Southwest Philadelphia at 71st Street and Buist Avenue. Founded in 1995 to maintain and revitalize the park, the organization has raised funds to finance a police bicycle patrol and has established an award-winning town watch program. Participating in the Pennsylvania Horticultural Society's Parks Revitalization Project (in cooperation with the Department of Recreation), the Friends have made major physical improvements to the site. The group continues to work with the Horticultural Society to offer educational programs to local youth.

A Century of Labor

John Kindness with the Friends of Elmwood Park

From the late nineteenth century through much of the twentieth, Southwest Philadelphia prided itself on its thriving working-class neighborhoods. Many thousands of Philadelphians raised their families here. They worked for major industries such as the Hog Island Shipyard, Fels Naphtha, General Electric, and Westinghouse.

At that time, the seven-acre Elmwood Park was the centerpiece of the community—a gathering place where workers and their families could relax, socialize, and enjoy the park's natural resources. Unfortunately, as business and industry departed from the area, so did many of the residents, and Elmwood Park suffered a long period of neglect. Since 1995, however, the Friends of Elmwood Park have been dedicated to revitalizing the site.

Many of the Friends of Elmwood Park are laborers, as were their parents and grandparents. The *New•Land•Marks* program introduced the Elmwood community to Irish artist John Kindness, whose father had been a shipbuilder in Belfast. Together, Kindness and the Friends agreed that the *New•Land•Marks* project should memorialize and celebrate the working class in Southwest Philadelphia, while educating, inspiring, and instilling pride in all community members who visit the park.

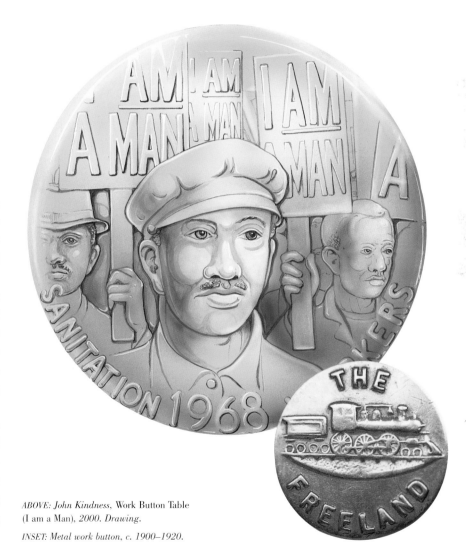

ABOVE: *John Kindness,* Work Button Table (I am a Man), *2000. Drawing.*

INSET: *Metal work button, c. 1900–1920.*

RIGHT: A community site visit in Elmwood Park.

FAR RIGHT: Kindness meets with community representatives.

BELOW: Female gear workers at a South Philadelphia factory in 1919.

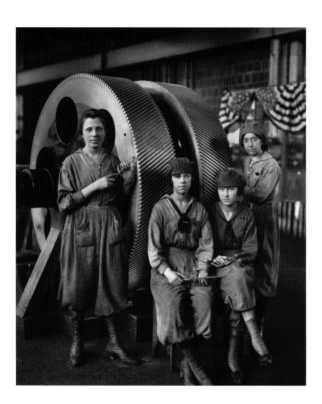

From his first visit, Kindness became aware that the park lacked a central gathering area. "There was nowhere in the park," he noted, "for a group of people to sit down and discuss anything; most of the park meetings seemed to take place in houses." He focused, therefore, on the creation of seating areas for the central area of the park.

Searching for a metaphor to symbolize the project, Kindness considered the typical uniforms worn by laborers, a common denominator regardless of trade or skill. He also learned that laborers of earlier generations often wore clothing with metal work buttons that bore a variety of interesting images: birds, elephants, trees, steam trains. These thematic explorations coalesced in his plan for *A Century of Labor.*

The center of Elmwood Park is laid out in the shape of a barbell: two circular areas with a connecting path. Kindness proposes that one of these areas be designed as a meeting or discussion place. Seven wooden benches around the perimeter would face seven circular bronze tables, each three feet in diameter. The tables would bear work-button images in low relief, commemorating important moments in trade union history. The interior area would be paved with a "denim-blue resin-bonded aggregate" resembling the color of work uniforms, crossed by terracotta pavers suggesting the orange stitching on workers' jeans.

In the other circular area, which would be dedicated to individual contemplation, the benches would face outward rather than inward. During his research, Kindness came across many striking historical photographs of

John Kindness, A Century of Labor *(three images)*, 1999. *Mixed-media drawings.*

RIGHT: Plan of barbell-shaped park center with proposed seating areas.

BELOW RIGHT: Benches facing outward.

BELOW FAR RIGHT: Work Button Tables *with seating facing inward.*

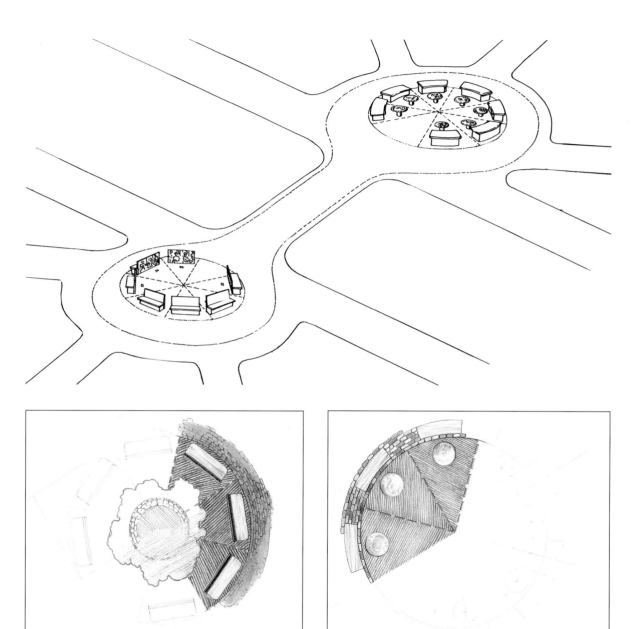

RIGHT: Metal work button, c. 1900–1920.

John Kindness, Work Button Tables *(four images), 1999. Mixed-media drawings.*

RIGHT, TOP TO BOTTOM: Brill Company, *preliminary design;* Iron Molders *and* Wobblies, *two proposed table tops.*

BELOW: Side view of typical table.

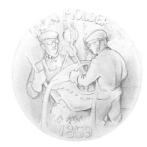

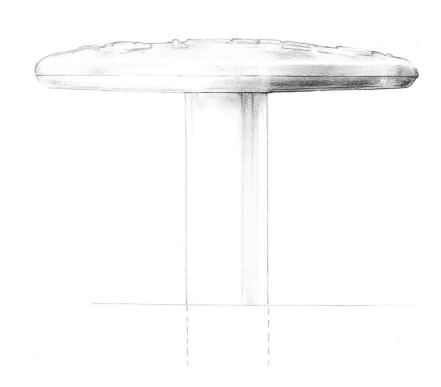

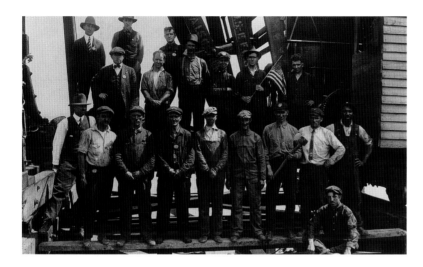

LEFT: Workers from South Philadelphia's Hog Island Shipyard in 1918.

laborers in their work environments. A selection of historic images will illustrate the "century of labor" theme. Each photo would be fired in porcelain enamel on a steel panel and mounted on the back of one of the outward-facing benches. Thus the inside of the circle would form a small photo gallery.

Each cluster of benches would have an opening at the path that joins the circular areas, so that visitors would sense the thematic connection between the two seating arrangements. The path would be paved in recycled Belgian blocks, large blue-gray cobblestones brought to the United States as ballast in ships from Europe and once used extensively as paving in the city. Timber for the benches would be salvaged from a tree that once stood in the park, an old oak destroyed by lightning. A small brand or stamp on each bench would inform park visitors of the source of the lumber. At night, overhead lighting would illuminate the work-button tables and photographic panels.

The Friends of Elmwood Park intend to reach out to labor organizations across the country to request help in realizing this proposal. "Philadelphia is the center of democracy, so it stands to reason that it would be a center of organized labor," says local resident Cathy Brady. "Without a doubt, our working-class community would be a fitting site for such a monument."—RR

JOHN KINDNESS

John Kindness, who lives and works in Ireland, addresses aspects of daily life through his work by collecting objects and souvenirs from a site and then using them "to reflect or reinforce" the identity of the place. Conscious of what he terms the "delight factor," Kindness uses a variety of techniques, including mosaic, fresco, and painting, to create work that subtly comments on contemporary culture while remaining pleasing and accessible to a wide audience. Through a joint project between Philadelphia's Institute of Contemporary Art and the Fleisher Art Memorial, Kindness created a series of frescoes inspired by morning walks in Philadelphia's Italian Market. The frescoes formed part of a 1997 solo exhibition at the Institute of Contemporary Art. Kindness has also exhibited extensively in Ireland and has participated in several shows in New York, most recently at the Drawing Center. He is a 2001 recipient of the British School at Rome's Sargant Fellowship.—SRK

PENNYPACK ENVIRONMENTAL CENTER ADVISORY COUNCIL is a volunteer organization formed in 1974 to support the operation and growth of the Pennypack Environmental Center. Located on a 100-acre site in Pennypack Park, in the northeast section of the Fairmount Park System, the Center offers programs that foster respect for nature and provide opportunities to enjoy a protected natural area. As part of its mission to inspire future generations to conserve and protect our environment, the Center provides residents of Philadelphia with access to nature trails, as well as a wide variety of environmental programs, including stream exploration, botany walks, and wildlife observation. Through the Fairmount Park Commission's Natural Lands Restoration and Environmental Education Program, the Center plans to enlarge its facilities and expand its activities.

Embodying Thoreau: dwelling, sitting, watching

Ed Levine with the Pennypack Environmental Center Advisory Council

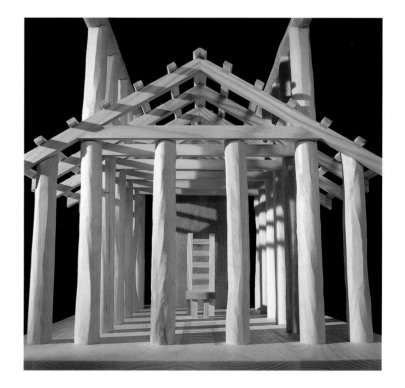

ABOVE: *Ed Levine,* Thoreau's Hut, *2000. Wood model. Interior view with seat and symbolic hearth.*

Pennypack Park, part of the extensive city park system overseen by the Fairmount Park Commission, follows the winding path of Pennypack Creek through Northeast Philadelphia. The Commission's Natural Lands Restoration and Environmental Program is overseeing improvements to the park's environmental center on Veree Road.

In 1992 the Pennypack Environmental Center Advisory Council and the Art Association discussed Pennypack as a possible site for Martin Puryear's *Pavilion in the Trees* (see page 19). Although another site was eventually chosen for Puryear's sculpture, the Advisory Council enthusiastically came forward again when the opportunity to participate in *New•Land•Marks* arose. "The Northeast has very little in the way of public art," says Margaret Shire, a member of the Advisory Council. "We deserve some artwork." The group desired a work of art that would reflect its mission to "inspire future generations to conserve and protect our environment."

After meeting with the Advisory Council and other community members, artist Ed Levine proposed *Embodying Thoreau: dwelling, sitting, watching,* a work inspired by the nineteenth-century author of *Walden,* Henry David Thoreau, whom Levine calls "the first American writer to imaginatively investigate the importance of our natural world." The artist was struck by

RIGHT: Ed Levine, Benches, *1999–2000. Wood models.*

BELOW: Ed Levine, Bird Blind, *1999–2000. Wood model.*

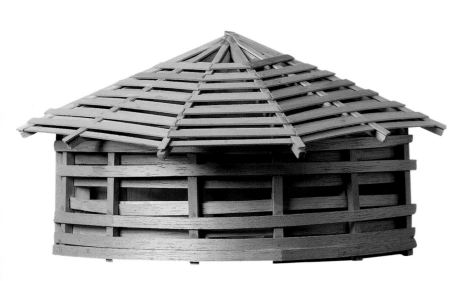

the similarity between Thoreau's values and those expressed by the park community. Thoreau "wrote about our need to observe, study, and relate to [natural] forces both outside and inside ourselves," Levine explains. "He also understood the need to move between the everyday world and the natural world. In other words, he saw and expressed the dynamic relationship between culture and nature."

The artist's proposal calls for a series of three interrelated wooden structures, located at different sites in the park and exploring different aspects of humanity's relationship to nature. One structure, *Thoreau's Hut*, would emphasize the human place within the natural world. Echoing the dimensions of Thoreau's cabin at Walden Pond in Massachusetts (ten feet by fifteen feet), the structure would be open to the elements. There would be seating inside, and a "symbolic hearth" would represent the hearth in Thoreau's cabin. Just as Thoreau's cabin was within earshot of a nearby rail line, the sounds of a local roadway would be audible from *Thoreau's Hut*— another reminder of the relationship between nature and culture.

At a nearby site, Levine plans three *Benches* to place visitors "in a social and personal relationship to the park." Facing one another, the *Benches* would suggest a family—two larger ones for adults and a smaller one for a child. Tilted back slightly, they would invite a view of the sky as well as the land. All would be relatively big for their intended occupants, and their size, says Levine, would "make the sitter aware of the scale of the

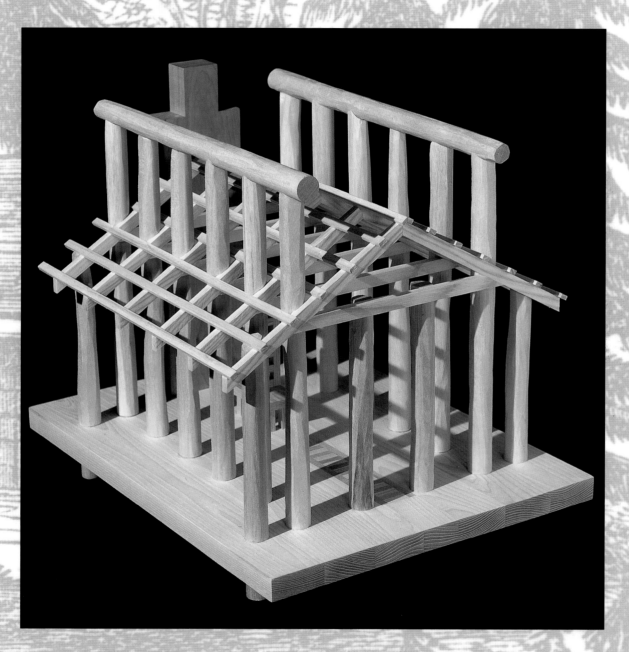

RIGHT: *Ed Levine*, Thoreau's Hut, *2000. Wood model. The proposed structure is informed by Henry David Thoreau's cabin at Walden Pond.*

RIGHT: Proposed site for Thoreau's Hut.

BELOW: Roland Williams, Map of Fallen Timbers in the Pennypack, *1999. Drawing.*

BELOW RIGHT: Ed Levine, Thoreau's Hut, *1998. Computer rendering.*

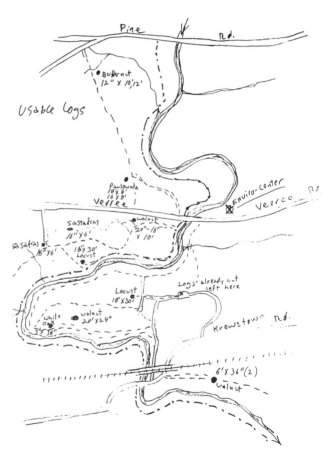

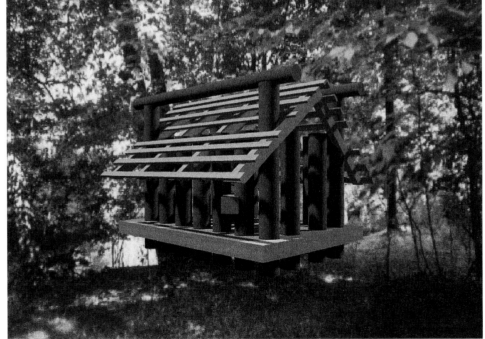

LEFT: 1854 wood engraving of Thoreau's Cabin at Walden Pond, *after a drawing by Sophia Thoreau from the original edition of* Walden; or, Life in the Woods.

body in contrast to the surroundings. The *Benches* become monumental in relationship to our bodies."

Levine's final proposed structure, the *Bird Blind*, would replace a temporary blind for bird watchers. At this site (see page 98), the artist hopes to encourage visitors to investigate human relationships with birds and other animals. Birds in particular "give us an awareness of our inherent rootedness in the earth and our desire to transcend it," notes Levine. But "to pay attention to them we need to find a way of letting them be, of reducing our presence." To convey both our connection with and our separation from other creatures, the artist plans to use two "structural systems." The interior of *Bird Blind*—the human side—would reflect standard architecture, but the exterior would be woven like a nest. "The two systems," he says, would "establish the different worlds we inhabit and the means through which we form these worlds."

All three structures, which Levine characterizes as "between sculpture and architecture," could make use of lumber recycled from the park's fallen trees. *Embodying Thoreau* would be integrated into the programs of the Pennypack Environmental Center, but the structures would also invite exploration by visitors taking casual walks through the park.—CM

ED LEVINE

Ed Levine has had a long and distinguished career as an artist, thinker, and educator. On his farm in Vermont, he has built a series of works that he calls Settlement: A conversation between art and water and the land. Settlement *serves as a laboratory for his constructions, which use active water features to explore the physical and kinetic properties of air, landscape, and water. These structures heighten the viewer's awareness of the interconnectedness of water with our lives and the landscape. Levine teaches at the Massachusetts Institute of Technology, where he formerly served as director of the Visual Arts Program. He has exhibited in many museums and other venues throughout the United States, including the Southeastern Center for Contemporary Art in Winston-Salem, North Carolina; the Atlanta Arts Festival; the Artists Space in New York; and the Minneapolis College of Art and Design. His* Floating Rocks: Looking into Time *was commissioned for Pusan, Korea.—SRK*

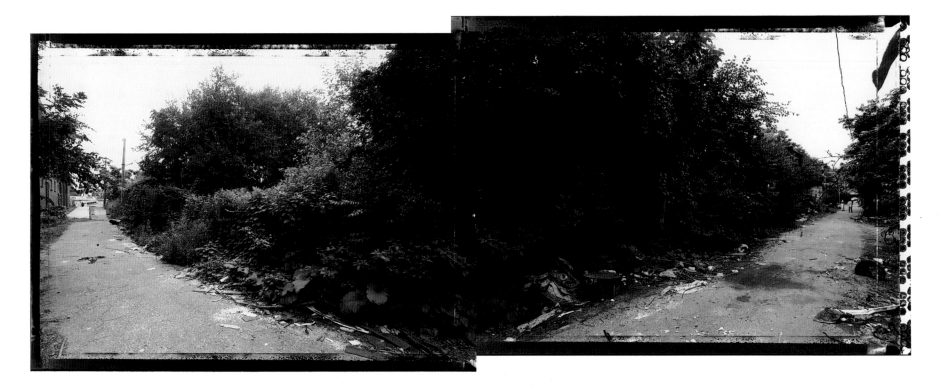

MILL CREEK ARTISTS' COLLABORATIVE is a diverse group of artists, educators, activists, and citizens formed to unite residents of West Philadelphia's neighborhoods. Located in the West Philadelphia Empowerment Zone and inspired by Professor Anne Spirn's West Philadelphia Landscape Plan, the group celebrates the life and resources of the Mill Creek watershed. Collaborative members have actively participated in neighborhood garden initiatives, a community school for adult learners, and a learning community for children at the Sulzberger Middle School. By taking part in the West Philadelphia Empowerment Zone's Welcoming Urban Landscape Project and the Pennsylvania Horticultural Society's Parks Revitalization Project at Carroll Park, Collaborative members are taking steps to beautify the community through cleanups, planting, and a number of blight-removal activities.

May Street: A Place of Remembrance and Honor

Rick Lowe and Deborah Grotfeldt

with the Mill Creek Artists' Collaborative

May Street is a quarter-mile-long residential block in West Philadelphia. Until a generation ago, the block formed part of a flourishing working-class neighborhood. Because of its proximity to nearby schools, community centers, and businesses, May Street was a popular pedestrian shortcut for neighborhood children and adults. But as the areas surrounding May Street began to deteriorate, families relocated. Vacant homes became a haven for illicit activities. Some houses were torn down, and the empty lots became dump sites for trash and abandoned cars. May Street came to be seen as unsafe, and most community members began to avoid it.

When artists Rick Lowe and Deborah Grotfeldt first visited Philadelphia for the *New•Land•Marks* program, representatives of the Mill Creek Artists' Collaborative pointed out a number of sites that might inspire a public art project, and they noted that Mill Creek itself could be a powerful metaphor for the process. Now buried underground, the creek once flowed freely through West Philadelphia, touching many different neighborhoods. Using the creek as a "literal and symbolic thread," the residents suggested, a public art project could "celebrate the natural and cultural history and traditions of the place and its people," and help community members "imagine and shape the future." The neighborhood's vitality, now "buried" like the creek, could reemerge.

Rick Lowe and Deborah Grotfeldt, May Street: A Place of Remembrance and Honor *(two documents), 1999. Mixed-media collage. Entrance to May Street before (TOP) and after (BOTTOM) proposed improvements.*

RIGHT: *Rick Lowe discusses the project with community participants.*

BELOW: *Rick Lowe and Deborah Grotfeldt, May Street: A Place of Remembrance and Honor, 1999. Mixed-media collage. May Street before proposed improvements.*

May Street seemed a perfect choice for such purposes. The block lies in the heart of West Philadelphia, and it offers a clearly defined geographic area of manageable size. The Mill Creek Cultural Center is nearby, as are schools, churches, and other community organizations. The artists also observed that community members "talk to each other in passing, wave to one another as they pass by in cars, call each other by name, and demonstrate the closeness, familiarity, and affection that are normally associated with small towns." These considerations led Lowe and Grotfeldt to propose *May Street: A Place of Remembrance and Honor*, an ongoing, multiphase, environmental public art project.

With community support, vacant lots would be planted and transformed into areas for both play and contemplation. Empty buildings would be restored and converted into studio spaces for artists. Weeds, trash, and abandoned automobiles would give way to gardens, landscaping, and benches. Murals and other artists' interventions would add color and meaning to the area. Revitalized, May Street would again provide a safe shortcut for children on their way to school or to the Mill Creek Cultural Center.

The project would draw heavily on the talents of local residents. As community members explained, "There are many artists now living in the

BELOW: *Rick Lowe and Deborah Grotfeldt,* May Street: A Place of Remembrance and Honor, *1999. Mixed-media collage. May Street after proposed improvements.*

Vacant and open spaces can be used to develop play areas, Quiet spaces, or gardens. After clean ups, the open spaces need to be used immediately. Gardens can be quickly developed as either herb paces.

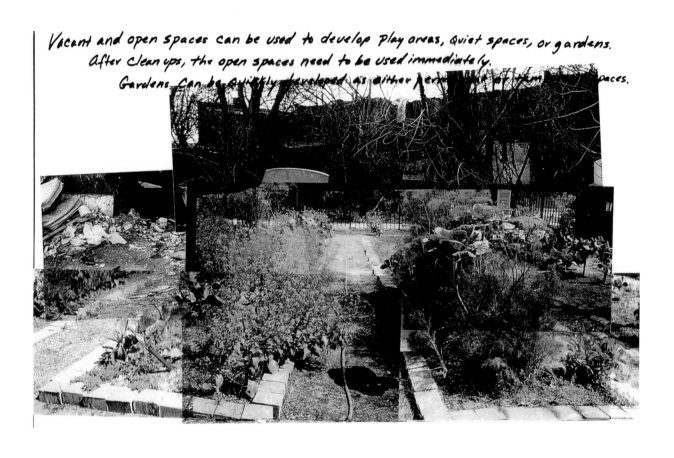

RIGHT: Street sign at the Westminster Avenue entrance to May Street.

BELOW: Rick Lowe and Deborah Grotfeldt, May Street: A Place of Remembrance and Honor, 1999. Mixed-media collage. Map of the area around May Street with ownership and tax information.

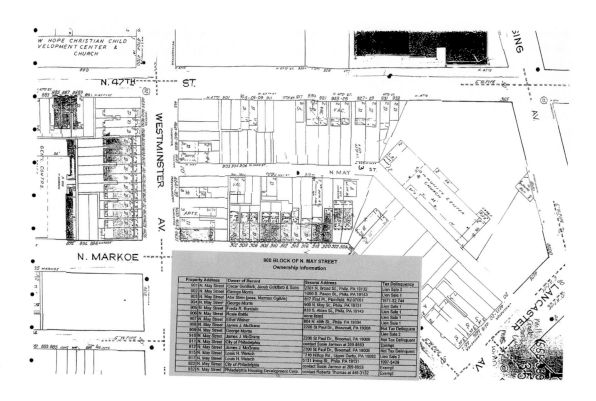

900 BLOCK OF N. MAY STREET
Ownership Information

Property Address	Owner of Record	Second Address	Tax Delinquency
901 N. May Street	Oscar Goldfarb, Jacob Goldfarb & Sons	2301 N. Broad St., Phila. PA 19132	Lien Sale 3
902 N. May Street	George Morris	1050 S. Paxon St., Phila. PA 19143	Lien Sale 1
903 N. May Street	Abe Stein (poss. Norman Ogilvie)	617 First Pl., Plainfield, NJ 07061	1971-52,744
904 N. May Street	George Morris	909 N. May St., Phila. PA 19131	Lien Sale 1
905 N. May Street	Freda R. Burstein	833 S. Alden St., Phila. PA 19143	Lien Sale 1
906 N. May Street	Rosie Battle	none listed	Lien Sale 1
907 N. May Street	Ethel Weiner	804 N. 46th St., Phila. PA 19104	Lien Sale 1
908 N. May Street	James J. McGrane	2206 St Paul Dr., Broomall, PA 19008	Not Tax Delinquent
909 N. May Street	George Morris		Lien Sale 2
910 N. May Street	James J. McGrane	2206 St Paul Dr., Broomall, PA 19008	Not Tax Delinquent
911 N. May Street	City of Philadelphia	contact Susie Jarmon at 209-8853	Exempt
912 N. May Street	James J. McGrane	2206 St Paul Dr., Broomall, PA 19008	Not Tax Delinquent
915 N. May Street	Louis H. Welsch	216 Hilltop Rd., Upper Darby, PA 19082	Lien Sale 2
917 N. May Street	Louis H. Welsch	5131 Irving St., Phila. PA 19131	1997-5426
922 N. May Street	City of Philadelphia	contact Susie Jarmon at 209-8853	Exempt
932 N. May Street	Philadelphia Housing Development Corp.	contact Roberta Thomas at 448-3132	Exempt

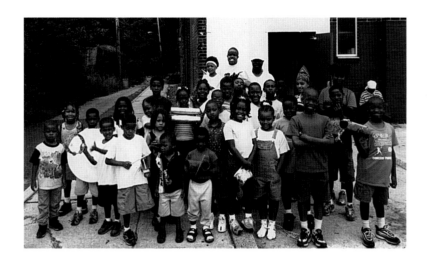

community: sculptors, painters, photographers, printmakers, muralists, jewelry makers, fabric artists, tie-dye artists, cartoonists, dollmakers, hair braiders, garden designers," and more. As the project develops, multiple ways should emerge for these artists to contribute, under the sponsorship of the recently formed Mill Creek Artists' Collaborative. Children from the local schools, along with their parents, would also help develop the gardens and play areas. Events such as annual festivals and exhibitions would unite local artists with those from outside the community.

Lowe and Grotfeldt believe that the "art" of the project would consist of much more than the visible objects it produced. "The art is the process—it's the experience, it's working with the community," Grotfeldt explains. Similarly, Lowe speaks of the "opportunity for the community to say that we care about this particular area. That's the challenge. That's where the art is." Local activist Zakiyyah Ali adds, "Truly, the art in our community is a living art."

Like the vigorous creek that once flowed here, May Street would become, in Lowe's words, "a vibrant, colorful, nurturing corridor connecting members of the community." In the long run, Lowe and Grotfeldt believe, the project could inspire revitalization efforts extending beyond May Street to other sections of West Philadelphia.—RR

RICK LOWE AND DEBORAH GROTFELDT

"Our world and communities around us are deserving of forms that are filled with aesthetic value," believe Rick Lowe and Deborah Grotfeldt. Lowe was the driving force behind Project Row Houses, *a unique project combining public art with community services in Houston, Texas. Grotfeldt was* Project Row Houses' *first Executive Director. Since the project's inception in 1992, the team has coordinated the acquisition and renovation of twenty-two historic "shot-gun" houses located in a two-block area of Houston's troubled Third Ward. Today the houses provide studio and exhibition spaces for artists, housing for single mothers, and facilities for educational and social service programs. Lowe, a painter and educator, and Grotfeldt, an arts administrator and photographer, are currently working on a project for the Watts Towers neighborhood in Los Angeles. The project will include fencing to create a unified neighborhood aesthetic, as well as a rehabilitated warehouse to house artists' spaces.—SRK*

VIETNAMESE UNITED NATIONAL ASSOCIATION OF GREATER PHILADELPHIA is a community organization that provides support to Vietnamese immigrants in the greater Philadelphia area. The organization offers social services to promote self-sufficiency among the Vietnamese population and to assist immigrants as they make the transition to life in the United States. The Association also offers cultural programs designed to celebrate Vietnamese culture and to promote understanding and appreciation among diverse ethnic communities.

The Vietnamese Monument to Immigration

Darlene Nguyen-Ely with the Vietnamese United National Association of Greater Philadelphia

In recent years, the Vietnamese community has added a dynamic new layer of culture to Philadelphia. "Before 1975, few Vietnamese lived in this country," relates Cuong Pham of the Vietnamese United National Association (VUNA). "After the fall of South Vietnam, the population increased with the waves of refugees called 'boat people,' who had escaped the communist regime." Since then, the Vietnamese community has grown to more than 40,000 people in Philadelphia and bordering counties.

Considering how their community might inspire a work of art, members of VUNA decided that the chief inspiration would come from the youngest and oldest individuals in the community. "Our children build upon our ongoing histories with their new explorations and endeavors. Our elders relay our history and cultural heritage and provide us with important values to live by." Thus the group hopes to create a landmark "that links our past to our present and future."

After visiting the Vietnamese community in Philadelphia, Seattle-based artist Darlene Nguyen-Ely made a preliminary proposal. She was inspired by the folk festival Tet Trung Thu, a major Vietnamese holiday based on a folktale about the moon fairy. This mid-autumn festival is chiefly dedicated to children, who make elaborate, decorated lanterns, sing songs, and perform dances.

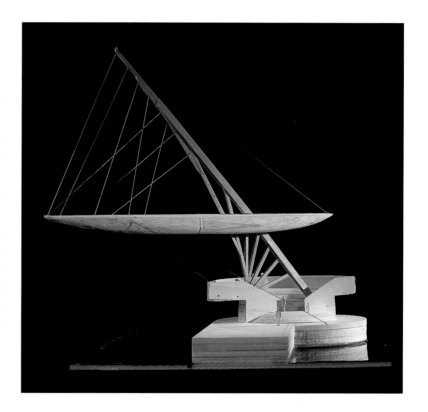

ABOVE: Darlene Nguyen-Ely, Vietnamese Monument to Immigration, *1999. Wood model.*

RIGHT: Darlene Nguyen-Ely, Vietnamese Monument to Immigration, *1999. Drawing. Schematic of monument, including structural details.*

BELOW: Cultural celebrations organized by the Vietnamese United National Association.

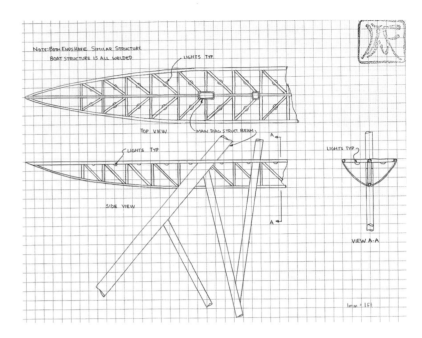

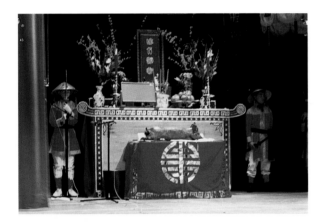

Adults bake special cakes, help the children construct the lanterns, and participate in lively cultural activities. Nguyen-Ely saw the intergenerational nature of the festival as a way of addressing the community's desire to link the cultural past and present. She proposed a series of giant kinetic lanterns that would be illuminated at night, evoking the spirit of Tet Trung Thu.

Although the community members recognized the proposal's connection to their own concerns, they also saw *New•Land•Marks* as a rare opportunity to commemorate the powerful story of Vietnamese immigration. As community member Thao Van Ho explained, "The project is a chance to explain to others why the Vietnamese came here and make Vietnamese people think about who they are." In response, Nguyen-Ely modified her initial ideas and developed her final proposal, *The Vietnamese Monument to Immigration.*

The monument would be a huge lantern-sculpture, approximately sixty feet high, with shapes suggesting the mast and hull of a boat. Besides its direct reference to the "boat people" and their journey, the work would call

BELOW: *Darlene Nguyen-Ely*, Vietnamese Monument to Immigration, *1999. Painting. Monument illuminated at night.*

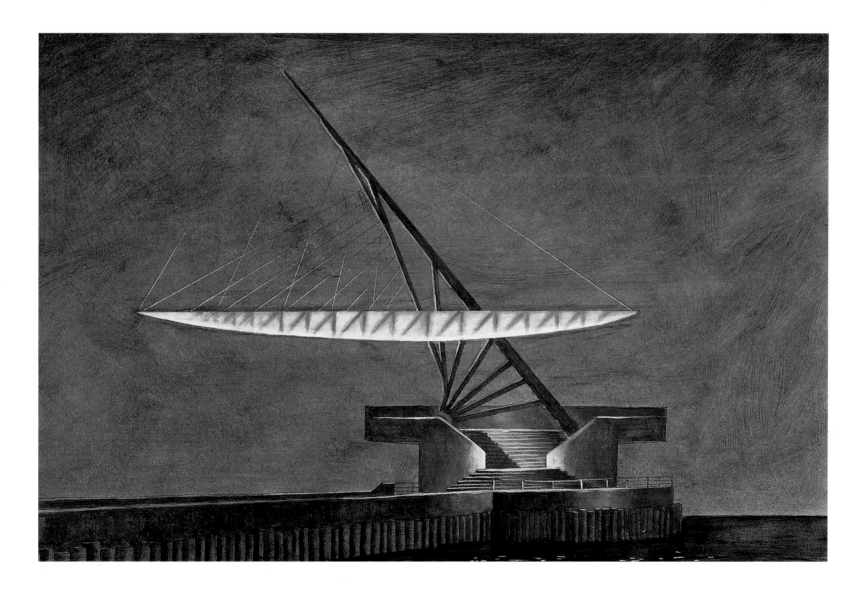

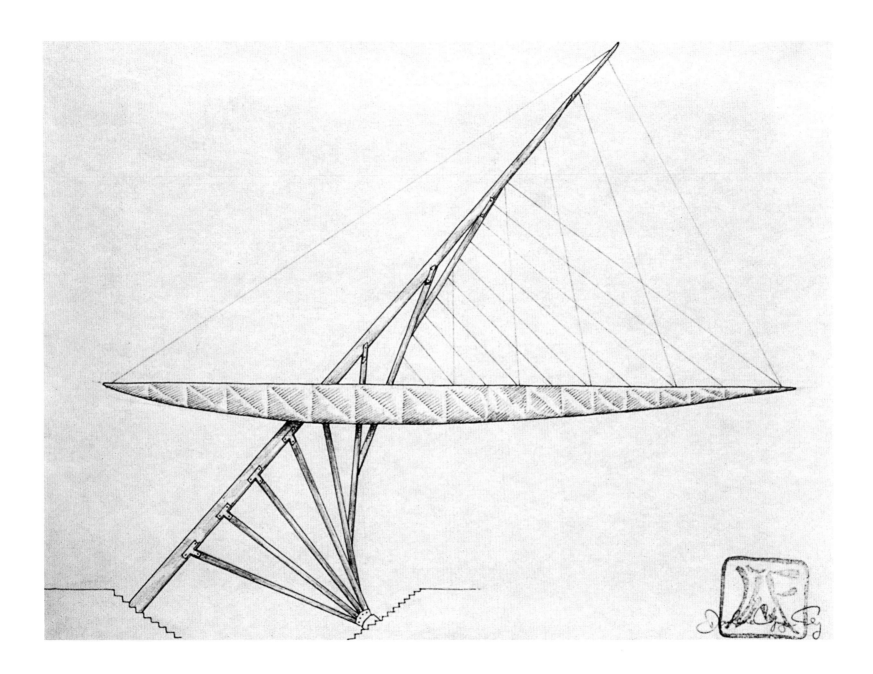

LEFT: Darlene Nguyen-Ely, Tet Trung Thu, *1999. Painting. Initial proposal to the community.*

FACING PAGE: Darlene Nguyen-Ely, Vietnamese Monument to Immigration, *1999. Drawing.*

to mind other modes of travel. The boat-like structure would float in midair like an airplane and be supported by cables like a suspension bridge. "To me," the artist explains, "the vessel is a symbol of travel, exploration, transformation, life changes—even a new life." As a lantern, moreover, the work would refer to the Tet Trung Thu festival. A nearby plaque would explain the story of the "boat people" as well as the significance of the festival.

Because Vietnamese Americans live in many neighborhoods throughout Philadelphia, the artist and community members faced a challenge in determining an appropriate site for the *Monument to Immigration*. After considering a number of locations, they settled on an existing concrete structure at the end of Penn's Landing Quay, along the Delaware River. This prominent site is close to the Vietnam Veterans Memorial, the *Columbus* monument (see page 39), the International Sculpture Garden, and the proposed *Memorial to Irish Immigration*. Since the Delaware shore is where many immigrants first set foot in Philadelphia, placement of the work here would give it another level of meaning.

With light from the lantern-sculpture reflecting in the water at night, Nguyen-Ely's *Monument to Immigration* would joyfully celebrate the legacy of Vietnamese culture in America. At the same time, it would evoke the powerful emotional impact of immigration for people of all nationalities who have taken the spiritual and physical journey to a new land.—CM

DARLENE NGUYEN-ELY

The sculptures and site-specific works of Darlene Nguyen-Ely, born in Vietnam, explore the symbolic and spiritual aspects of her journey by boat to the United States. Concerned with travel as a metaphor for change, as well as with the aesthetics of travel, Nguyen-Ely incorporates into her work imagery from the "machinery" of transportation, such as the aluminum of an airplane or the wooden frame of a ship. She also explores the interface between the traditional and the high-tech—for example, by placing tiny computer-generated images inside carefully crafted wooden sculptures. Nguyen-Ely exhibits her work at galleries throughout the United States, Canada, and Europe. She has twice been the recipient of a Pollock-Krasner Foundation Grant.—SRK

COMMUNITIES OF KENSINGTON AND FISHTOWN. This proposal originated with Kensington HISTORIES, a community organization that documents and celebrates the rich history of Kensington and Fishtown through publications, tours, an oral history project, and special events. After Kensington HISTORIES voluntarily withdrew from *New·Land·Marks,* a coalition of community groups—including the Kensington South Neighborhood Advisory Committee and the New Kensington Community Development Corporation—expressed interest in the proposal. Seeking to promote a sense of community, the Kensington South Neighborhood Advisory Committee coordinates the efforts of public and private agencies relating to issues of housing and vacant or abandoned land. The New Kensington Community Development Corporation is a nationally recognized nonprofit that provides housing and economic development services, sponsors efforts to revitalize vacant land, and works to build community through neighborhood-driven programs.

Perseverance

Todd Noe with the communities of Kensington and Fishtown

As two of Philadelphia's oldest neighborhoods, Kensington and Fishtown have an impressive past. Here, in 1682, Chief Tamanend of the Lenni Lenape is said to have signed a treaty granting William Penn the land for Pennsylvania. Ships built in these neighborhoods fought in the War for Independence. During the Industrial Revolution, Kensington and Fishtown produced goods that were sold throughout the United States.

With the shift to a postindustrial economy, much of the industry in these communities has vanished, and the history of the area often goes untold. Abandoned buildings are being demolished, leaving vacant lots, and other reminders of the area's past are rapidly disappearing.

In developing his *New•Land•Marks* proposal, artist Todd Noe worked with a number of community groups, including the Kensington South Neighborhood Advisory Committee and the New Kensington Community Development Corporation. A local newspaper, the *Kensington and Fishtown Star*, published ideas for the project and meeting announcements.

Noe's proposed work would capture symbols of the area's past in a series of sculptures. The title, *Perseverance*, reflects the name of the world's first steam-powered ship, built at a local shipyard, and the term also "sums up the spirit" of the community, says Noe. All of the sculptures would be

ABOVE: Todd Noe, Baseball Bench, 1999. Mixed-media model. Baseballs were once produced in Kensington by the A. J. Reach Company.

RIGHT: *Todd Noe,* Sunken Schooner, *1999. Mixed-media model.*

BELOW TOP: *Workers at Kensington's Stetson Hat Factory in 1914.*

BELOW BOTTOM: *1892 lithograph of Cramp Ship Yard, a major employer in Kensington until it closed in 1927.*

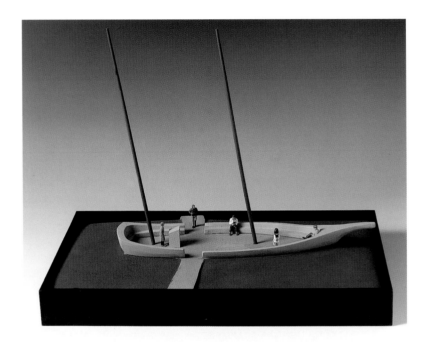

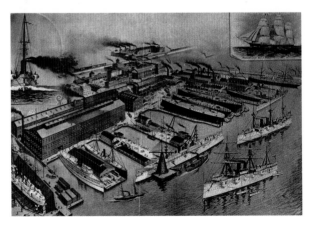

functional as well as symbolic. They would "provide seating or exist as 'street furniture,'" the artist explains. "It was clear the communities wanted something that would be useful as well as meaningful."

Several of the sculptures would commemorate the industries of fishing and shipbuilding that once thrived in these neighborhoods. The *Fishing Dory Benches*, shaped like small rowboats, would be inscribed with the names of important ships constructed in the area. The cement walkway surrounding the benches would bear incised images of shad, a reference to the local legend that the shad were once so plentiful that you could walk across the Delaware River on their backs. The *Sunken Schooner* seating area would resemble a partially submerged ship, with "masts" functioning as light poles and a podium in the shape of a deckhouse. A *Propeller Bench*, commemorating a later period of shipbuilding, would incorporate a large propeller donated by a shipyard.

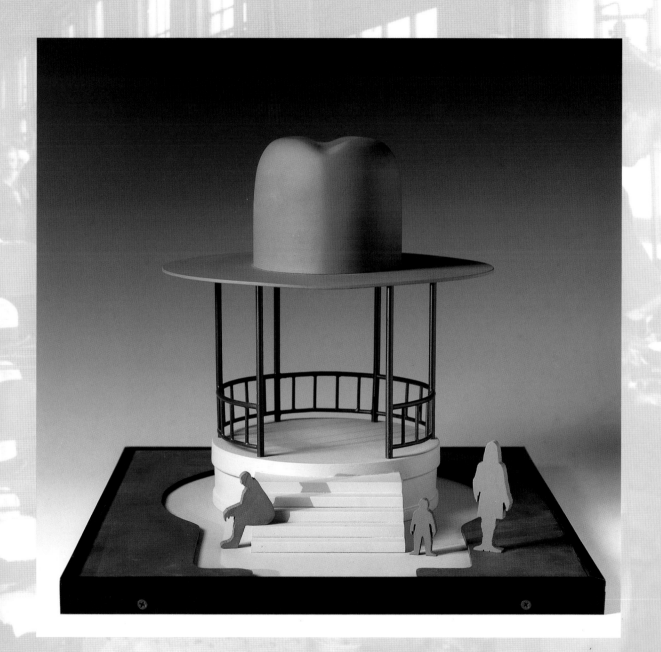

RIGHT: Todd Noe, Hat Bandstand, *1999. Mixed-media model. Stetson hats were manufactured locally until the 1960s.*

Todd Noe, Perseverance *(five images), 1999. Mixed-media models. Functional elements incorporate symbols from the neighborhood's past.*

RIGHT, TOP TO BOTTOM: Propeller Bench; Fishing Dory Bench; Mother Jones Bench; Soup Bowl Bench.

BELOW: Bacon's Essay Bench.

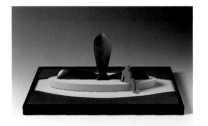

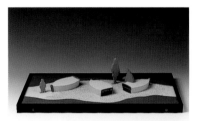

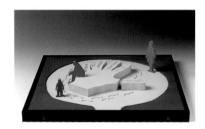

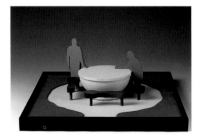

Other local industries would be celebrated as well. A book-shaped *Bacon's Essay Bench* would commemorate a volume printed here in 1688—the first book published in the middle colonies. The *Hat Bandstand*, crowned with a large Stetson hat, would refer to the world-renowned hat company once located in the community. A *Baseball Bench* would evoke the memory of the A. J. Reach Company, founded by Al Reach, who is often described as the first professional baseball player. At one time, the Reach Company supplied baseballs for the American League, and some current residents remember the days when local women stitched the baseballs together while sitting on their front steps.

Kensington and Fishtown also have a long tradition of charity and community service, including soup kitchens. The Kensington Soup Society, founded in 1844, still operates today. This aspect of community history would be commemorated in Noe's *Soup Bowl Bench*. The "bowl" part would actually be a table, surrounded by spoon-shaped benches. *Mother Jones Bench* would memorialize the Mother Jones marches through Kensington and the child labor law movement. A sculpture of a child's hand with a severed thumb would represent the type of injury a child might have received while working in a turn-of-the-century mill.

Together with the community groups, Noe has explored several possible locations for his project. Some residents have advocated a single location, Penn Treaty Park, which has clear historical significance. Others favor placing the sculptures at multiple locations along Frankford Avenue, on sites stabilized by urban greening initiatives (see page 116). "Many vacant lots have been cleaned and planted," Sandy Salzman of the New Kensington Community Development Corporation points out. "But they do not have a designated use, and we often ask ourselves, 'What next?' These sculptures would make the lots useful again and would be a way to embody our history in our open spaces."

Wherever they may be sited, Noe intends his sculptures to "provoke questioning from the audience. What does a baseball or a big Stetson hat have to do with Kensington? Why is there an old schooner over there on dry land?" Leading people to ask such questions, he realizes, is an important step in restoring a sense of community history and pride.—CM

TODD NOE

Through his sculpture, Todd Noe explores the "iconography of humanity." Trained as a metalsmith, Noe creates large- and small-scale works based on everyday, easily recognizable objects. These sculptures evoke individual memories and perceptions among viewers, who experience the work through the filter of their own lives. Noe's tactile public commission, Dwellings (1995), created for the Maryland State Library for the Blind and Handicapped, includes a series of twelve miniature iconographic homes. When these bronze structures—which range from a log cabin to a doghouse—are experienced as a collection, they comment on the similarities and differences among human beings, and serve as a reflection of our cultural history. By evoking memories of viewers' own homes, the work also allows audience members to participate in the installation. A Philadelphia resident, Noe has exhibited widely in the Philadelphia region and, in 1996, was awarded a Pew Fellowship in the Arts.—SRK

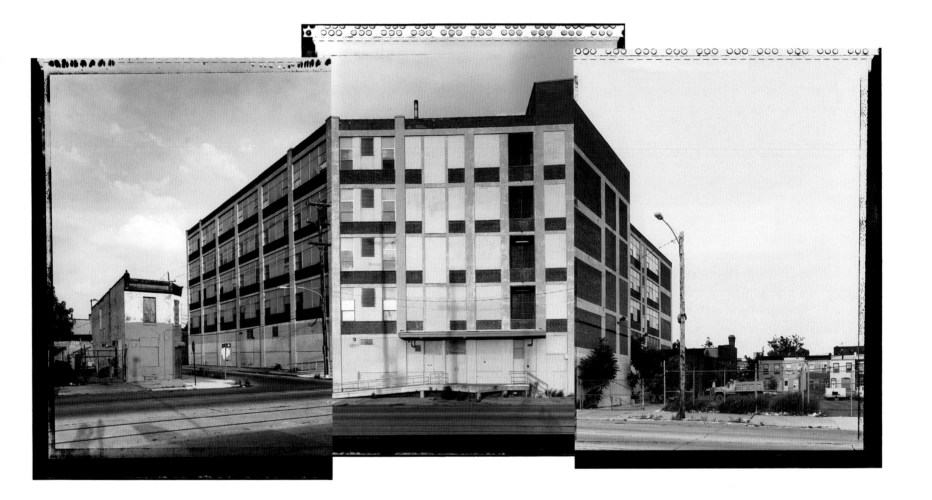

CONGRESO DE LATINOS UNIDOS is a multicultural community agency and the leading provider of social, economic, health, and educational services to the Latino community of Philadelphia. Intended to build "human capital," Congreso's broad range of programs offers a holistic approach to community development and social services. Although Congreso does not define its constituency geographically, its services focus primarily on the eastern section of North Philadelphia, the area of the city with the highest concentration of Latino citizens in need. The new facility at American and Somerset Streets will position the organization in the heart of Latino Philadelphia and provide it with space to accommodate its rapidly expanding programs.

I have a story to tell you . . .

Pepón Osorio with Congreso de Latinos Unidos

To respond to the changing needs of the Latino community, Congreso de Latinos Unidos is relocating to a larger facility at American and Somerset Streets, a former industrial building donated by the City of Philadelphia. The organization saw *New•Land•Marks* as an opportunity to transform the new headquarters into a dramatic community landmark. "It was very clear to us that a family and workforce development center in the heart of North Philadelphia needed to involve the arts and culture," says former executive director Alba Martínez. "We believe that culture can transform communities."

The representatives of Congreso wanted an artist to "invest" himself or herself in the community, "to spend time with us and our people." They also posed an ambitious goal for the project: to help the artist do work that he or she "could do nowhere else." Pepón Osorio's artistic process precisely reflected the group's interests. "My principal commitment," says Osorio, "is to return art to the community. My creative process is one of listening to stories, uncovering histories, channeling collective experiences, and transforming these into works that can serve as reflectors to the group."

Osorio met extensively with members of Philadelphia's Latino community. When he asked what issues should be addressed, a common refrain began to emerge. People were dissatisfied by the way their community was

ABOVE: Pepón Osorio, I have a story to tell you . . . , 1999. Mixed-media model. A small photo-laminated glass casita is proposed for the courtyard of Congreso's new facility.

Pepón Osorio, I have a story to tell you . . . ,
1999. Mixed-media collages.

RIGHT: *Sample photo-laminated windows
superimposed on architectural drawing by
Agoos/Lovera Architects.*

BELOW: *Detail of photo-laminated window.*

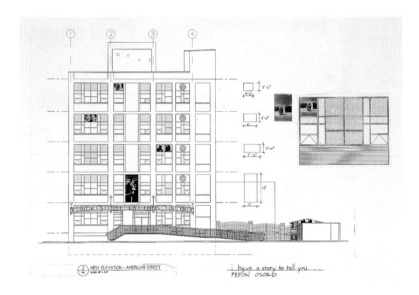

often portrayed in popular media. "It seems that the only time you see our community on TV," said one participant, "is when something bad happens. You rarely see the positive side." As Alba Martínez explains, community participants "envisioned a landmark that would pay homage to our community's sacrifices and struggles and that would combat feelings of invisibility and 'outsiderness.' People wanted to see their history, values, strengths, and hopes for the future conveyed."

Thus Osorio proposed *I have a story to tell you . . .* , a project that would give the community an opportunity to represent itself through a public work of art. As a first step in realizing the work, Osorio would collect photographs from community members through an open call for submissions. Meetings and community newspapers would help spread the word. Osorio would look in particular for images that "trace commonalities and shared experience" or "depict local events that have impacted community life."

Drawing on this wealth of images, the artist would incorporate selected photographs in a glass-walled *casita* (little house) proposed for the courtyard adjacent to the Congreso building. The photographs would be enlarged and

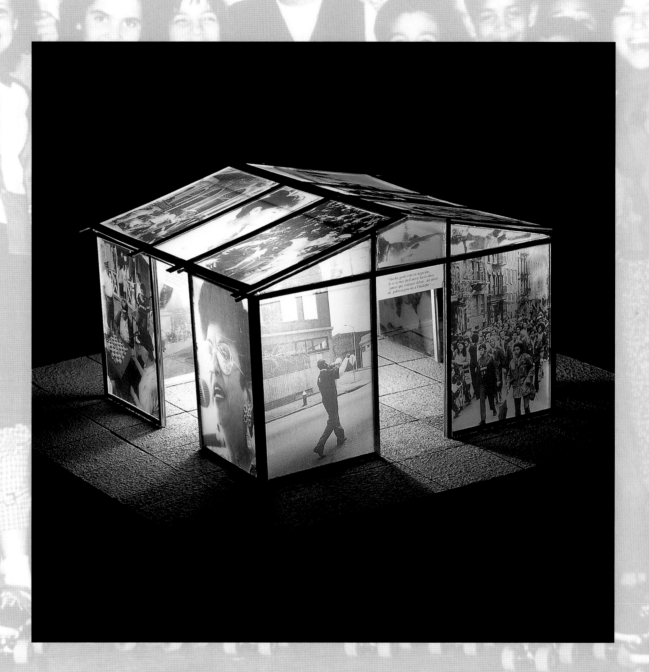

RIGHT: Pepón Osorio, I have a story to tell you . . . , *1999. Mixed-media model. The* casita *illuminated at night.*

RIGHT: Pepón Osorio, I have a story to tell you . . . , *1999. Mixed-media collage. Door detail superimposed on architectural drawing by Agoos/Lovera Architects.*

BELOW: Domingo Negron, a community leader, instrumental in the founding of Taller Puertorriqueño, c. 1975. Osorio would collect photographs from community members through an open call for submissions.

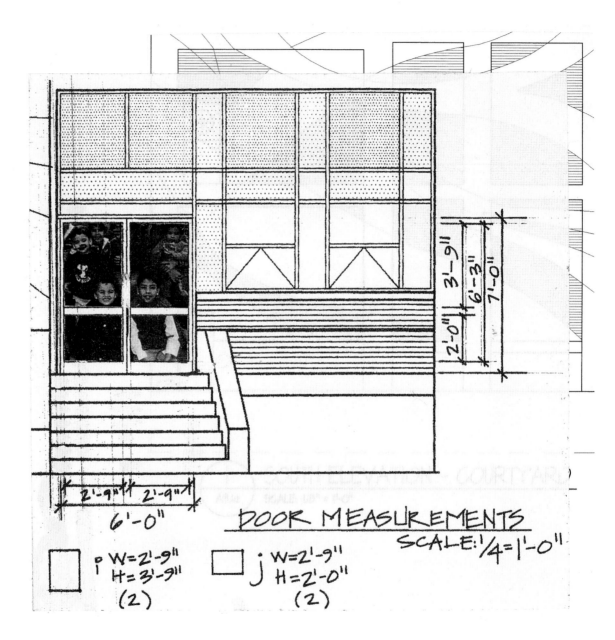

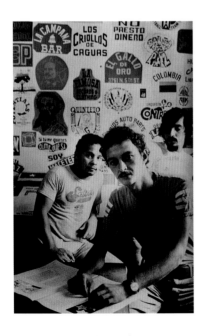

DOOR MEASUREMENTS
SCALE: 1/4=1'-0"

laminated within glass panels which would form the exterior walls of the structure. The *casita* would serve as a community gathering space, and the images would be be visible from both inside and outside the structure. At night, internal lighting would make the *casita* appear as a glowing "community photograph album."

Working with the renovation project architects, Agoos/Lovera Architects, Osorio also plans to integrate photographs into the main building. Here enlarged photographs would be laminated within selected windows throughout Congreso's new facility. During the day, visitors to the building would be able to see these images from the community superimposed on the sky or the local landscape. "Near or far, the photographs are intended to speak to you and follow you as you walk around the building," says Osorio. The photos would be placed so as to create a "visual dialogue with each other."

Illuminated from within at night, the artwork would animate the Congreso building and make it a distinctive landmark. *I have a story to tell you . . .* would indeed "tell a story—and many stories—at once," says Alba Martínez. Speaking of the proposed *casita* structure, she adds, "It might look fragile . . . but it would be unbreakable—just like the North Philadelphia Latino community."—CM

LEFT: *Children enjoy rollerskating at the Mid-City YWCA, (date unknown). Temple University's Urban Archives contains a collection of images of the city's Latino community.*

PEPÓN OSORIO

Born in Puerto Rico, Pepón Osorio creates installations that incorporate images and artifacts from daily life in Puerto Rico and in Latino communities on the mainland. His work explores the processes of cultural transmission, as well as the construction of social and cultural identity. Seeking to "bridge boundaries . . . that separate the art world and community life," Osorio has engaged underserved communities around the country in the process of creating contemporary art. His installations grow from a dialogue among community members, social service providers, and the commissioning institution. The resulting projects, such as En la Barbería No Se Llora—*which explored notions of masculinity through a re-created barbershop—are often sited in nontraditional venues. In 1999, Osorio received two prestigious awards: the CalArts/Herb Alpert Foundation Award in the Arts and a John D. and Catherine T. MacArthur Foundation Fellowship. Osorio recently relocated to Philadelphia, where his most recent multisited project,* Home Visits, *was exhibited in 2000.—SRK*

MANAYUNK DEVELOPMENT CORPORATION (MDC) encourages healthy economic development to benefit all segments of the Manayunk community. Founded in 1985 by a coalition of business and community leaders in response to the decline of the neighborhood's commercial district and other evidence of community disinvestment, the MDC has been instrumental in Manayunk's economic revitalization. Committed to the health of both the residential and the business communities, the MDC offers a variety of programs to improve the quality of neighborhood life, including neighborhood cleanups and town watch initiatives. The group also seeks to expand recreational and educational opportunities for all of Manayunk's citizens.

Manayunk Stoops: Heart and Home

Diane Pieri and Vicki Scuri with the Manayunk Development Corporation

Led by the Manayunk Development Corporation (MDC), several community groups saw *New•Land•Marks* as a chance to influence the redevelopment of the canal along the Schuylkill River. One of the oldest industrial canals in the United States, the Manayunk Canal was once the lifeblood of the area. It supported local industry for two centuries, helping to provide jobs for the community in nearby mills. In the past several decades, however, the canal's industrial use has waned.

During the 1980s, Manayunk underwent rapid change as Main Street, only a block from the canal, was converted into a high-end retail and dining district. "The development of Main Street," says Kay Smith of the MDC, "has created a physical barrier between the community and its waterfront. We wondered if a *New•Land•Marks* project could reconnect the neighborhood with the canal."

The MDC further hoped to involve an artist eager to work with children from the neighborhood. Local organizations that sponsored children's programs—including the North Light Community Center and the Venice Island Playground Community Council—expressed their enthusiasm for a public art project. "Our community has undergone a great deal of change over the past decade," explains Irene Madrak of the North Light Community

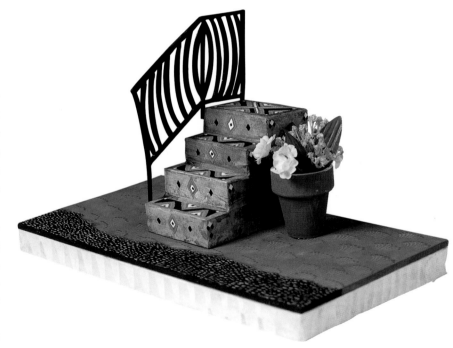

ABOVE: Diane Pieri, Manayunk Stoops, *2000. Mixed-media model. "Stoops" are a prominent feature of Manayunk vernacular architecture.*

RIGHT: Vicki Scuri, Manayunk Stoops, *2000. Computer rendering. Schematic diagram of decorative iron railing and tile-work.*

BELOW TOP: "Stoops" play an important role in the social life of Manayunk.

BELOW BOTTOM: Lauren Fleming, Untitled, 1999. Drawing. Diane Pieri led children's workshops during the proposal development phase.

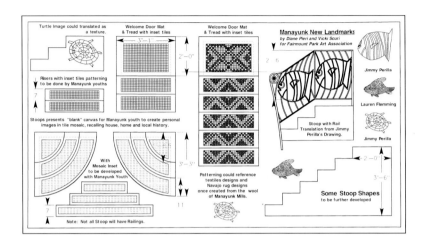

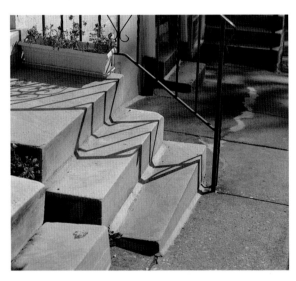

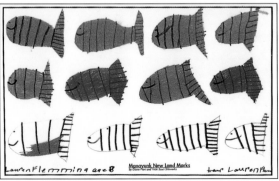

Center. "We saw *New•Land•Marks* as a way to invest our children in their rich heritage."

Artists Diane Pieri and Vicki Scuri met with the community groups, investigated the local industry and culture, and examined the canal and neighborhood. Inspired by the local vernacular, they proposed *Manayunk Stoops: Heart and Home,* a series of ten landscaped "stoops" (a local term for front steps) along the Manayunk Canal towpath. Made of cast concrete with inset tile mosaics, the *Stoops* would provide a place to pause while walking or biking along the canal. They would include custom iron railings, mosaic "welcome mats," and tiled planters, suggesting the entire tableau of "folk landscaping" that surrounds a typical stoop. The *Stoops* would abut existing buildings whose arched architectural elements suggest doorways. Landscaping would further integrate the artwork into the site.

The artists selected the stoop motif because it is a "symbol of interaction and connection." Residents of Manayunk, like those in many other Philadelphia neighborhoods, traditionally sit on their front stoops to socialize. "The stoop is a living room for the street," Vicki Scuri notes. Diane Pieri adds, "By bringing the stoops to the canal, we hope to bring the language of the community to the canal. The stoops are unpretentious yet meaningful reflections of the people and social customs in Manayunk."

RIGHT, TOP AND BOTTOM: Diane Pieri, Manayunk Stoops. 2000. Mixed-media models.

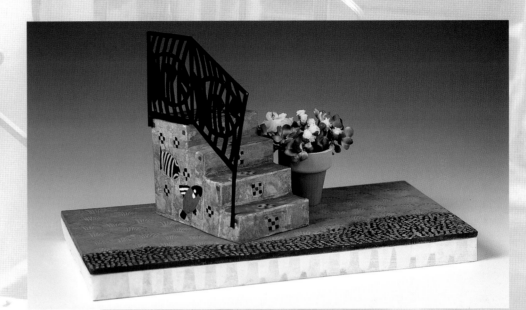

RIGHT: Potential sites for Manayunk Stoops *beneath arched elements along the Manayunk Canal.*

BELOW: Map of Manayunk Canal towpath from Cotton Street to Lock Street, 1982.

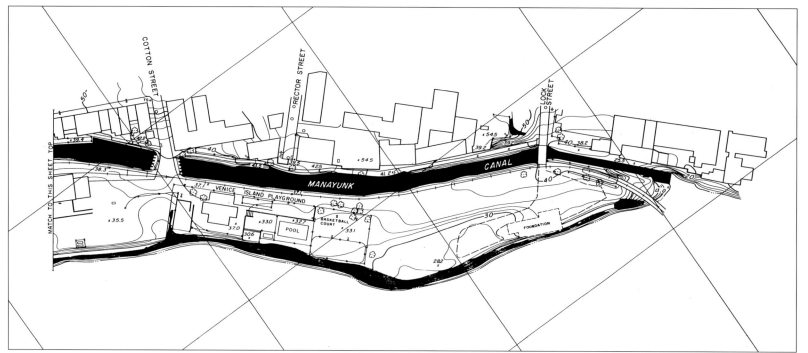

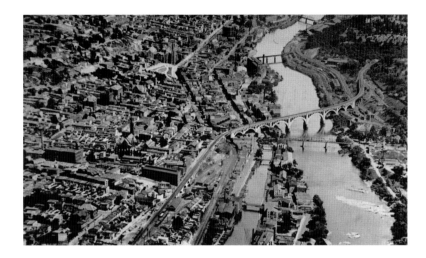

LEFT: Aerial photograph of Manayunk and the canal, (date unknown).

Children of the community would participate by providing design motifs. Pieri led several preliminary workshops with children from the North Light Community Center, and she plans additional workshops to finalize the designs. The children would create their own images reflecting the canal and the neighborhood, such as drawings of fish found in the canal and textile patterns associated with local mills. The artists would then incorporate aspects of these designs in the mosaics and railings.

The artists have further imagined a community-sponsored extension of the project. They suggest mass-producing several versions of the tiled planters, which could then be sold in stores along Main Street. These planters "could be placed throughout the community next to the actual stoops that inspired the project," says Pieri. The proceeds would be reinvested in community endeavors, such as maintenance of the landscape along the canal.

For the artists, the *Manayunk Stoops* project represents the "heart and home" of the community. There is also a larger symbolism. "Manayunk is built on a large, steep hill," Pieri notes. "An amazing staircase actually runs from the bottom to the top of the hill." Because the neighborhood is literally "stepped," the *Stoops* would become a metaphor for the ascension of the community itself.—CM

DIANE PIERI AND VICKI SCURI

Manayunk Stoops *is the first collaboration between Diane Pieri and Vicki Scuri, who met in 1990 while creating site-specific installations at the Socrates Sculpture Park in Long Island City, New York. Pieri, well known in Philadelphia as an artist and educator, creates paintings and sculptures that incorporate abstract patterning. She describes her motifs as a "symbolic language" and a "hybrid between the decorative and the political" through which she addresses issues of social and political concern. Pieri was recently awarded a prestigious Pollock-Krasner Foundation International Grant to Visual Artists. Based in Seattle, Vicki Scuri's projects integrate public art into infrastructure developments, including bridges, parking garages, and public buildings. Her work is distinguished by its use of light, color, and pattern as vehicles to interpret culture, as well as by its attention and responsiveness to community desires, historical context, and landscape. Among Scuri's past projects are the award-winning* Dreamy Draw Pedestrian Bridge *in Phoenix, Arizona, and the* Boren Avenue Parking Garage Project: Tire Tread Patterns in Site *in Seattle, Washington.*—SRK

NEIGHBORS OF FAIRHILL are local residents and members of area community organizations who are working to revitalize their North Philadelphia community and rehabilitate Fairhill Square, a four-acre Department of Recreation park located at 4th and Lehigh Streets. Once a thriving industrial area, Fairhill experienced rapid decline as businesses, institutions, and industries left the neighborhood. Today the Neighbors work in cooperation with other programs, including the Women's Community Revitalization Project and the Pennsylvania Horticultural Society's Parks Revitalization Project. Through these collaborative efforts, vacant lots have been reclaimed as neighborhood gardens; regular park cleanups have been established; and areas of the park have been replanted.

Glorietas of Fairhill Square: The Completion of a Neighborhood Cosmos

Jaime Suárez with the Neighbors of Fairhill

One of two land parcels in the area deeded to the city as open space, Fairhill Square is located at the center of an ethnically mixed community. Residents are predominantly African American and Latino, and neighborhoods of Asian and white populations are close by. This diversity is one of the area's special qualities that the Neighbors of Fairhill recognize and hope to embrace with a work of public art.

A *New•Land•Marks* project, the Neighbors believe, could assist them in their efforts to rehabilitate the once-vibrant community and refurbish the park. A work of art could "invite people to enter the park," helping to make it "a gathering place for the community, a place where children and neighbors can congregate, enjoying nature, recreation, and the company of each other."

In meetings with local residents, artist Jaime Suárez began to develop his proposal by posing two questions: First, "what can provide common meaning to diverse cultures, or what can constitute a common language?" Second, "what is Fairhill Square?" After many discussions with community members, he envisioned the answers. Common to most cultures, he concluded, is a collection of myths, especially cosmological myths featuring the sun and the moon. And Fairhill Square, he noted, already possessed an

ABOVE: Jaime Suárez, Glorietas of Fairhill Square: The Completion of a Neighborhood Cosmos, *1999. Computer rendering.*

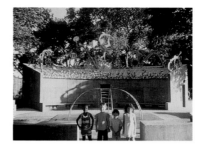

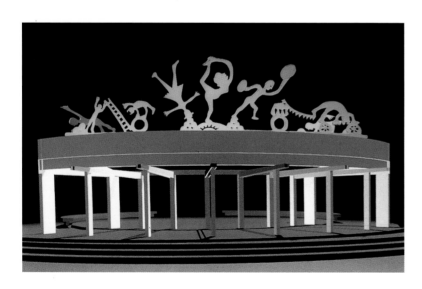

evocation of the moon in Rafael Ferrer's *El Gran Teatro de la Luna* (Grand Theater of the Moon), a painted aluminum sculpture developed through the Art Association's Form and Function program in 1982.

The outcome of Suárez's thinking was his proposal for *Glorietas of Fairhill Square*, a series of elements that would "complete" the cosmological associations of the park by adding references to the sun and the air. *Glorieta* is the Spanish term for a pavilion or gazebo, and two such structures form the heart of the proposal. Both would be lightweight steel structures that could function as outdoor stages.

Toward the north end of the park, the *Glorieta del Gran Teatro de la Luna* would serve as a new base for Ferrer's sculpture. Originally Suárez planned to create this *glorieta* by modifying the old park utility building on which Ferrer's work had rested for seventeen years. During the proposal's development, however, the unsightly building was demolished by the city at the community's request. Consequently, Ferrer's colorful figures, which had provided a community landmark—and a "sense of joy," as residents put it—were moved to storage. Suárez now proposes an all-new structure that would restore the sculpture to its rightful place.

At Fairhill Square's opposite end, the *Glorieta del Gran Teatro del Sol* (Pavilion of the Grand Theater of the Sun) would balance the *glorieta* of the moon. Overhead beams spreading out from the center would suggest the rays of the sun. In the colder months, says the artist, this *glorieta* would offer "the promise of spring and summer."

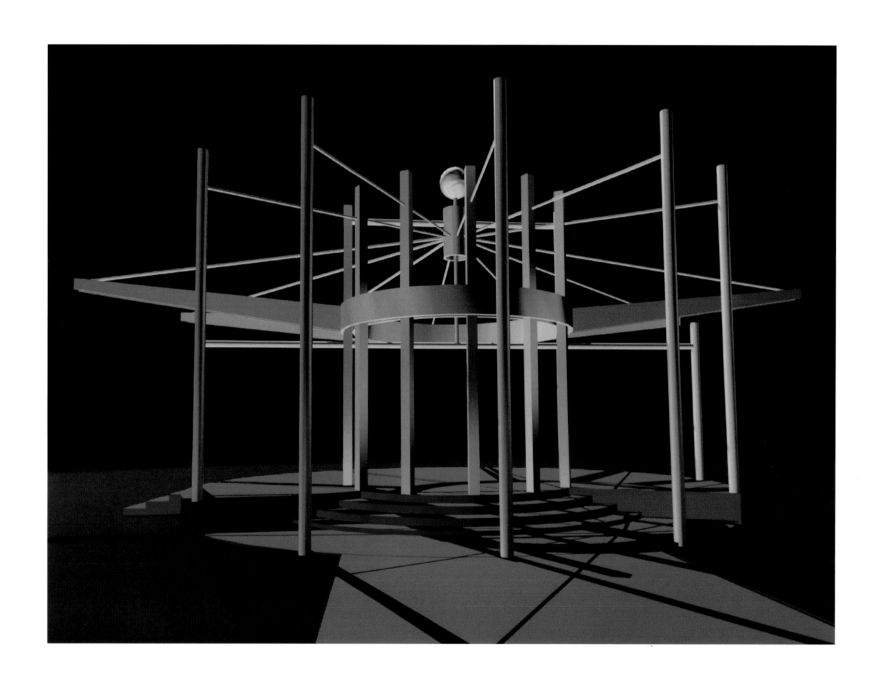

Jaime Suárez, Glorietas of Fairhill Square:
The Completion of a Neighborhood Cosmos
*(four images), 1999. Pastel drawings. The
moon and sun meet in an eclipse, reflecting
the proposal's cosmological symbolism.*

LEFT: Jaime Suárez, Guardians of the Park, *1999. Pastel drawing. Children would create ceramic hands and eyes for entrance totems.*

Two playgrounds, located on the east and west sides of the park, would symbolize the third cosmological element, air. A lightweight steel grid would form a basic structure to support commercial playground equipment: swings, seesaws, jungle gyms, ladders, and other elements that children would associate with air and flight. Atop the playground structures, sculptural elements or mobiles would move with the wind.

For the center of the park, where six pathways come together, Suárez proposes the *Plaza of the Eclipse*, a gathering space for the community. Halfway between the two *glorietas*, the plaza would represent the convergence of the sun and moon. Finally, at the four diagonal entrances to Fairhill Square, Suárez would place the *Guardians of the Park*, three-foot-high concrete totems covered with brightly colored ceramic hands and eyes. These ceramics would be created by the children of the neighborhood. As a mark of the collaborative process, Suárez anticipates creating one "eye" and "hand" himself to place among the many contributions from the community.—RR

JAIME SUÁREZ

One of the founders of Casa Candina, a school, museum, and gallery created in the 1970s to promote the ceramic art of Puerto Rico, Jaime Suárez is a pivotal figure in the contemporary Puerto Rican ceramic art movement. Suárez, an architect as well as a ceramic artist, lives and teaches in San Juan, Puerto Rico, where he has received numerous public commissions, including Totem Telúrico *(1992), a ceramic and granite column that reflects Puerto Rico's colonial and indigenous heritage. Suárez has exhibited widely, both nationally and internationally. In 1998, his ceramics were featured in Philadelphia in* Contemporary Puerto Rican Ceramics, *a collaborative exhibition by the Clay Studio and Taller Puertorriqueño.—SRK*

FRIENDS OF THE WISSAHICKON was founded in 1924 as a nonprofit organization to help preserve and protect the Wissahickon Creek section of Fairmount Park. One of the city's oldest Park Friends groups, the organization has been responsible for the construction of many public structures and nature trails in the area. Today the group has over a thousand members, many of whom provide volunteer labor for projects such as maintaining the trails, buildings, and bridges and planting trees and shrubs throughout the park. The Friends work closely with the Fairmount Park Commission to develop long-term conservation and usage strategies for the Wissahickon.

Proposals for the Wissahickon

George Trakas with the Friends of the Wissahickon

"In terms of urban parks," artist George Trakas said after first visiting the Wissahickon section of Fairmount Park, "this could easily be one of the best-kept secrets in the world." "The Wissahickon," as Philadelphians call the area, is a deep, wooded gorge that stretches for seven miles along Wissahickon Creek. Because the area seems so much like a wilderness, visitors can easily forget that they are still within the city.

The park's aging infrastructure, which includes paths, houses, bridges, and other structures, poses complex preservation problems. "The challenge," says Ed Stainton of the Friends of the Wissahickon, "is to make the necessary improvements, yet preserve the sense of wilderness and remain sensitive to the park's historic fabric." Having worked with the Art Association on a previous project, *Fingerspan*—Jody Pinto's pedestrian bridge (see page 17)—the Friends recognized the potential of a public art project to "improve a problem area" with minimal disturbance to the natural setting.

George Trakas describes his work as "bringing people close to the interface of land, sea, and sky in an intimate and integral way." With his experience in creating site-specific works such as bridges, pathways, and shoreline reconstruction, Trakas appreciated the Friends' concerns: "It's also important for young people to realize that nature will regenerate an area that has been

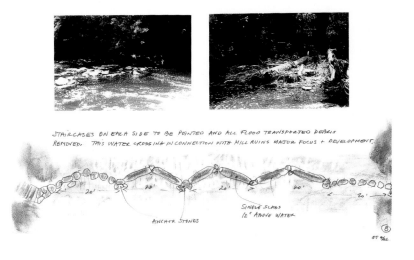

ABOVE: George Trakas, Stepping Stone Bridge, *1998. Photographs and drawing. From artist's working document.*

RIGHT: George Trakas, Untitled, *1998. Drawing. Proposed access points to Wissahickon Park near Ridge Avenue.*

BELOW TOP: Artist George Trakas works with Fairmount Park Commission staff on Water Bridge (Gawain's), *a demonstration project at Devil's Pool in the Wissahickon Park.*

BELOW BOTTOM: The artist and a community clean-up near the Livezey Dam.

FACING PAGE: George Trakas, Stepping Stone Bridge at Livezey Dam *(two images), 1999. Drawings. Plan (TOP) and elevation (BOTTOM).*

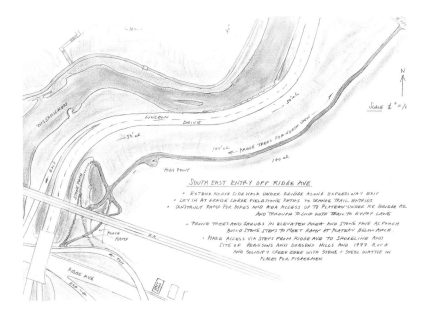

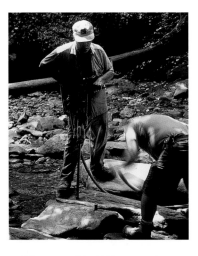

ravished." Accompanied by community representatives, Trakas repeatedly explored many areas of the park, and he outlined several possible projects. He recommended methods of stabilizing eroded shorelines. He suggested ways to create new access points for bikers in an underutilized section of the park, reducing the bikers' impact on other parts of the landscape. To help educate visitors about the park's past, he proposed the excavation and reconstruction of a historic mill race. He also investigated building a bridge—using existing foundations—to help connect the park to the nearby bike path along Kelly Drive.

Together, Trakas and the Friends group decided to focus on a proposal for a *Stepping Stone Bridge at Livezey Dam*. Except for two short steel decks spanning deep sections, the bridge would consist of a series of stones set into the creek bed. Made of Wissahickon schist, a handsome rock found abundantly in the park, this pathway across the water would fit gracefully into the natural environment, and it would bring visitors into a dramatic physical relationship with the creek. For adults standing on the stones of the bridge, the

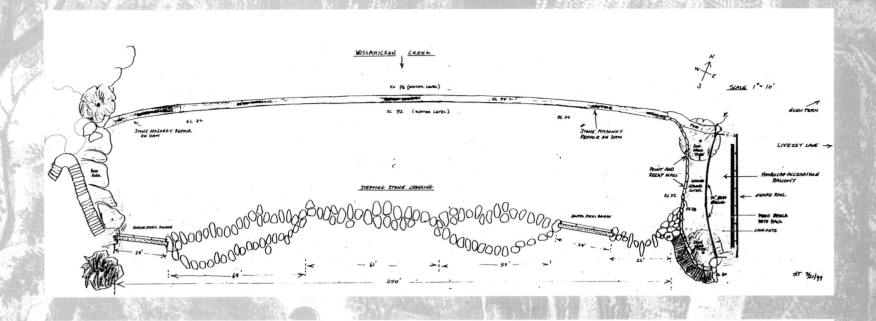

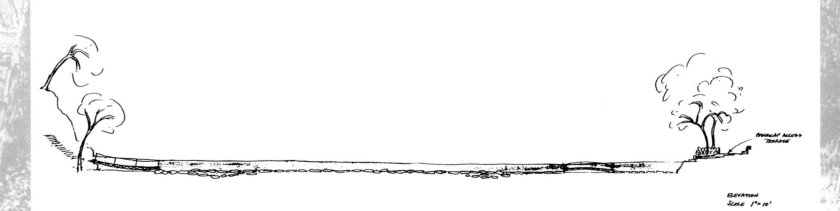

ELEVATION
SCALE 1"=10'

RIGHT: Eroding shoreline along the Wissahickon Creek in 1998.

FAR RIGHT: George Trakas, Untitled, 1998. Mixed-media model. Shoreline stabilization project.

BELOW: George Trakas, Untitled, 1998. Drawing. Proposed method of shoreline stabilization.

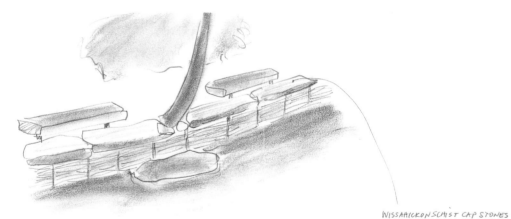

THERE ARE A NUMBER OF AREAS WORE FISHERMEN AND THE PUBLIC HAVE WORN DOWN THE BANK IN THEIR EFFORTS TO GET CLOSE TO THE WATER

THESES AREAS NEED SUBTLE YET SOLID REINFORCEMENT TO HELP THE PUBLIC AND PRESERVE THE BANK

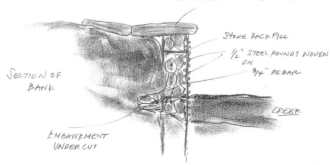

WISSAHICKON SCHIST CAP STONES

STONE BACKFILL

½" STEEL ROUNDS WOVEN ON ¾" REBAR

SECTION OF BANK

CREEK

EMBANKMENT UNDER CUT

④

GT 7/9/98

water would be at eye level as it tumbles over the dam. People using the bridge would also discover that, as Trakas says, "the sound of the waterfall is enthralling."

The project suits the history of the area, for an earlier stepping stone bridge once occupied the site. Two staircases dating back to the Work Projects Administration still lead down to the water on either side of the creek. By connecting the two staircases, the bridge would serve an important practical purpose as well, allowing Park Rangers to respond more quickly to emergencies. The proposal further calls for a creekside terrace that would provide access for visitors with disabilities.

As part of the proposal development phase, Trakas led several hands-on projects in the Wissahickon. With the help of the Friends group and Fairmount Park Commission staff, Trakas and volunteers removed debris that had washed down the stream and gathered at the site. As a demonstration project, Trakas also built a small stepping stone bridge near Devil's Pool. Unfortunately, the floodwaters of Hurricane Floyd, which reached the 100-year flood mark, essentially destroyed that small bridge.

The artist gave this small demonstration project the title *Water Bridge (Gawain's)*, alluding to the medieval tale of Sir Lancelot and also to one of Trakas's previous works, the *Sword Bridge* in Thiers, France. In the tale, Lancelot successfully crosses the Sword Bridge in an attempt to save Lady Guinevere. Against Lancelot's advice, Sir Gawain tries to cross the Water Bridge but dies in a torrent. Like Gawain, Trakas's *Water Bridge* perished, but the artist's resolute wit shows his appreciation for all the forces of nature—a perspective that informs his proposal for the *Stepping Stone Bridge*.—CM

GEORGE TRAKAS

George Trakas has worked internationally to create environmental installations that involve viewers directly in the landscape and connect people to their surroundings. Among his many notable achievements are Reconnection *(1993), a footbridge over the Belmullet Canal in Belmullet, Ireland, that has reestablished original patterns of pedestrian movement along the canal;* Berth Haven *(1983), a series of decks that hug the shore of Lake Washington near Seattle that was commissioned by the National Atmospheric and Oceanic Administration's influential public art program; and* Sword Bridge *(1989) in Thiers, France.* Curach and Bollard, *Trakas's work for the Thames and Hudson River Project, calls for the redesign of a portion of Pier 26 in New York City to reflect the Hudson River's environment and rich history while providing facilities for expanded environmental education programs and public river access. Trakas is also developing a* Waterfront Nature Walkway *for the City of New York's Department of Environmental Protection through the Department of Cultural Affairs Percent for Art Program.*—SRK

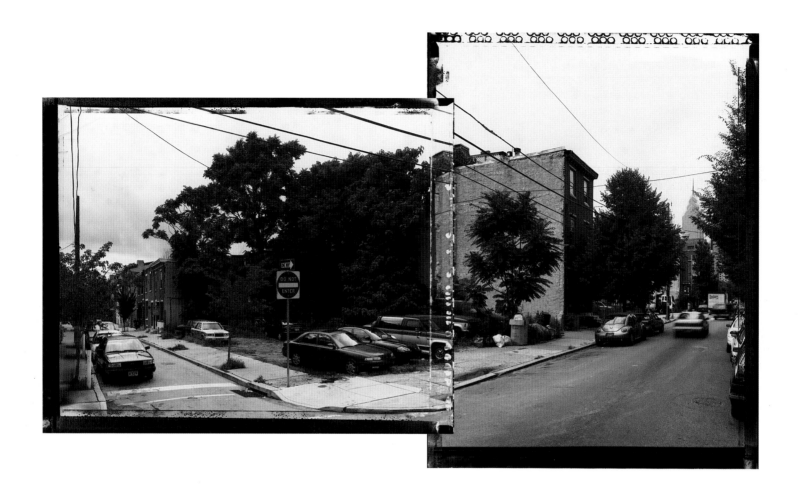

SOUTH OF SOUTH NEIGHBORHOOD ASSOCIATION (SOSNA) is a community development corporation that serves the area bounded by South Street to the north, Washington Avenue to the south, Broad Street to the east, and the Schuylkill River to the west. Committed to improving the quality of life in its community and increasing the area's desirability as a residential neighborhood, SOSNA serves as a forum for strategic planning. The organization also develops affordable housing, converts vacant properties into usable assets for the community, and works to spur commercial revitalization, particularly along the South Street corridor. In all of these efforts, SOSNA is dedicated to promoting neighborhood unity and civic pride.

Open-Air Library and Farmer's Market Plaza

Janet Zweig with the South of South Neighborhood Association

The "South of South" neighborhood has experienced both the benefits and drawbacks of proximity to Philadelphia's Center City. During the nineteenth century, development of the fashionable Rittenhouse Square district required a labor force, and many of the laborers took up residence south of South Street. Railroads and a local shipyard also helped transform the neighborhood into a bustling working-class area. By the turn of the twentieth century, South of South had a largely African American community, with enclaves of Irish Americans. In the later twentieth century, neighborhood decline began as the industries departed and Center City demanded fewer blue-collar workers. More recently, because of the affordable housing south of South Street, a new challenge has arisen—gentrification.

"Today," explain members of the South of South Neighborhood Association (SOSNA), "the historically strong African American and Irish American communities are being stirred with Center City professionals of all backgrounds, students, a significant gay and lesbian community, and a growing number of immigrants from Asian countries. We are proud of the spirit of tolerance and cooperation which prevails in our neighborhood." SOSNA itself has become adept at striking a balance between community development and preservation of the neighborhood for existing residents.

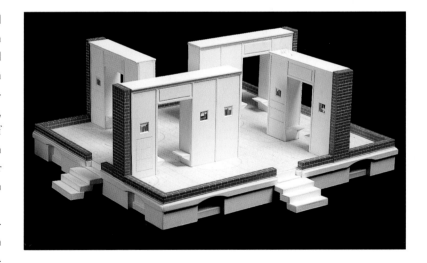

ABOVE: Janet Zweig, Open-Air Library, *1999. Mixed-media model. Library (closed).*

BELOW TOP: *Open-air book kiosks in Paris (LEFT) and New York City (RIGHT).*

BELOW BOTTOM: *John Wanamaker Branch of The Free Library of Philadelphia, 2123–25 South Street (now destroyed).*

FACING PAGE: *Janet Zweig,* Open-Air Library, *1999. Mixed-media model. Library (open).*

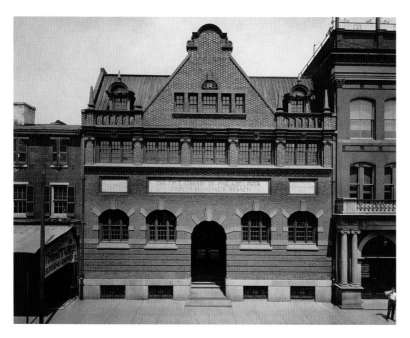

When New York artist Janet Zweig first visited Philadelphia, she became aware of this complex situation. She realized, too, that the neighborhood might often be overlooked by outsiders; she even had trouble finding it on her map because it was obscured by the map's legend. As she explored the neighborhood with local residents, she learned more about the community's needs. When she asked whether a new artwork should be indoors or outdoors, the overwhelming choice was outdoors. Some of the neighborhood's disadvantaged people, she was told, would be reluctant to enter a "cultural institution." She also learned that the community no longer had a neighborhood branch library. The Wanamaker Branch Library, opened in 1904, had long since been demolished.

Putting these pieces of information together, Zweig proposed an *Open-Air Library*, which would "literally open a cultural institution to the public." She was inspired in part by the open-air bookstalls in Paris and in New York's Union Square.

Zweig would convert a vacant lot into a brick-paved plaza, landscaped with trees and benches. Part of the plaza would be used for a local farmer's market that has been forced to relocate. At one end of the plaza, Zweig would construct the *Open-Air Library*. Marble steps, a doorway, and window frames would suggest a typical row house with its exterior walls removed. The library's interior walls would house bookshelves, and removable panels would protected the books from the elements. Unbreakable glass panels in the doors could be used for images, signs, or displays.

Zweig's design, created with the assistance of architect Peter Lynch, borrows details from local architecture. The marble steps, salvaged from a neighborhood building, would resemble a typical rowhouse "stoop." Brick, also salvaged from demolished homes in the neighborhood, would be used for the outer facing of the walls. The platform's base would be faced with stone similar to that used for the foundations of local houses.

"The library would be nontraditional and run in a very experimental way," says Zweig. To help plan the practical functioning of the library, Zweig has enlisted the collaboration of Drexel University's College of Information Science and Technology. Guided by the faculty, Drexel graduate

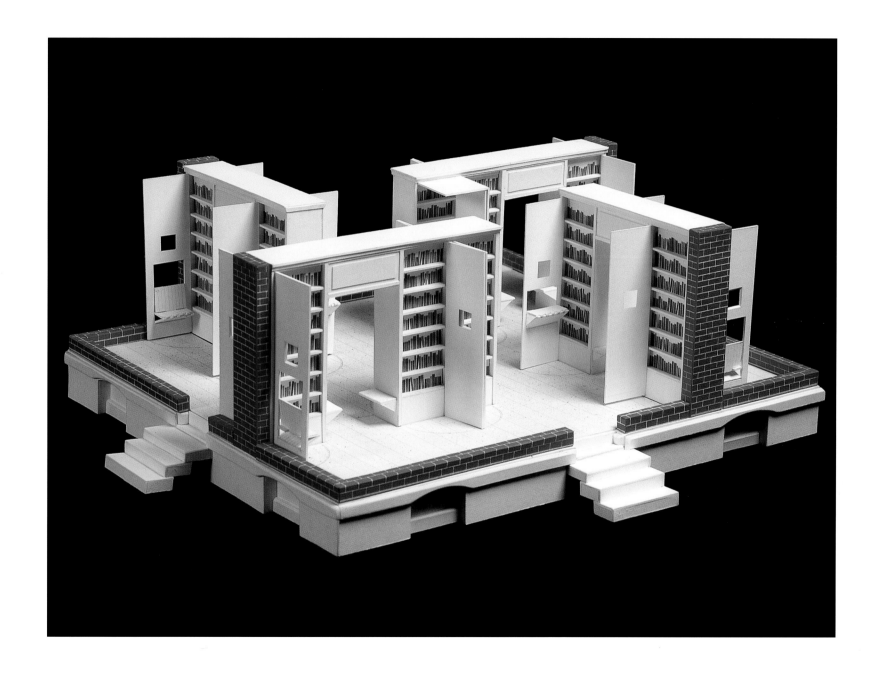

RIGHT: Janet Zweig, Open-Air Library,
2000. Watercolor by Edward del Rosario.
Library (closed).

BELOW RIGHT: Janet Zweig, Open-Air
Library, *2000. Drawing. An alternate version*
of the proposal.

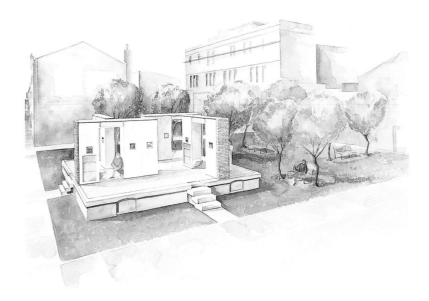

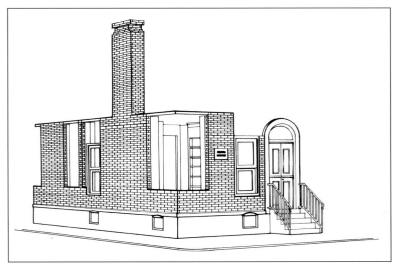

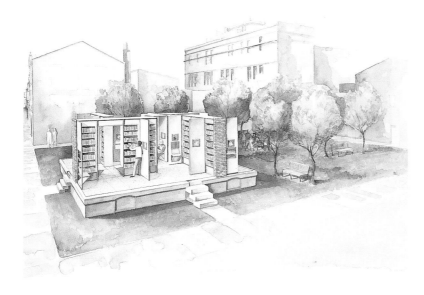

JANET ZWEIG

Janet Zweig seeks to create work that "is collaborative, beautifully designed, and . . . generates life and activity in its interaction with the people who experience it." Zweig addresses information and text as subjects and creates installations that are narrative, time-based, and interactive. Her 1993 Mind Over Matter *includes a computer that generates its own narrative from sentences provided by the artist. Zweig's first public art commission,* Your Voices *(1997), created for Walton High School in the Bronx, also creates narrative but relies on student participation for its input. The installation includes twelve slotted bronze boxes, each labeled with a word such as "suggestions," "wishes," and "problems." Students insert written comments, which are then collected and published. Zweig, the recipient of awards from the New York Foundation and the National Endowment for the Arts, teaches at Yale University and the Rhode Island School of Design. She is currently working on a commission for the University of Minnesota School of Journalism. Her work has been exhibited at galleries and museums, throughout the country, and including the Brooklyn Museum of Art.—SRK*

students have prepared a detailed analysis, including suggestions for acquiring the library collection and for building a volunteer staff. A "take a book, leave a book" policy would be adopted, reducing the need to keep track of borrowers. The students have also distributed a two-page survey to community members to explore the needs and interests of prospective library patrons.

SOSNA has brought exceptional resources to the project by integrating it into ongoing community development initiatives. After helping to evaluate possible locations, the organization has taken steps to acquire a vacant lot at 16th and Kater Streets.

Summing up the potential impact of the project, Zweig notes that libraries are central tools for self-improvement and civic discourse. "Reading," she says, "is a way to remain in your neighborhood, but also a way to venture out of it."—CM

New·Land·Marks Glossary

Like many other comprehensive fields of interest, public art has its own language. Words borrowed from various sources may be cast with different meanings. The following definitions are presented to help develop a shared vocabulary among participants in the public art process.

Aesthetic enhancements. Features that contribute to the improvement and beautification of a site.

Artistic integrity. The wholeness of the artist's vision.

Beauty. A combination of exceptional qualities that gives pleasure to the senses and uplifts the mind or spirit.

CDC (Community Development Corporation). A community-governed organization committed to improving the physical environment, fostering economic development, and addressing social needs.

Civic pride. Appreciating and participating in one's community.

Commemorate. To celebrate or preserve the memory of a person, event, or place.

Commission. To engage an artist to create a work of art.

Commitment. A dedication to a continuous involvement and interest.

Community. A group of people having a shared interest, identity, experience, or vision.

Conservation. The physical care of art following its creation, consisting of three stages: examination, preservation, and restoration.

Conservator. A specialist with advanced training in conservation.

Controversy. The discussion that often surrounds a work of art, reflecting diverse or opposing perspectives.

Cooperate. To establish a purposeful relationship with others that supports and benefits all parties. Unlike compromise, cooperation enhances rather than limits.

Creative teams. Visual artists working with other creative professionals, such as historians, writers, anthropologists, ecologists, and scientists.

Creativity. The ability to give shape to an idea in an imaginative and inventive manner.

Cultural diversity. The inclusion of many cultural perspectives.

Culture. Knowledge, social beliefs, and customary behaviors shared by a group and handed down to succeeding generations.

Enduring. Existing for a long period of time in both physical form and social relevance.

Environment. The surroundings of a person or a work of art, including both the natural elements and those made by humans.

Exemplary projects. Works of public art that reflect the spirit of *New•Land•Marks*.

Explore. To investigate through experimentation, study, and analysis.

Functional art. Art that also serves a practical purpose, such as a bridge, bench, or fence.

Imagination. The act of envisioning a creative or original idea.

Infrastructure. The underlying framework of a city, such as roads, sewerage, and communication networks.

Innovative. Characterized by the introduction of something new and unique.

Inspire. To instill a positive thought or feeling into another person.

Installation. The act of placing a work of art in its designated site.

Interpret. To actively examine the meaning of a work of art. One work of art may have many interpretations.

Knowledge. Understanding gained by experience.

Landmark. Object or structure that marks or identifies a location in a unique way.

Legacy. What a person or community contributes to future generations.

Maintenance. The continual care of a work of art to prevent deterioration, generally supervised by a professional conservator.

Master plan. A strategy for the development and preservation of a city, infrastructure, neighborhood, or building.

Medium/media. The material(s) out of which a work of art is made, such as bronze, marble, granite, steel, wood, or found materials.

Memorial. A lasting reminder that commemorates a person or event.

Memory. An individual or collective ability to remember the past.

Monument. A public symbol or work of art that reflects its times and commemorates the collective memory of a person, event, or idea.

Neighborhood. People from a district that form a geographic community within a town or city.

New•Land•Marks. A program that engages artists and communities to plan and create enduring works of public art that will serve as legacies for future generations.

Opportunities. Unique situations or assets in a community.

Partnership. A supportive relationship in which partners are able to achieve more through cooperation than by working alone.

Placemaking. The process by which a location acquires distinguishing characteristics.

Proposal. A description of a proposed project that can include drawings, site photographs, models, and other materials.

Public amenity. A feature for public enjoyment, such a playground, a pool, or a park.

Public art. Art placed in public places and spaces.

Public spaces. Places open to everyone to use and enjoy, such as sidewalks, subways, and parks.

Responsive. Receptive to ideas, feedback, and opportunities that may exist.

Revitalization. Renewed energy or interest in a place or thing.

Site. The physical location of a work of art.

Site-specific art. Art that is designed for a particular site.

Unique. Remarkable, rare, and one of a kind.

"Untold" histories. The histories of remarkable people or groups that have, for various reasons, not been preserved in traditional, academic histories.

Urban greening. The adaptation and reuse of vacant urban land for park land and green spaces.

Vision. Extraordinary foresight or imagination.

Bibliography

Philadelphia

Central Philadelphia Development Corporation with Research and Policy Associates. *Arts Resources for Children and Youth in Philadelphia.* Philadelphia: The Pew Charitable Trusts, 1997.

Cotter, John L., Daniel G. Roberts, and Michael Parrington. *The Buried Past: An Archaeological History of Philadelphia.* Philadelphia: University of Pennsylvania Press, 1993.

Community Voices, "Envisioning Public Art," *The Philadelphia Inquirer,* 8 August 1999, E5.

Fairmount Park Art Association. *Sculpture of a City: Philadelphia's Treasures in Bronze and Stone.* New York: Walker Publishing Company, 1974.

Gallery, John Andrew, ed. *Philadelphia Architecture: A Guide to the City.* Philadelphia: Foundation for Architecture, 1994.

Klein, William M. *Gardens of Philadelphia and the Delaware Valley.* Photography by Derek Fell. Philadelphia: Temple University Press, 1995.

Miller, Frederic M., Morris J. Vogel, and Allen F. Davis. *Philadelphia Stories: A Photographic History.* Philadelphia: Temple University Press, 1988.

_____. *Still Philadelphia: A Photographic History.* Philadelphia: Temple University Press, 1983.

Office of Housing and Community Development. *Neighborhood Transformations: The Implementation of Philadelphia's Community Development Policy.* Philadelphia: City of Philadelphia, 1997.

The Oliver Evans Chapter of the Society for Industrial Archaeology. *Workshop of the World: A Selective Guide to the Industrial Archaeology of Philadelphia.* Wallingford: Oliver Evans Press, 1990.

The Pennsylvania Horticultural Society. *Urban Vacant Land: Issues and Recommendations.* Philadelphia: The Pennsylvania Horticultural Society, 1995.

Scharf, Thomas J. and Thompson Westcott. *History of Philadelphia 1609–1884.* Philadelphia: L.H. Everts, 1884.

School District of Philadelphia. *Children Achieving.* Philadelphia: Board of Education/The School District of Philadelphia, 1995.

Scranton, Philip and Walter Licht. *Work Sights: Industrial Philadelphia, 1890–1950.* Philadelphia: Temple University Press, 1986.

Stern, Mark J. "Re-Presenting the City: Arts, Culture, and Diversity in Philadelphia," Working paper #3 in *Social Impact of the Arts Project.* Philadelphia: University of Pennsylvania School of Social Work, 1997.

Stern, Mark J. and Susan C. Seifert. "Civic Engagement and Urban Poverty in Philadelphia," Working paper #4 in *Social Impact of the Arts Project.* Philadelphia: University of Pennsylvania School of Social Work, 1997.

Stevick, Philip. *Imagining Philadelphia: Travelers' Views of the City from 1800 to the Present.* Philadelphia: University of Pennsylvania Press, 1996.

Strothers, Burt. *Philadelphia: Holy Experiment.* New York: Doubleday, Doran, 1945.

Toll, Jean Barth and Mildred S. Gillam. *Invisible Philadelphia: Community Through Voluntary Organizations.* Philadelphia: Atwater Kent Museum, 1995.

Urban Neighborhoods Task Force with the Center for National Policy and the Local Initiatives Support Corporation. *Life in the City: A Status Report on the Revival of Urban Communities in America.* Washington, D.C.: Center for National Policy, n.d.

Vogel, Morris J. *Cultural Connections: Museums and Libraries of Philadelphia and the Delaware Valley.* Philadelphia: Temple University Press, 1991.

Watson, John F. *Annals of Philadelphia and Pennsylvania, in the Olden Time: Being a Collection of Memoirs, Anecdotes, and Incidents of the City and Its Inhabitants.* Philadelphia: Edwin S. Stuart, 1899.

Weigley, Russell F. et al., eds. *Philadelphia: A 300 Year History.* New York: W. W. Norton & Co., 1982.

Public Art and the Environment

Alexander, Christopher. *The Timeless Way of Building.* New York: Oxford University Press, 1977.

Alexander, Christopher, Sara Ishiwaka, and Murray Silverstein. *A Pattern Language: Towns, Buildings, Construction.* New York: Oxford University Press, 1977.

Bach, Penny Balkin. *Form and Function: Proposals for Public Art for Philadelphia.* Philadelphia: The Fairmount Park Art Association and the Pennsylvania Academy of the Fine Arts, 1982.

_____. *Public Art in Philadelphia.* Philadelphia: Temple University Press, 1992.

_____. "The Integrity of the Artist-Citizen." In *Art for the Public: New Collaborations.* Dayton, Ohio: Dayton Art Institute, 1988, 11–20.

Bachelard, Gaston. *The Poetics of Space.* Boston: Beacon Press, 1969.

Bacon, Edmund N. *Design of Cities.* New York: Penguin Press, 1976.

Beardsley, John. *Earthworks and Beyond: Contemporary Art in the Landscape.* New York: Abbeville Press, 1984.

Bowles, Elinor. *Community Development and the Arts.* Pittsburgh: Manchester Craftsman's Guild, 1995.

Boyer, M. Christine. *The City of Collective Memory: Its Historical Imagery and Architectural Entertainments.* Cambridge: MIT Press, 1994.

Brown, Catherine R. and William R. Morrish. *Planning to Stay: Learning to See the Physical Features of Your Neighborhood.* Minneapolis: Milkweed Editions, 1994.

Brown, Gerard and Eils Lotozo. "Art Attack," *Philadelphia Weekly,* 28 July 1999, 28–34.

Bubman, Klaus, Kasper König, and Florian Matzner, eds. *Sculpture. Projects in Münster 1997.* Münster: Westfälisches Landesmuseum, 1997.

Cooper-Marcus, Clare and Carolyn Francis, eds. *People Places: Design Guidelines for Urban Open Space.* New York: Van Nostrand Reinhold, 1990.

Corrin, Lisa G., ed. *Mining the Museum: An Installation by Fred Wilson.* New York: The New Press, 1994.

Cranz, Galen. *The Politics of Park Design: A History of Urban Parks in America.* Cambridge: MIT Press, 1982.

Cruikshank, Jeffrey L. and Pam Korza. *Going Public: A Field Guide to Developments in Art in Public Places.* Amherst: Arts Extension Service, 1988.

David, Catherine. *Short Guide/Kurzführer documenta X.* Germany: Documenta und Museum Fridericianum Veranstaltungs-Gmbh, 1997.

Deutsche, Rosalyn. *Evictions: Art and Spatial Politics.* Cambridge: MIT Press, 1996.

Dewey, John. *Art as Experience.* New York: Minton, Balch and Company, 1934.

Dissanayake, Ellen. *Art and Intimacy: How the Arts Began.* Seattle and London: University of Washington Press, 2000.

_____. *Homo Aestheticus: Where Art Comes From and Why.* Seattle: University of Washington Press, 1992.

_____. *What Is Art For?* Seattle: University of Washington Press, 1988.

Doss, Erika. *Spirit Poles and Flying Pigs: Public Art and Cultural Democracy in American Communities.* Washington, D.C.: Smithsonian Institution Press, 1995.

Felshin, Nina, ed. *But Is It Art? The Spirit of Art as Activism.* Seattle: Bay Press, 1995.

Finkelpearl, Tom. *Dialogues in Public Art.* Cambridge: MIT Press, 2000.

Francis, Mark, Lisa Cashdan, and Lynn Paxson. *Community Open Space: Greening Neighborhoods Through Community Action and Land Conservation.* Washington, D.C.: Island Press, 1984.

Friedman, Martin et al. *Visions of America: Landscape as Metaphor in the Late Twentieth Century.* New York: Denver Art Museum and the Columbus Museum of Art, 1994.

Fuller, Patricia. *New Works: A Public Art Project Planning Guide.* Durham: Durham Arts Council, 1988.

Gablik, Suzi. *The Reenchantment of Art.* New York: Thames and Hudson, 1991.

Geertz, Clifford. *The Interpretation of Culture.* New York: Basic Books, 1983.

Hayden, Dolores. *The Power of Place: Urban Landscapes as Public History.* Cambridge: MIT Press, 1995.

Hine, Thomas. *Facing Tomorrow.* New York: Alfred A. Knopf, 1991.

_____. *The Rise and Fall of the American Teenager.* New York: Avon, 1999.

Hiss, Tony. *The Experience of Place.* New York: Alfred A. Knopf, 1990.

Hood, Walter. *Urban Diaries.* Washington, D.C. and Cambridge: Landmarks #02, Spacemaker Press, 1997.

Hughes, Robert. "The Case for Elitist Do-gooders." *The New Yorker*, 12 May 1996, 32–33.

Jacob, Mary Jane. *Places with a Past: New Site-Specific Art at Charleston's Spoleto Festival.* New York: Rizzoli International Publications, 1991.

Jacob, Mary Jane with Michael Brenson. *Conversations at the Castle: Changing Audiences and Contemporary Art.* Cambridge: MIT Press, 1996.

Jacob, Mary Jane, Michael Brenson, and Eva M. Olson. *Culture in Action.* Seattle: Bay Press, 1995.

Jacobs, Jane. *The Death and Life of Great American Cities.* New York: Random House, 1961.

Jellicoe, Geoffrey and Susan Jellicoe. *The Landscape of Man: Shaping the Environment from Prehistory to the Present Day.* New York: Viking Press, 1987.

Jordan, Sherrill, ed. *Public Art, Public Controversy: The Tilted Arc on Trial.* New York: American Council for the Arts, 1987.

Kelling, George L. and Catherine M. Coles. *Fixing Broken Windows: Restoring Order and Reducing Crime in Our Communities.* New York: Martin Kessler Books, 1996.

Kozloff, Joyce. "The Kudzu Effect (or: The Rise and Fall of a New Academy)," *Public Art Review* (fall/winter 1996): 41.

Lacy, Suzanne, ed. *Mapping the Terrain: New Genre Public Art.* Seattle: Bay Press, 1995.

Lippard, Lucy R. *The Lure of the Local: Senses of Place in a Multicentered Society.* New York: New Press, 1997.

_____. *Mixed Blessings: New Art in Multicultural America.* New York: Pantheon Books, 1990.

_____. *On the Beaten Track: Tourism, Art, and Place.* New York: The New Press, 1999.

_____. *Overlay: Contemporary Art and the Art of Prehistory.* New York: The New Press, 1983.

Lynch, Kevin. *What Time Is This Place?* Cambridge: MIT Press, 1972.

Lynch, Kevin and Gary Hack. *Site Planning*. Cambridge: MIT Press, 1960.

McHarg, Ian. *Design with Nature*. New York: John Wiley & Sons, 1992.

Merryman, John Henry and Albert E. Elsen. *Law, Ethics, and the Visual Arts*. Philadelphia: University of Pennsylvania Press, 1987.

Naude, Virginia Norton and Glenn Wharton. *Guide to the Maintenance of Outdoor Sculpture*. Washington, D.C.: American Institute for Conservation of Historic and Artistic Works, 1993.

Novakov, Anna, ed. *Veiled Histories: The Body, Place and Public Art*. New York: San Francisco Art Institute Critical Press, 1997.

Olin, Laurie. *Transforming the Common Place*. Princeton: Princeton Architectural Press, 1996.

Potteiger, Matthew and Jamie Purinton. *Landscape Narratives: Design Practices for Telling Stories*. New York: John Wiley & Sons, 1998.

Prentice, Helaine Kaplan. *Suzhou, Shaping an Ancient City for the New China: An EDAW/Pei Workshop*. Washington, D.C. and Cambridge: Landmarks #08, Spacemaker Press, 1998.

Preservation Heritage. *Today for Tomorrow: Designing Outdoor Sculpture*. Washington, D.C.: Preservation Heritage (Formerly National Institute for the Conservation of Cultural Property), 1996.

Raven, Arlene, ed. *Art in the Public Interest*. Ann Arbor: Umi Research Press, 1989.

Reed, Christopher. "Imminent Domain: Queer Space in the Built Environment," *Art Journal* (College Art Association) (winter 1996): 64–70.

Rudofsky, Bernard. *Streets for People: A Primer for Americans*. Garden City: Doubleday, 1969.

Ruppersberg, Allen. *A Tourguide to: The Best of All Possible Worlds/Die Beste Aller Möglichen Welten*. Münster: n.p., 1996.

Schama, Simon. *Landscape and Memory*. New York: Random House, Vintage Books, 1995.

Scruggs, Jan C. and Joel L. Swerdlow. *To Heal a Nation: The Vietnam Veterans Memorial*. New York: Harper & Row, 1988.

Senie, Harriet F. *Contemporary Public Sculpture: Tradition, Transformation, and Controversy*. New York: Oxford University Press, 1992.

Senie, Harriet and Sally Webster, eds. *Critical Issues in Public Art: Content, Context, and Controversy*. New York: Icon Editions, 1992.

Spirn, Anne Whiston. *Granite Garden: Urban Nature and Human Design*. New York: Basic Books, 1984.

_____. *The Language of Landscape*. New Haven and London: Yale University Press, 1998.

Whyte, William. *The Social Life of Small Urban Spaces*. Washington, D.C.: Conservation Foundation, 1980.

Wilson, James Q. and George L. Kelling. "Broken Windows: The police and neighborhood safety," *The Atlantic Monthly*, March 1982: 29–38.

Wypijewski, JoAnn, ed. *Painting by Numbers: Komar and Melamid's Scientific Guide to Art*. New York: Farrar, Straus & Giroux, 1997.

Index

Illustration Credits

The Fairmount Park Art Association wishes to thank the photographers and institutions who have provided the illustrative material for this book. We are particularly grateful to James B. Abbott for his photographs of community sites and to Will Brown for his documentation of the artists' materials. Photographers and illustration sources are listed below by page number. Unless otherwise indicated, an illustration credit refers to all the illustrations on that page.

DEFINING THE PUBLIC CONTEXT Pages 13–14: Courtesy Fairmount Park Art Association Archives. Page 15: Howard Brunner. Page 16: Courtesy Fairmount Park Art Association Archives (right); D. James Dee (below right). Page 17: Wayne Cozzolino. Page 18: Rick Echelmeyer. Page 19: Wayne Cozzolino. Page 20: Franko Khoury. Page 21: Courtesy Doris Jones Holliday. Page 22: Penny Balkin Bach.

WHY PUBLIC ART IS NECESSARY Page 27: Courtesy The Atwater Kent Museum. Page 30: Courtesy Pennsylvania State Archives; Manuscript Group 219, Philadelphia Commercial Museum Collection; Industry; Hats; Felt; No. 3094. Page 31: Courtesy Friends of the Japanese House and Garden. Page 32: Courtesy Vietnamese United National Association. Page 34: Permission Spanish Merchants Association of Philadelphia, Inc. Photographs, Balch Institute for Ethnic Studies.

THE ART OF IDENTITY Page 37: James B. Abbott. Page 38: Will Brown. Page 39: Courtesy Venturi, Scott Brown, and Associates, Inc., photograph by Matt Wargo (left); Penny Balkin Bach (far left).

THE OBJECT OF PROCESS Page 47: Robin Redmond. Page 48: Charles Moleski. Page 50: Robin Redmond. Page 52: Charles Moleski.

CHURCH LOT Page 56: James B. Abbott. Page 57: Will Brown. Page 58: Robin Redmond (right); Lonnie Graham (far right); Courtesy Project H.O.M.E. (below). Pages 59–60: Will Brown. Page 61: Courtesy Project H.O.M.E. (left); Mark Garvin (portraits).

BALTIMORE AVENUE GEMs: GRAND PLANTERS, EARTHBOUND CROW'S-NEST, MIDSUMMER'S FOUNTAIN Page 62: James B. Abbott. Page 63: Will Brown. Page 64: Charles Moleski (right); Malcolm Cochran (far right); from EVERYDAY THINGS: WIRE ©

1994 by Susan Seslin, Daniel Rozensztroch, Stafford Cliff, Jean-Louis Menard, and Gilles de Chabaneix. Published by the Abbeville Publishing Group (below). Page 65: Will Brown. Page 66: Will Brown (right and below); James B. Abbott (below right). Page 67: Will Brown (left); Mark Garvin (portrait).

THE*YARE*US Page 68: James B. Abbott. Pages 69–71: Will Brown. Page 72: Will Brown (right and below); Permission Aerial Press, illustration by Christopher Shaw (below right). Page 73: Courtesy Urban Archives, Temple University, Philadelphia, Pennsylvania (left); Mark Garvin (portrait).

GOLDEN MOUNTAIN BUNKA-ZA Page 74: James B. Abbott. Page 75: Will Brown. Page 76: Courtesy Friends of the Japanese House and Garden (right and far right); Will Brown (below). Page 77: Will Brown. Page 78: James B. Abbott (right and far right); Courtesy Fairmount Park Art Association Archives (below). Page 79: Will Brown (below); Mark Garvin (portrait).

THE REVITALIZATION OF MALCOLM X MEMORIAL PARK Page 80: James B. Abbott. Page 81: Will Brown. Page 82: Kate Loal (right and far right); Courtesy Martha Jackson-Jarvis (below). Page 83: Courtesy Martha Jackson-Jarvis. Page 84: Will Brown. Page 85: James B. Abbott (left and far left); Mark Garvin (portraits).

BRIGHT LIGHT TRAIL Page 86: James B. Abbott. Page 87: Will Brown. Page 88: Robin Redmond (right and far right); Will Brown (below). Page 89: Will Brown. Page 90: James B. Abbott (right); Will Brown (below). Page 91: Will Brown (left); Mark Garvin (portrait).

A CENTURY OF LABOR Page 92: James B. Abbott. Page 93: Will Brown (above); Courtesy John Kindess (inset). Page 94: Charles Moleski

(right); Robin Redmond (far right); Courtesy Hagley Museum and Library (below). Pages 95–96: Will Brown; photograph of work button courtesy John Kindess. Page 97: Courtesy The Atwater Kent Museum (left); Mark Garvin (portrait).

EMBODYING THOREAU: DWELLING, SITTING, WATCHING Page 98: James B. Abbott. Page 99: Will Brown. Page 100: Will Brown. Page 101: Will Brown. Page 102: James B. Abbott (right); Will Brown (below and below right). Page 103: Courtesy The Free Library of Philadelphia.

MAY STREET: A PLACE OF REMEMBRANCE AND HONOR Page 104: James B. Abbott. Page 105: Will Brown. Page 106: Robin Redmond (right); Will Brown (below). Page 107: Will Brown. Page 108: James B. Abbott (right); Will Brown (below). Page 109: James B. Abbott (left); Mark Garvin (portraits).

THE VIETNAMESE MONUMENT TO IMMIGRATION Page 110: James B. Abbott. Page 111: Will Brown. Page 112: Will Brown (right); Courtesy Vietnamese United National Association (below). Pages 113–114: Will Brown. Page 115: Will Brown (left); Mark Garvin (portrait).

PERSEVERANCE Page 116: James B. Abbott. Page 117: Will Brown. Page 118: Will Brown (right); Courtesy Pennsylvania State Archives; Manuscript Group 219, Philadelphia Commercial Museum Collection; Industry; Hats; Felt; No. 3098 (below top); Courtesy The Free Library of Philadelphia (below bottom). Pages 119–120: Will Brown. Page 121: Mark Garvin (portrait).

I HAVE A STORY TO TELL YOU . . . Page 122: James B. Abbott. Page 123: Lonnie Graham. Pages 124–125: Will Brown. Page 126: Will Brown (right); Courtesy Urban Archives, Temple University, Philadelphia, Pennsylvania, photograph by Sonnee Gotlieb (below).

Page 127: Courtesy Urban Archives, Temple University, Philadelphia, Pennsylvania, photograph by Wasco.

MANAYUNK STOOPS: HEART AND HOME Page 128: James B. Abbott. Page 129: Will Brown. Page 130: Will Brown (right and below bottom); James B. Abbott (below top). Page 131: Will Brown. Page 132: Diane Pieri and Vicki Scuri (right); Courtesy Fairmount Park Commission (below). Page 133: Courtesy The Free Library of Philadelphia, photograph by Robert Kiker (left); Mark Garvin (portraits).

THE GLORIETAS OF FAIRHILL SQUARE: THE COMPLETION OF A NEIGHBORHOOD COSMOS Page 134: James B. Abbott. Page 135: Courtesy Jaime Suárez. Page 136: Penny Balkin Bach (right and far right); Courtesy Joel Katz design associates (below). Page 137: Courtesy Jaime Suárez. Page 138: Will Brown. 139: Will Brown (left); Mark Garvin (portrait).

PROPOSALS FOR THE WISSAHICKON Page 140: James B. Abbott. Page 141: Will Brown. Page 142: Will Brown (right); Charles Moleski (below top); Ed Stainton (below bottom). Page 143: Will Brown. Page 144: Charles Moleski (right); Will Brown (far right and below). Page 145: Courtesy The Free Library of Philadelphia (left); Mark Garvin (portrait).

OPEN-AIR LIBRARY AND FARMER'S MARKET PLAZA Page 146: James B. Abbott. Page 147: Will Brown. Page 148: Janet Zweig (below top); Courtesy The Free Library of Philadelphia (below bottom). Page 149: Will Brown. Page 150: Will Brown. Page 151: Will Brown (left); Mark Garvin (portrait).